Bruce Davidson Photographs

Bruce Davidson
79

Bruce Davidson Photographs

by Bruce Davidson

Introduction by Henry Geldzahler

An Agrinde/Summit Book

Library of Congress Cataloging in Publication Data
Davidson, Bruce, 1933-
Bruce Davidson Photographs.
1. Photography, Artistic. 2. Davidson, Bruce, 1933-
3. Photographers—United States—Biography.
I. Title.
TR654.D36 770′.92′4 (B) 78-73352
ISBN 0-671-40067-3
ISBN 0-671-40068-1 pbk.

Printed in the United States of America by Thomas Todd Company, Boston, Mass.
Bound by Sendor Bindery, Inc., New York, New York
Designed by Elton Robinson
Produced by Bob Adelman

AGRINDE PUBLICATIONS LTD.
665 Fifth Avenue New York, New York 10022

Preface

Bruce Davidson's subjects are not mounted on a pin like a precious butterfly, nor are they oddities in the tradition of P. T. Barnum or Madame Tussaud. If the poetry in a Davidson essay can be described, it is in the total sense it gives us of the subject; past, present and even destiny are held in suspension for our delectation and for our improvement. The subject is not exhibited; it is revealed, and though we may be delighted, our best instincts are also brought very much to the fore. Tolstoy argued that good art is good for you. Bruce Davidson's revelations of human dignity in the face of many kinds of adversity make good art and present a good example.

The development in Bruce's work over the entire span of his career is visible in the contrast between the painterly evocation of Montmartre and the artist's studio in his earliest essay (1958) to the more resonant poetry and sharp reality of the Garden Cafeteria (1974). The sentiment in the earlier photos does not descend to sentimentality; it is deeply felt. The clothing in which these feelings are draped, however, is borrowed. It is particularly fitting today for the work of a young artist to be perceived as having come from somewhere. Fashionable revolutionaries often make the mistake of throwing out the past rather than criticizing it and building on it. Only the primitive artist, the first caveman, invents the very idea of art. Pure invention in the wake of historical development is usually arbitrary or impoverished. Thus, judging from the richness and breadth of Bruce Davidson's mature work, it is not surprising that his first effective photographs resume much of the history of photography up to the moment at which they were shot.

A civilized artist chooses his vocation in large part because he has seen art which has moved him deeply. If Bruce was not specifically aware of the Stieglitz mystique, there is in *Mme. Fauchet* much that refers to the effect of painterliness; abundant detail slightly out of focus, and a generalized soft light that bathes and includes all. In the picture on page 20 the alternation of soft and hard focus tells a charming tale. The old lady in black, bent over, makes her way alongside a park bench. She is moving away from us toward her destiny. In other photographs it has been established that she worships at the shrine of her husband's work and memory. Nearer to us, behind her, out of her line of vision, a young and handsome couple in soft focus embrace on another bench. Are they an evocation of her youth shared with the painter? Is there an irony to the contrast? A telling poetry? Or is this a picture on which we can impose our several interpretations? It is a strength of these photographs and of the essay format that we can glean enough information from the accumulation of images to spin such questions.

Another strength of Bruce Davidson's work is that he never returns to scenes of earlier triumph. There is no typical Davidson photograph or subject. The facile disgusts him with the true self-disgust of the artist who will not repeat himself. He is concerned with the journey, not merely a frozen and perfect image. His interest in where he has been is limited to what he can learn (and thereby teach us) about the continued unfolding of a sensibility thoroughly engaged in life: teenage gangs, an artist's widow in Paris, Welsh miners, the Garden Cafeteria — worlds apart that are threaded by the filigree of Bruce Davidson's empathetic embrace of the subjects that arrest him.

In the *England* essay, the ladies bowling make a beautifully architectonic image, as precise as a military formation and as surreal as Giacometti figures striding across an unspecified square. The structure of the essay is reinforced by the touching contrast between the team of bowlers in this photograph and the intimate posture of the two ladies by themselves—particularly the pleased, shy smile, downturned head and eccentrically placed feet

of the lady facing us. While each of these pictures stands on its own, their power and resonance are increased through sequence and juxtaposition. Much the same point can be made about the *Dwarf* pictures; we see him close up, with and without make-up, small and in soft focus, the elephant's backsides towering above him, and finally in the intimacy of his sleeping berth. In the process of this unfolding we learn to admire him. Without preconceptions or a carefully constructed world-view, Bruce Davidson recognizes authenticity. He is no moralist; he does not consciously judge. He penetrates the situations to which he is drawn, and in so doing, is compassionate.

We gain much, too, from Bruce's ability to depict relationships, especially between two people—the young black boy and girl in *East 100th Street*, the Welsh miner standing in his doorway with his alabaster baby—many kinds of affection and companionship are revealed. In the picture of the seated black man with the sheriff standing in a cowboy hat, he visualizes what William Faulkner spent years in explicating: the beauty, acceptance and humanity of the Southern black; the rigidity, primness and inherited values of the white who never feels altogether comfortable in his role. The acceptance of the black and discomfort of the white are laid out for us.

Bruce Davidson's sympathies are wide. His typical subject matter is the disadvantaged, the humbled, the wounded, living in proud acceptance of circumstances. The black lady holding her baby in the brightly lit doorway of her collaged and decorated shack; the father and sons in stasis amid the detritus of the Jersey Meadows; the Brooklyn gang defiantly creating a communal style from a poverty of role models—we enter worlds formerly closed to us, worlds opened by Bruce Davidson's talent for being accepted and yet barely a factor in the situations he sets up and captures. We sense his presence only as he is responsible for the neutral occasion on which a photograph was taken. The *East 100th Street* pictures became possible because Bruce returned day after day to the same block of Spanish Harlem bearing prints of yesterday's pictures as gifts to those who had posed, thus becoming an unthreatening, familiar figure, the guy who gives out pictures. While residual pride and defiance remain, there is trust in the relationship of the photographer and his subject.

Bruce's gift stems from his ability to give con-crete and permanent definition to what for the rest of us are, at best, fleeting images of worlds we fear to penetrate or to which access is impeded or denied. But there are dangers as well as opportunities for greatness in using such potent subjects to stimulate and satisfy the viewer's interest. Too many photographs please or titillate on first viewing, then have little more to offer; further viewings allow us to remember the first impact in diminished terms—much as we may grow to loathe an artificial flower, however exquisite. In contrast, Bruce Davidson's best photographs continue to reveal their content through the passage of time and through many encounters.

I have my favorites among these photographs, pictures I have known for years. Others serve as muted background. It is these photographs that create the context in which the best can shine forth. The essay is by nature contextual, dramatic and cumulative. We can slip our favorites out of context and admire them in themselves, and this is the destiny of the individual print. But Bruce Davidson would not have been capable of essentializing such images as: *The Dwarf* (portrait in make-up), *England* (couple at tea in front of hotel), *Black Americans* (man in white apron against metal siding), *East 100th Street* (child on fire escape), had he not devoted himself to his role as an outsider with a need to belong—the participant observer who makes the most effective recorder of images.

Bruce Davidson's career in still photography can be understood best as a series of essays in self-definition and discovery. Through the exploration of contemporary life in all its variety, his early innocence has evolved into a sympathetic realism. His touching and honest account of the journey tells us much about the memorable images it was written to explicate. His discussion of these images is not facile. Rather, like the photographs themselves, it is carefully and arduously won. If it is with both difficulty and serendipity that the distilled image is achieved, it is an inspired and monumentally human stumbling to which we are witness, a stumbling upon profound truths.

In the *Garden Cafeteria* highlighted faces emerge from a palpable darkness that evokes the passage through which these people have come. We have moved from the Impressionism of *Mme. Fauchet*, light, charming and wistful, to another painterly vision, achieved like the first through an intuitive identification with the subject. The poetic mood is darker, more amused and infinitely heartbreaking, that of the mature Rembrandt and *his* Jews, nestled in an area of darkness, highlighted in a golden glow of wisdom and compassion. This development is the reward of a struggle for self-realization and technical mastery which Bruce Davidson has undertaken as a man, lonely and connected. We see the evidence of the struggle, its stages and resolutions, in the photographs, and we are given a sense of what lies ahead: the struggle will continue and we will be the richer for it.

Henry Geldzahler
August, 1978

6

Introduction

I can remember my parents arguing behind closed doors while I played with my toy blocks under the dining-room table, afraid of their voices. My father gambled and bet on the horses, neglecting his law practice and our family. When I was five they were divorced. The war came and he joined the Navy. We moved into my grandparents' house in Oak Park, a suburb outside Chicago. Soon after our move, my grandmother died. I remember coming home from school through the backyard garden into the house where everyone was silent and she lay very still.

My grandfather was born in Warsaw. He came to this country as a tailor and started a menu-cover business with his two sons in Chicago. He often took my brother and me to the fire station and gave us nickels to buy candy at the corner store. After my grandmother died, he soon re-married and moved to Chicago.

At times my father came back on leave from the Navy, and my younger brother and I got dressed up, took our baseball gloves and went on the "El" to the city to meet him at the USO club. He took us to a Cubs game, gave us dinner, and put us on the train back home.

I began to have trouble reading and failed second grade. My class went on, and I stayed behind to enter a class of strangers. I was afraid that if I failed again they would put me across the hall with the slow children in the special room.

The war years floated by. We would meet Mother at the bus stop coming home from the tor-pedo plant where she worked, and on Saturdays we went to a Western double feature at the local movie theater. Most of our spare time was spent on sports—basketball in the spring, baseball in the summer and football in the fall. Our uncles paid for the braces on our teeth and helped with the bills.

We had a game we played in the alley called "Donkey." If you missed the six letters in d-o-n-k-e-y you were out and had to sit out the game until everyone else was out. I was out when a friend came along and asked if I wanted to see pictures develop in the dark. I followed him into his dark-ened basement. There, under the dull ruby globe, I saw trays with strange chemical solutions in them. He placed a negative with a blank sheet of photographic paper under a piece of glass, ex-posed it to white light for a few seconds, then put the paper in the tray of dark solution. Slowly the image of a person appeared in the dim glow of the ruby room. The magic of the process, the chemical smells, the running water and darkened room attracted me. I wanted to develop pictures too.

I saved money from my paper route and bought a Fulcon 127 box camera and developing equip-ment at the drugstore. My mother emptied out her jelly closet in the basement for a darkroom, and I began as a boy of ten in photography. I took pictures of my mother, our dog, the house, and my brother at camp pretending he could swim in the lake. At about this time, I started Hebrew School to prepare for my bar mitzvah. For two years I struggled, learning to read in the Torah, prepar-ing for the day when I would stand before our congregation, recite, and become a "man." Off to the side in the rabbi's study I could see a box that I knew was a camera. After the final speech, an uncle of mine gave me my first good camera— an Argus A2 with several rolls of film. I took pic-tures with my new 35-millimeter camera all the time. I began to work as a stock boy in a camera store on Saturdays. There I met a local commer-cial photographer named Al Cox. I began to ap-prentice with him at his studio in Oak Park. He was an excellent craftsman who taught me to en-large my photographs, to use his Rolleiflex with flash on newspaper assignments, and to aid him in making dye transfer color prints. My mother would often call at the studio asking him to try

to get me to study in school, but nothing seemed to help.

My mother was an attractive, strong, determined person who worked hard to support my brother and me. She taught us to make our meals, keep the house clean, and take care of each other while she was away at work. Part of me felt close to her warmth and love, and part of me felt afraid to fail her, to become a failure like my father. I felt a need to escape. I began running on the track team, exploding my energy from the starting block to the finish line, but I usually came in last. I began exploring the city streets and forest preserves with my camera.

In my sophomore year, my mother remarried and we moved into a large house in an adjacent suburb. My new father built a darkroom, bought an enlarger, and gave me his expensive Kodak Medalist camera. He was careful and patient with us, but I could not conform at home or succeed in school. I began to feel more distant and alone.

I began to take more trips into Chicago by myself with my camera. There I discovered the teeming markets of Maxwell Street where I saw pushcart peddlers, street hawkers and sidewalk merchants. I took pictures of an old woman wearing a babushka selling rags and of a black child sleeping on his shoeshine box. At night I ventured under the bridges along the Chicago River and took pictures, using a tripod, of the Wrigley Building lit up at night, reflected in the river.

School continued to be a problem. Other high school students were talking about going away to college. My chances of getting into college were very poor, and I was afraid I would be left behind. In my senior year, I won first prize in the Kodak National High School Snapshot Contest, in the animal division, with a close-up picture of an owl I had photographed at a trailside museum in the forest preserve. My stepfather wrote letters to the Rochester Institute of Technology, a college that specialized in photography, to see if I could qualify.

I was accepted on probation my first semester at R.I.T., with an asterisk next to my name on the bulletin board for everyone to see. I worked hard in college classes—organic chemistry, photographic sensitometry, light physics and studio illustration. My grades that term were close to straight A's, and I was allowed to stay.

There was an inspiring teacher, Ralph Hatters-ley, who gave a class that he called Creative Illustration. In his class he showed us Robert Frank's grim pictures of Welsh miners coming up from the mines, the elemental mood of a mother nursing her child, and the ominous gloom of the traffic line down an empty New York street. We looked at W. Eugene Smith's portrait of Dr. Albert Schweitzer that projected the reflective essence of the man. He brought in Cartier-Bresson's *The Decisive Moment,* and we looked at his photographs of the old women sitting on a bench in Hyde Park, the Mexican women leaning out of their doors, and the man running across a plank floating in water. Looking at those images, we confronted the idea of the photograph for the first time. It challenged our notions of what a picture should be. At times it was hard to fathom what I was seeing and to understand its deeper meaning.

There was a lovely girl in our class who had a copy of *The Decisive Moment,* and we sat together in the living room of the girls' dormitory looking at Cartier-Bresson's pictures. We entered his world, where the visual rhythms and silver tones gave us a feeling of life and a sense of the creative spirit. She read me part of the introduction: "I believe that, through the act of living, the discovery of oneself is made concurrently with the discovery of the world around us." It was then that I fell in love for the first time, with the girl and with Cartier-Bresson.

I thought that if I could take pictures like his she might like me. I smuggled a hotplate into my dormitory, and lived on canned soup and peanut butter and jelly sandwiches for months. With the food allowance I saved, I bought a secondhand 35-millimeter Contax. I went into the streets of Rochester each day to look for the discovery that would bring me closer to Cartier-Bresson's photographs. I took pictures of a ragpicker pushing his cart home, children playing in the street, vagrant men at the storefront mission. I started to develop a sense of distance and timing that made me begin to understand Cartier-Bresson. Later I showed my photographs to my friend, but she had fallen in love with our English professor, and I was left with Cartier-Bresson.

In my senior year at R.I.T., I was sitting in a coffee shop near school. Next to me was a girl who looked as if she came from a South Sea island. She had sloping eyes, full lips, and long dark hair. I began to take pictures of her, and then we started to talk. She told me that she had spent a lot of time on the street after leaving home when she was sixteen. We went to my friends' apartment to take more pictures. She took off her clothes. I took a few pictures, undressed and embraced her. We kissed and made love. Then I became afraid that my friends would come home and discover us in their bed or that I would contract a venereal disease my first time with a woman. I got dressed and returned to the dormitory. When I developed the films and looked at the negatives, I saw her beautiful body that earlier had moved beneath me. Days passed. I looked for her each day in the coffee shop and along the street, but I never saw her again.

At the end of our senior year, Eastman Kodak Company sent a man to recruit a student for a job at their big studio in New York. Their manager looked at the work I had done in our studio class, pictures that mimicked the slick advertising photographs that I had seen printed in the glossy national magazines—cross-lighted close-ups of machine gears, silhouetted models holding backlighted perfume bottles, and high-key corn flakes boxes on seamless paper backgrounds. He seemed to be impressed with the way I did these pictures and I got the job. Meanwhile, my parents had moved to a suburb outside New York and they were proud that I had a secure career at the Eastman Kodak Company.

For the next few weeks, I photographed commercial products in the studio with an 8x10 camera, using the lighting techniques I had learned in photography school. Soon the monotonous routine began to bore me and I decided to apply to the Yale University School of Design.

My interview at Yale with Professor Josef Albers was on a rainy day. I crossed the quadrangle to the office of the chairman of the Painting Department soaked to my skin, carrying a wet box of heavy prints. Albers looked at my photographs thoughtfully, then turned to me and asked me to throw out all my "sentimental work." I didn't know what he meant. They were my efforts of the past two years—the destitute men at the Light House Mission, the ragpicker pushing his cart home, the torso of a nude lying on a crumpled bed.

In the fall of 1954, I was accepted at Yale and studied with Albers in his drawing and color courses. My student friends at Yale graduate

school were serious painters, designers, and architects. They uncovered a new visual world of abstract painting, graphic design and architecture. However strong their influence, I still remained aloof from the academic climate at school and returned to the street with my camera and my need to explore.

I wanted to be a *Life* magazine photographer. I bought a Leica M-3 with a normal lens and began to photograph the Yale football team behind the scenes, in the dressing room and on the players' bench. The forms of taped arms, a twisted towel, and athletes lying spent on the dressing-room table were the images that caught the tension I felt there.

After my first term at Yale, the draft board in New Haven asked me to report for military service. I was getting restless at school and welcomed the army—that meant I could see the world. Before I was inducted into the service, I sent my football pictures to *Life* magazine.

During my first months in the army at Camp Gordon, Georgia, I took pictures of the life of soldiers during basic training. I submitted them to *Life* and they sent a writer down to the camp. Then I received orders for Fort Hauchica, a remote post in southern Arizona. I was assigned to the photo lab, drying prints and mopping the floor in the captain's office. Whenever the door opened, sand blew in from the desert and I would have to start sweeping all over again.

One day the captain came in with a copy of *Life* which contained a five-page football essay with my byline, called "A Dangerous Silence." The next day I was riding in a jeep with a Speed Graphic to photograph the general.

Hitchhiking to Mexico on a three-day pass to see the bullfights, I met a 92-year-old prospector who drove a Model T Ford. I stayed with him and his wife at their bunkhouse in Patagonia, Arizona, on weekends. There was a timeless feeling living with them. The smell of age mixed with the sense of the Old West I had seen in cowboy movies, echoed in the way they moved slowly around the bunkhouse.

After living a year in the vast Arizona desert,

I received orders for Supreme Headquarters Allied Powers in Europe, stationed outside of Paris, and was assigned to the photo lab, developing film. I bought a motor scooter and rode it to Paris on weekends. I visited the Louvre, took pictures in the markets of Les Halles, and walked along the Seine to Notre Dame. I fell in love with a French girl who straddled the back of my scooter holding my waist tight. We stopped at a café to drink hot wine, then walked together in the Tuileries while I took pictures. After a few months our love affair ended. I continued to roam the streets alone, filled with a sense of the kind of life I had seen in French paintings. I received a telegram from my brother that my father, whom I had not seen in ten years, had died of a heart attack in Chicago. He was fifty-four. His death seemed far away from me, but it left unanswered questions of who I was.

A French family asked me to lunch at their home in Montmartre. After lunch, I stood on the terrace watching people pass down below. I saw an old woman making her way slowly up the steep street using her cane. I learned that the woman lived upstairs in a garret. She was the widow of an Impressionist painter called Leon Fauchet. I was introduced to her in her studio that overlooked the Sacré-Coeur and the Moulin de la Galette. She lived alone, surrounded by her husband's paintings, many still on their easels. I visited Mme. Fauchet on weekends, driving up the Rue Lepic on my motor scooter. She told me that her husband had taught Gauguin lithography and exhibited with him, and she showed me photographs of Lautrec, Renoir, and others from that era. During the weeks that followed, I saw Mme. Fauchet every weekend. We walked together along the streets, sat in the parks, and went into the market where the merchants called us lovers.

My photographs of her had taken on the somber tone of age. I had found a feeling with Mme. Fauchet that touched the past, the Impressionist era, and I felt close to Paris. I discovered more in Cartier-Bresson's photographs that reached deep within me, the sense of a total life. I came to an end within myself and disappeared from Mme. Fauchet.

After a few weeks I took my photographs of Mme. Fauchet to *Life's* Paris office. The editors looked at the pictures and sent them to the New York office. I went to the Magnum office in Paris to

show my pictures to Cartier-Bresson. He sat on a tall stool at a table with a cup of coffee next to him and carefully looked at the pictures, turning them over slowly; then he looked at the contact sheets, pointing a finger at an image occasionally. He sat very straight and erect, was dressed neatly, had ordinary features and was slightly balding. He didn't look like any hero I knew. He didn't look like my father, teacher, or coach. After looking at the pictures, he told me that they were sensitive photographs and to keep working. We took a walk for a few minutes together. The street became his photographs. A young couple embraced, a fat man walked and a child skipped. Cartier-Bresson paused and held his Leica smoothly to his eye.

In 1957, my two years in the army were over and I returned to New York to begin working for *Life* magazine through a free-lance program for young photographers. For the next few months, I was assigned *Life* picture stories— a college going co-educational, a society bandleader on tour and a Broadway stage production. I learned to use various cameras, light with strobe to achieve a natural effect, and take pictures under difficult conditions.

I was promised a staff position by the end of the year, but I was disappointed in my work; it seemed trite and empty. I felt the need to belong when I took pictures—to discover something inside myself while making an emotional connection with my subjects. The work of W. Eugene Smith gave me the direction which I was determined to follow. His intimate *Life* photo-essays of "Spanish Village," "Midwife" or "Schweitzer" taught me that a photograph could not only communicate emotions, but could also serve the human condition. It was what I saw in the dramatic tones and powerful forms of his photographs that led me to *Life* and gave me inspiration. The dream of being a *Life* photographer dissolved, and I searched for a new climate to grow in.

I went back into the streets of New York, to the Lower East Side, where the immigrants settled to begin a new life in America. I felt free in the teeming vitality of the tenement streets.

In the winter of 1958, I joined Magnum Photos, the international picture cooperative owned by its member photographers and staff. It was an open climate that concerned itself with moral principles and personal growth. In that year I completed photographic essays on Leonard Bernstein, Central Park and the Statue of Liberty. Cartier-Bres-

son came to New York on an assignment to photograph the city. We took a bus together to the Lower East Side. On the bus he spoke to me about self-discipline, reading and looking at paintings. Once on the street, we separated and he disappeared into the crowd. As I walked, I took photographs of a fish peddler holding a fish, a plucked chicken hanging in a window of a kosher butcher shop, and children flying their kites down the tenement street.

The man who headed the picture library at Magnum told me about a small circus that had pitched its tent at Palisades Amusement Park in New Jersey. I began to photograph the circus every day during the weeks it was there; then I traveled with it along its route. I took pictures of the circus acts—the girl riding the elephant, the lion tamer, the man shot from the cannon and the clowns. I rode with the cannon man and his family in a silver truck that carried his cannon. The roustabouts helped me climb the rim of the tent to the top, where I saw the circus far below.

I first saw the dwarf standing outside the tent in the dull mist of a cold spring evening. His distorted torso, normal-sized head and stunted legs both attracted and repelled me. He stood sad and silent, smoking a cigarette outside the tent.

Loud music played and he disappeared into the lights and laughter of the tent. His name was Jimmy, but he called himself "Little Man," and sometimes after the last show we went into a diner together where people snickered and laughed at us. When I finished the photographs of him, I gave Jimmy a small camera that could fit into his hands.

After I finished the dwarf essay in the summer of 1959, I went back to doing assignments. I photographed a rodeo rider in New York, Ava Gardner making a movie and the first moon rocket launching at Cape Canaveral. I lived in a one-room skylight studio in Greenwich Village. I made a kitchen-darkroom combination. Using a ruby light in the refrigerator, I ate cold chicken and Hershey bars out of it while I printed.

In the late fifties, New York was plagued by youth gangs. Gang "rumbles" became so frequent that a Youth Board was formed to stop the violence. A Brooklyn gang called the Jokers made headlines in the papers, and I contacted them through the Youth Board. At first I went with a Youth Board worker to take pictures of their wounds from a gang war in front of their candy store hang-out. Later they let me go alone with them to Coney Island at night where they would lie under the boardwalk drinking beer. In the morning they would dance down the boardwalk together. A girl stopped to comb her hair at the cigarette-machine mirror. Then they took the long bus ride back to where they lived. In 1958, they were about seventeen and I was twenty-four. As we rode the bus, the sun burned in the windows. I held my Leica tight and released the silent shutter curtain the moment they looked alone. I force-developed the film to increase the harsh contrast that reflected the tension of their lives. I took the finished photographs to the editors at *Life* who looked at them and gave them back to me.

Later the gang pictures were published in *Esquire* magazine in June of 1959. I became more aware of the photographs of Robert Frank, who had just published *The Americans*. In it I saw an America that diminished the dream and replaced it with a piercing truth. It was hard for me to endure those bitter, beautiful photographs, for I had still within me the dream of hope and sympathy that I had found in the widow, the dwarf, and the gang.

During the next year, I photographed the Metropolitan Opera, fell in love with a young ballerina, went to a Caribbean resort hotel and made love to a woman old enough to be my mother, then returned to an exclusive country school and had an affair with a student. My Magnum assignments took me in every direction—photographing everyone from Marilyn Monroe to Premier Krushchev.

In the fall of 1960, I was asked by *Queen* magazine to come over to Britain for two months and photograph. Before I left for England I had a tailor make the pockets of my jacket larger to hold my Leicas. I carried three cameras—two in my pocket and one in my hand. The 35-millimeter wide-angle lens opened the space. It allowed me to come closer to subjects while including more background and depth.

On the moors of Argyll I stayed with a shepherd for a few days. I roamed the bleak hills where his small dogs worked the sheep into tight herds. The light was grey with a fine cold mist that brightened the grass. Later the wind picked up and the shepherd leaned against it, leading his dogs back to the farmhouse. We sat before the fire with the tea and biscuits his wife served.

I got a small convertible with red leather seats and traveled around the countryside eating bananas and cookies that lay beside my cameras on the front seat. I took pictures on the strand in Brighton, in a cemetery in Yorkshire and at a coffee bar in London. I stood alone in the mute landscape and found an inner distance that placed me where I wanted to be. My camera was loaded with a sensitive English film. The texture of its delicate grain pattern matched the diffused tones of the opal light.

When I returned to New York, the art director of *Vogue* asked me to his office. He sat in a large white room with thick grey carpets, surrounded by serious secretaries and intense fashion editors who came in and out wearing hats and carrying clothes. He asked me to photograph high-fashion models in color using the "vision" I had with the teenage gang. He said I could do other things—beauty, travel features. The idea of fashion appealed to me; it meant I was closer to success.

In 1961 I was given my first assignment to photograph high fashion for *Vogue* at an atomic energy exhibit in New York. I didn't know anything about clothes. My own clothes consisted of frayed army shirts, khaki pants, and work boots. I arrived at the location with my Leica. I asked a fashion editor they called "the baron" what was important about the dress. He told me that it was completely "a visual thing," and stuck some pins into his mouth. I introduced myself to the tall model in a blue chiffon dress and photographed her walking along the exhibit display of atoms whirling in the background. The editors told me how "marvelous" my "blue pictures" were. I was drawn to the attention I was given and to the glitter of high fashion with its beautiful women.

Sometimes I photographed in my skylight studio apartment where I slept on a mattress in the middle of the room. The models and editors would walk into the room carrying boxes of hats and clothes, and they would stand on my bed.

I used the speed of my Leica the same way I used it on the street. The pictures were my pic-

tures, but I felt removed from the world they represented, and at the same time attracted to it. I had drifted away from the emotional attachment and relationships I had had with the dwarf and the gang. I wasn't sure where I was being taken. That year I applied for a Guggenheim Fellowship to photograph "Youth in America." I wanted to find my way back to myself.

In May of 1961, a Freedom Rider bus was burned outside Anniston, Alabama, and its riders were beaten by a white mob. Young students who had integrated a bus that crossed a state line were planning another ride from Montgomery, Alabama, to Jackson, Mississippi. The National Guard had been called in to escort the Freedom Riders. I received a *New York Times* assignment through Magnum to cover the story. I arrived in Montgomery on an early spring day and met the riders at a private home where they were staying. Some of them were bandaged, and they sat together in chairs and on the floor. The mood of the room was still and tense.

We boarded a Trailways bus at the station. I photographed the Freedom Riders surrounded by grim National Guard troops and a dozen police cars. Solemn soldiers stood in the aisle with fixed bayonets. The riders started singing "Freedom, Freedom," and the bus pulled away from the depot, passing jeering whites who lined the streets. During the hours that the bus traveled the deserted tree-lined highway, there was fear that snipers might fire on the bus. The riders quietly sang freedom songs to dispel their fears. When the bus reached Jackson they were arrested and taken away in police cars.

I returned to New York and continued magazine assignments—a new bra for *Vogue*, a society ball for *The Saturday Evening Post* and a trip to Sicily for *Holiday*. In Sicily I photographed the Roman ruins at Siracusa. It was hard to come to grips with the past. I made images of small children playing in a field in front of the temple at sunset. A child ran past me. I felt blurred and distant from myself.

I returned again to New York to photograph fashion and make flattering portraits of the "Beautiful People" for important editors and powerful art directors. That year I married the daughter of a wealthy lingerie manufacturer.

In the spring of 1962, I received a Guggenheim Fellowship and began to travel in the South. I photographed a farm migrant labor camp in South Carolina, cotton being picked in Georgia, and a funeral in Mississippi.

In Brownsville, Tennessee, I was arrested one night by the local sheriff for taking pictures of a black couple dancing at a jukebox in a small restaurant in town. They took me to the jail where they questioned me for an hour. They wanted to know if I was a Communist or a civil rights worker. I told them I was a photographer on a grant to take pictures of the South. The sheriff said they had had trouble with "agitators" and said, "Get out of town before we have to stomp you!"

A few weeks later I joined ten integrated marchers retracing the steps of a postman who had been killed by a sniper's bullet when he walked down an Alabama highway carrying a sign, "Eat at Joe's Both Black and White." I walked with the marchers, taking pictures of them and of the angry youths that followed close behind. When the marchers rested, the youths came closer. One black marcher sat at the roadside surrounded by some white youths, talking to them. One youth struck a match and dropped it beside the marcher's head, but he kept quietly talking. Carefully, I slowly brought the Leica to my eye, made a couple of exposures, and stood there looking at the ground, hoping they would not attack us.

I began to feel the strong conflict between the emptiness of my fashion work and the violence and trust I had witnessed in the South. I saw my wife of a few months fall away in betrayal, and I became sharply aware of the lie I had been living. The pain paralyzed my photography, and I fell into a deep depression. Friends urged to me enter psychotherapy.

For months I lay on the analyst's couch trying to uncover lost feelings of rage that would help me find feeling again. To support the sessions I continued magazine work. The problems of others, I discovered in group sessions, were not so different from my own. I needed to take some first steps into the real world again.

Passing under the construction of the Verrazano Narrows Bridge one day, I saw men pouring concrete into the giant anchorage that held the expanse of cable spinning back and forth for over a mile across the bay from Brooklyn to Staten Island. The building of this structure made me think of the great Pyramids—it was a continuation of humanity's efforts to grow, reach out, and change. I received permission to go onto the bridge, guided by the "boomers" who were building it. Walking over the completed spans, I photographed the lifting of the heavy sections from the bay hundreds of feet below. The ironmen cautioned me not to stand close to the heavy lifting cables, which could snap, cutting a person in two. Below, the cargo ships passed under me like toys; above, the men balanced themselves, walking back and forth on the iron girders. At times this suspension bridge looked dense, armored, and at other times it had the delicacy of a flying insect.

I held onto the guy wire with one hand and my camera with the other. The structure of the bridge was a skeleton of danger and tension. I used an extreme wide-angle lens. It allowed me to explode the space around me while at the same time exploring the intricate detail of the bridge. At other times I used a strong telephoto lens to compress the distance of the span across the bay.

One day I took the elevator to the top of the pylon and photographed the expanse of the Narrows 400 feet below. The two roadways now joined; the bridge was completed. I had been connected to it, and I had reached a turning point. I began having a relationship with a beautiful woman who cared for me and helped me believe in myself again.

Esquire asked me to photograph Los Angeles. The L.A. airport had palm trees planted in the parking lot. I ordered food through a microphone in a drive-in restaurant. The streets were blank and brilliant from the sun. The sea reflected off metallic bumpers and glared on the freeway. People like mannequins seemed at peace in the desert and euphoric on Sunset Strip. I stood there ready with my Leica, aware of my shadow falling like a black cloth on the bright pavement. I walked up to strangers, framed the environment, focused and released the shutter at one determined time. I found a deeper consciousness that made me want to see more sharply.

By the end of 1964, my *Vogue* fashion work began to fall off. I continued feature work for them— Philip Johnson in his glass house, Andy Warhol in his loft, and Mrs. Henry Ford in her Grosse Pointe

backyard. I was sent to Iran to photograph the crown jewels and to make portraits of the king.

I photographed a young couple in their remodeled carriage house while the writer asked which they preferred, six or eight for dinner. I said to myself, a little too loudly, "Let's throw up." The writer reported me to the art director, who told me that to work for *Vogue* I had to play the game.

I began teaching a photography workshop in my Greenwich Village studio with ten students I selected from various walks of life—a suburban housewife, a retired businessman, a newspaper reporter and a young high-school dropout. I gave them assignments to take self-portraits and street photographs, to meet a stranger and make a series of portraits. I showed the work of Atget, Evans, Cartier-Bresson, Smith, Frank and others important to the history of photography. I asked Kertész, Avedon and Arbus to participate by showing their work for an evening. Kertész brought his photographs of the naked man sitting on a rock, a woman in repose on a sofa, and a lone cloud next to a tall building. Avedon showed his pictures of the tormented patients in a mental hospital, an unmasked look at Marilyn Monroe, and the painful face of a man born in slavery. Arbus came with pictures of an obese family lying nude on the ground, midgets in a bedroom posing together, and a widow sitting in her ornate bedroom.

The strong presence of these photographers plus the impact of their work changed my perception. They all gave us clues to their inner world. Kertész let us see our mortality in a piece of crusted rock and a man's flesh; Avedon made us confront his anger in the aged black man's pores and crystal-clear eyes; Arbus broke through the desperate pain of her aloneness into the cruel world of the midget's taboo.

After the class that evening, Diane Arbus and I went for a walk in the Village and had a pizza together. We took a trip to Atlantic City to see a burlesque show; then on the way back we stopped at a small lake where she took pictures with her Rolleiflex of bathers who looked directly into her camera. We took pictures of ugly plaster garden statues that were for sale in a backyard. A fat woman came out and chased us away. We laughed.

In the winter of 1965, I went into the industrial wasteland outside New York. There I explored the back roads that led through the brackish tidal marshland, garbage dumps and factories built on waste fill on the fringe of New York City. I met Willie Royka who picked the dumps for scrap metal and trapped muskrats with his young son. They took me deep into the New Jersey Meadows where the reeds obscured the city skyline. We made our way through the soft ground to the traps. At the end of the day, they took me home where they skinned the pelts.

In the spring of 1965, I returned to the South, joining the Selma march in Alabama. Hundreds of people were marching the fifty miles from Selma to Montgomery, the state capital. There were reporters, press, TV crews, helicopters, police and the National Guard, making the event seem like a parade. As I walked with the marchers, I photographed them by themselves when they stopped to rest. I took pictures of them looking straight into the camera. They confronted an invisible audience with proud, determined looks.

During the night that the march ended, Viola Liuzzo, a white civil rights worker from Detroit and mother of four children, was killed by a shotgun blast through her car windshield. The next morning I saw the bloodstained seat, shattered glass fragments and skid marks where her car had gone off the road. The violence in the South had reached into me deeper than my personal pain.

Later in the year *Esquire* sent me to a "topless" restaurant in San Francisco. The editors wanted pictures of an entertainer who had large breasts. I stood in the audience and saw the passive look of women on small stage platforms swaying their naked bodies to loud music. I went into the kitchen where a young waitress, with stretch marks from a child she had borne, carried platters of food to vacant-faced businessmen on their lunch hour. The true subject of these photographs was not their naked bodies but their endless aloneness.

In the fall of 1965, I went to Wales for a *Holiday* magazine assignment to photograph the Welsh castles. After completing the assignment, I traveled to the mining country in South Wales. I began to work in a way that was new to me. I started to stage-direct the picture. I brought a child into the graveyard where she often played and asked her to sing and dance for me. The mines, coal fields, and children playing in factory towns held a certain mystery for me. What attracted me to these images was the survival of the human spirit coming out of the deep caverns into the grim surroundings.

I returned to New York and became restless in therapy. I decided to try it on my own for a while. In the spring of 1966, I borrowed a pick-up camper and loaded it with developing equipment, cameras, a tape recorder, camping gear and food. I started across the country for two months alone. I photographed people I met along the way. I camped in the high country, in the Bridger Wilderness, and in the Grand Tetons. I set up my view camera, looked into the ground glass and saw a world of great scale. I took a pack trip up into the mountains and photographed the landscape. At dusk I built a campfire and looked out at the sharp peaks still light from the sun above the timber line. The bright evening star appeared, and it felt good to be alone.

That fall a friend asked me to a party to meet a friend she thought I might like. I saw Emily sitting in a corner of the room. Her beauty was delicate but strong. She had a thin face, large alert eyes, and a firm, full body. There was something biblical about the way she held herself, a gentle, quiet quality that came from warmth and inner strength. We talked, and I told her about a block I was beginning to photograph that peope called the "worst" block in the city. The next week, after returning from a meeting with the Metro North Citizens' Committee, I showed her my dwarf, gang, England, and civil rights photographs. We drove in my camper bus to Coney Island playing The Mamas and the Papas on my tape deck. We walked together, and I showed her where I had taken pictures of the gang under the boardwalk.

She told me that she had studied acting for a long time, but nothing had come of it. We later went to my studio and looked at the photographs I had begun to make on the block in Spanish Harlem. She looked for a long time at the pictures of tenement fronts, people on the street, and a family posing in their kitchen. During the months that followed, we became closer to one another.

I continued to photograph on East 100th Street with the view camera on its heavy tripod and the black focusing cloth. I stood there next to the

camera, holding the shutter release. I looked into the eyes of the people. They stood still and silent, went into themselves in their repose.

The large negative and strobe light made it possible to see with greater depth and sharper detail into the rooms, buildings, vacant lots, streets and rooftops that defined the space they called their home. The street was a place I would go each day to see the invisible.

Emily and I went to the block together, photographing and giving the pictures I made to the people. She had a natural way about her that the people liked, and we began to be accepted by the community. We felt close to each other, and in the spring of 1967 we were married in the garden of her sister's house near Washington, D.C. We drove our camper bus across the country. I took her to the Grand Tetons and to the places I knew in the Bridger Wilderness. We sat together at dusk by the campfire.

We returned to the block at the end of the summer in 1967. I went deeper into the lives of the people and deeper into myself. Sometimes I had to force myself to go to the block because I was afraid to break the painful barrier of their poverty. But once I was there and made contact with someone and felt connected, I never wanted to leave. Women called me from their windows and children said, "Hi, picture man." Every day I appeared with my large bellows camera, heavy tripod and box of pictures. Like the TV repairman or organ grinder, I appeared and became part of the street life.

People asked me into their homes to make records for the citizens' committee of leaks, cracks and unheated buildings. The powerful strobe light enabled me to expose the film fully in rooms that were lit by one naked bulb and a dark window, bringing out detail without losing the sense of darkness in those rooms. When the rooms were flooded by natural daylight or were bright, I made the pictures convey that mood. Outside people stood in the open shade to be photographed. Shafts of light crossed the buildings or were reflected into rooms where I took long time-exposures of people looking directly into the camera. Sometimes I pointed the strobe directly at subjects at night to confront a more sinister reality. Later at night I developed the negatives and made prints for the next day.

During the next year I photographed many peo-ple who let me into their lives. I followed a man into the broken foundation of an abandoned building, where he showed me rats. I made copy photographs for George of his grandfather's First World War infantry battalion picture, and helped Toni with his wedding photography. From the National Endowment for the Arts, I received a grant to continue my work on East 100th Street and worked until the end of the summer of 1968.

After nearly two years on East 100th Street, I felt my work there had come to an end. Two thousand pictures of people existed in scrapbooks, on walls, or hidden in drawers. I decided to take the collection of photographs to publishers. They said that they needed a written text, but I didn't want to break the trust that people gave me when they stood before the camera in that suspended moment when they went into themselves and looked out at the world.

By the end of the summer of 1968 I felt an impulse to break through the black and white stillness of my work into color, sound and movement. I bought a 16-millimeter movie camera and began filming on East 100th Street. I filmed a young girl practicing ballet in her living room, a boy combing his hair, and a fat lady laughing.

At the end of the summer, I took a job with Michelangelo Antonioni making still pictures for *Zabriskie Point,* a film he was making in Hollywood and Death Valley. Emily and I stayed with the film for six months.

In July 1969 our first child, Jenny, was born by natural childbirth. The birth scene of Emily pushing, the doctor speaking calmly beneath his mask, the emergence of a head, blood, a pair of shoulders, arms, legs, a cry, and a life was beyond my photography. I stood there with my mouth open underneath my mask.

Two weeks later we went to an island cottage by the sea. At night we listened to our child's gentle breathing next to us and the pounding of the sea. We were now a family, and I was a father.

In the spring I received a grant from the American Film Institute to make a documentary. I went back into the New Jersey Meadows to film the Royka family who picked the dumps for metal. They roamed the mountains of garbage and debris searching endlessly in order to survive. They chose this life to be free. Willie Royka was like a natural man who might have survived in the Meadows eons ago. I called the film "Living Off the Land."

It won a Critics Choice Award given by the American Film Institute.

In the fall of 1970, *East 100th Street* was published and given an exhibition at the Museum of Modern Art. People from 100th Street came to see themselves. I hoped that in some way the pictures did serve the community.

The following year, in the spring of 1971, I made a short children's film for CBS called *Zoo Doctor,* about a veterinarian I knew at the Bronx Zoo. I began to replace magazine assignments with industrial photography and advertising to support us while I learned about making films.

In the spring of 1972, I received another grant from the American Film Institute to make a television documentary on an American writer. I chose to make the film on Isaac Bashevis Singer, the Yiddish writer, whom I had met in 1965 when I photographed him for a magazine. Now we were living in the same building. I often saw him in the elevator and at times we spoke briefly to each other. I began reading his novels and short stories, and they gave me a sense of my own lost heritage. I wanted to work in fiction, but I had been given the grant money to make a documentary. To disguise the fact that I was filming fiction, I integrated one of Singer's short stories into a film about him. Singer was the subject of the documentary and an actor in his short story. I chose an unpublished story called "The Beard" which went well with both film forms, and I began to work on the script. Singer took me with him to his university lectures, to a cafeteria on the Lower East Side where he often sat and wrote, and to his apartment, where we talked for hours about his life. His energy, humor and creative tenacity inspired me. We filmed for nine days, edited for several weeks and finished the film, *Isaac Singer's Nightmare and Mrs. Pupko's Beard,* for television. It was distributed to schools and universities around the country, and it won first prize in fiction at the American Film Festival the following year.

But I found that making documentary films could not support my family, and I went back into the factories and office buildings, making industrial photographs for corporate annual reports, public relations brochures and advertising. I photographed stockbrokers on Wall Street, television electronics manufacturing, and the moon rocket engine production. I traveled across America and around the world.

I had not completely given up still photography, and I was not yet making the films I wanted to make—dramatic, fictional films. I needed to return to what I knew. I went back among the old people who sat in the cafeteria that Singer had shown me. There, like remnants of a past age, they sat alone at tables along the wall or in small groups at the larger tables. Some were survivors from the concentration camps; others had lived on the Lower East Side their entire lives or had come as young immigrants before the war.

I went each day to the cafeteria and sat at the tables with my small camera on a tripod, or hand held it with a strobe. The direct flash caused the background to go black, isolating the people from the environment and conveying that sense of silent waiting that permeated the endless rattle of dishes, the fragile movements of the aged and the slow, careful swallowing of food. I found myself going back again and again, sitting with these people who, like myself, were Jews.

Jenny was now three and going to nursery school. Emily studied acting, singing and dance, did some modeling and pulled the family together. On days that were still like winter we went to Coney Island to ride the carousel with Jenny and strolled along the boardwalk sharing cones of cotton candy. Later we went back home, put our child asleep in her room, and all had a nap.

During 1974 I kept going back to the cafeteria, and I began to read more of Singer's writing. I read his novel *Enemies, A Love Story,* about the survivors of the war and the concentration camps living in New York in 1950. Many of the people I knew in the cafeteria were like the characters in the story—survivors and displaced persons, violently torn away from their past, trying to re-root themselves, to find passion and promise again in this strange land. It was a story that was about today—our reaching for roots and trying to live with passion and duality in a world where one spark can end it all. I wanted to make it a film.

The Whitney Museum of American Art showed *Isaac Singer's Nightmare and Mrs Pupko's Beard* at its New American Filmmakers Series in March

of 1974. A woman who saw my films and knew my still photography offered to help with the new film project. I brought her to the cafeteria where we sat together and watched the old people come in, take a check, and sit silently alone with secret lives that had lain hidden for 25 years.

We worked with a film producer to obtain the rights to the novel and I began work on the script. In the fall, I worked for a while with the producer putting it into a final form. We looked for actors and he began financing. After two years, no money had been raised and I decided to take hold of the project myself.

In the fall we had our second child, Anna. I wondered if I was going in a self-destructive direction producing a feature film, but Emily encouraged me to go on and see it through to the end. I felt the need to find a path back to my photography. I looked through the hundreds of contact books that lined the walls of my studio. They contained thousands of proof sheets with every image I made over the past twenty years. Turning these pages revealed subjects, friends, family, and myself. As I looked back at my work, time stopped and started again. I went into my darkroom for several months to enlarge the negatives of my pictures. I wanted to return to my subjects. I spoke to my dwarf friend from the circus, now married to a kind woman who sent my wife a necklace she had made. I went back to East 100th Street. A young man who had helped me had joined the Marines and was wounded in Vietnam. He returned to the community to become a minister. He told me that my photographs had helped him see his life.

In Brooklyn I found the girl who had combed her hair in the Coney Island mirror. She had married the gang leader. Their daughter is fifteen, the same age she was then. She said, "We all had a dream, but we lost it. Most of the kids we knew are on drugs, in crime, or dead. You meant a lot to us because you were someone from the outside who had a camera and was taking pictures of us." I told her that her picture is hanging in museums around the world. When her teenage daughter came into the room, she turned to her daughter and said, "Look, this is a picture of momma when she was your age." Then she turned to me and smiled. "Maybe my dream isn't quite lost."

Bruce Davidson

Widow
of Montmartre

1956

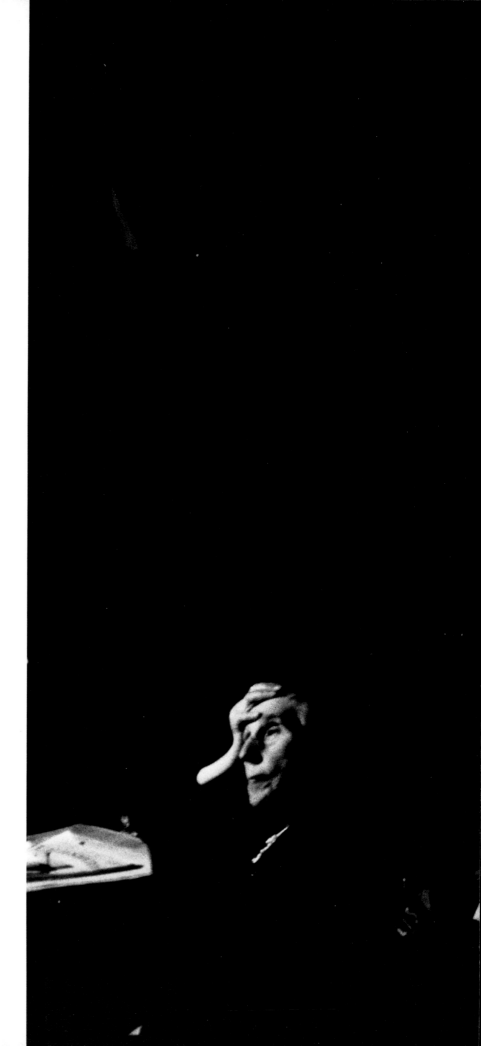

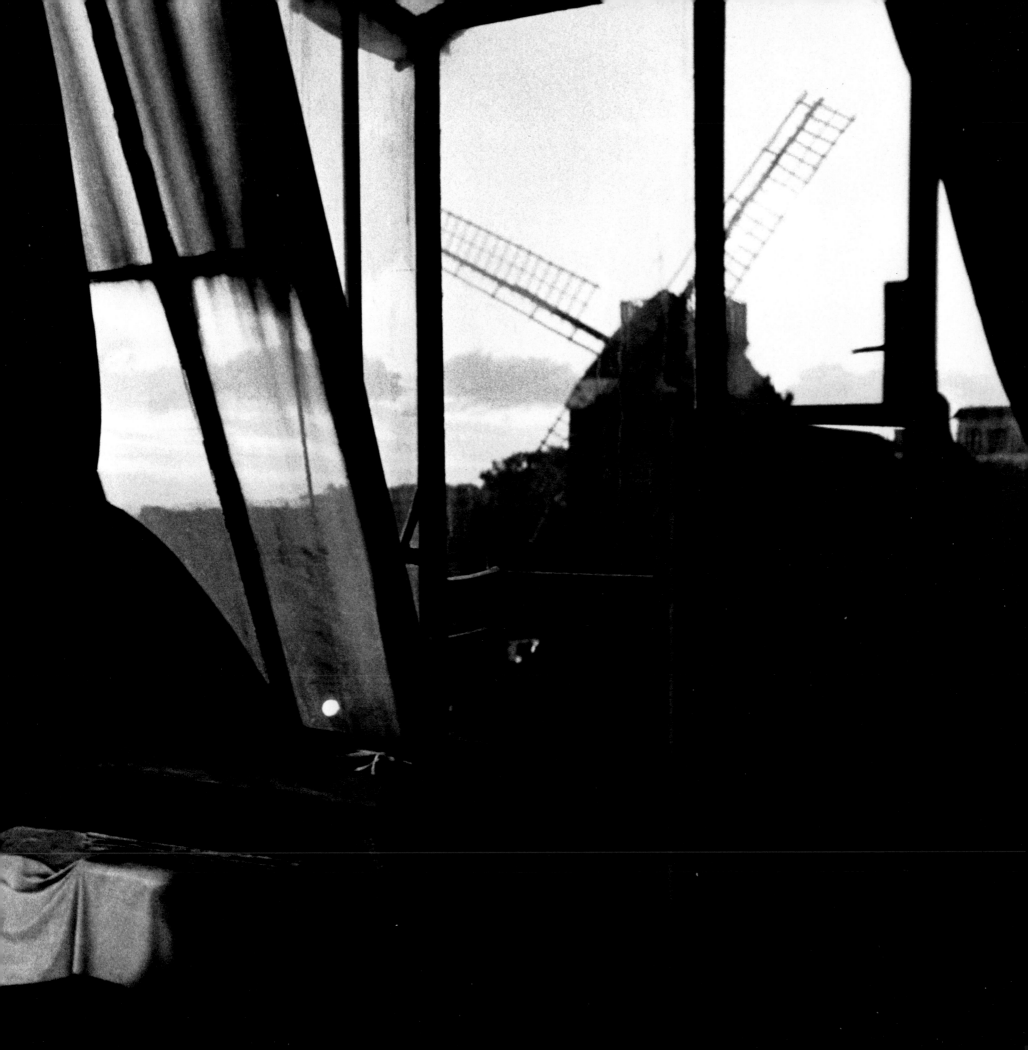

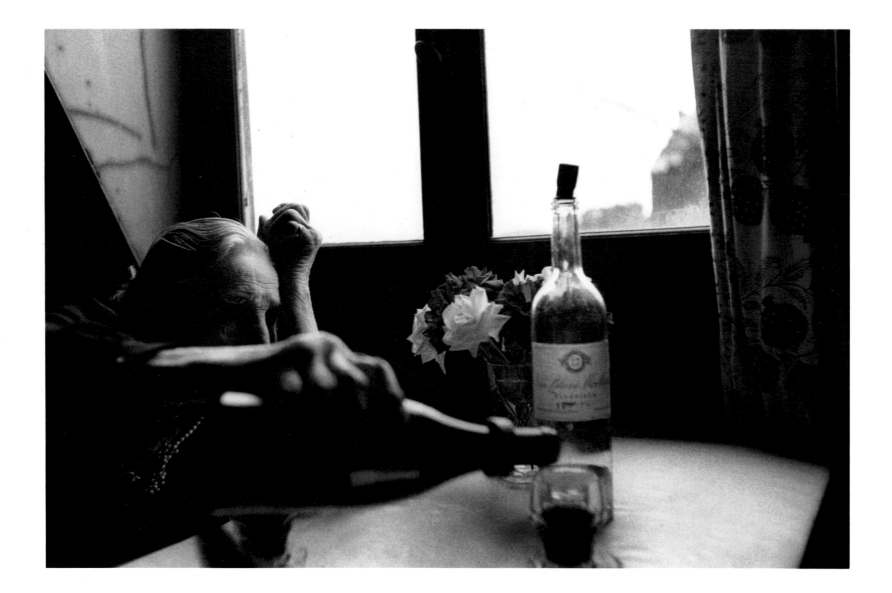

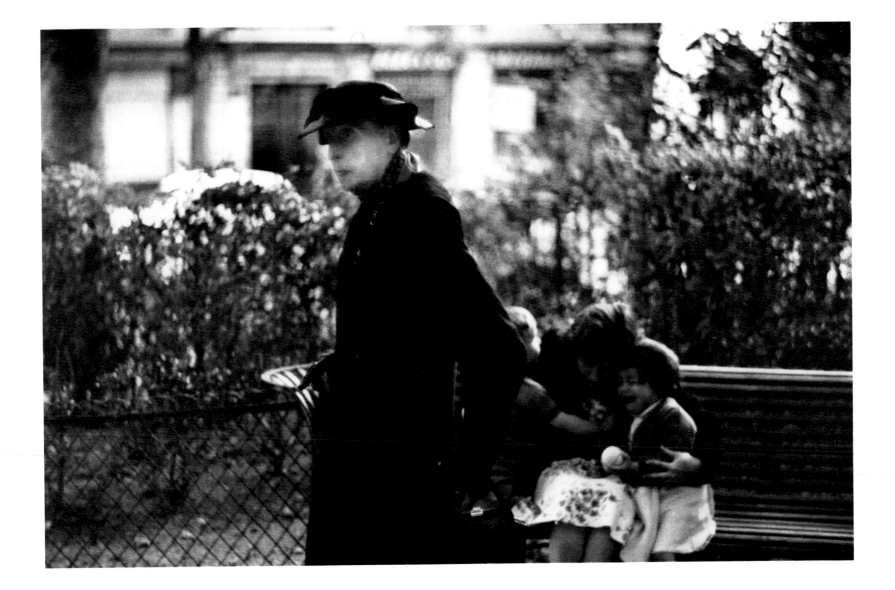

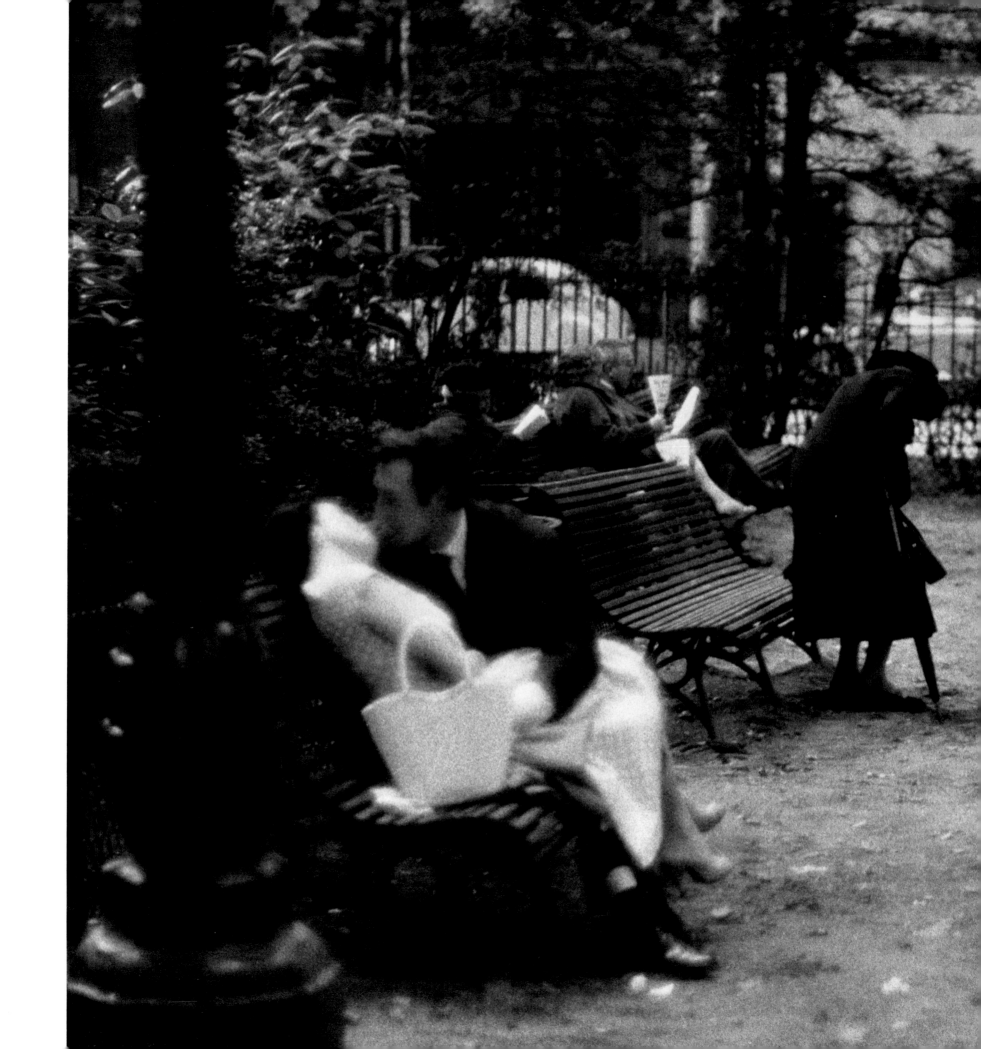

The Dwarf

1958

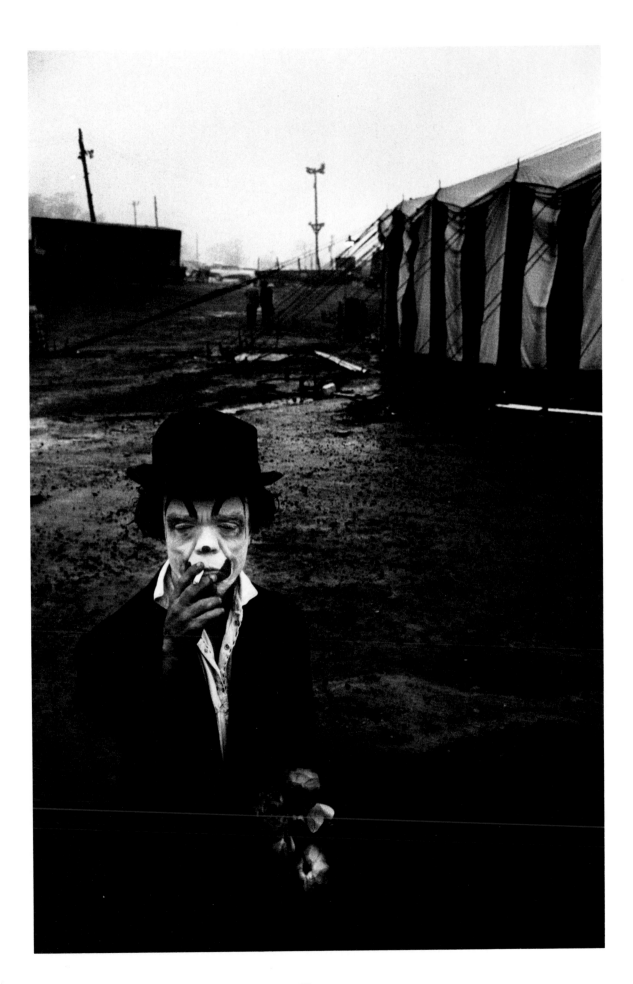

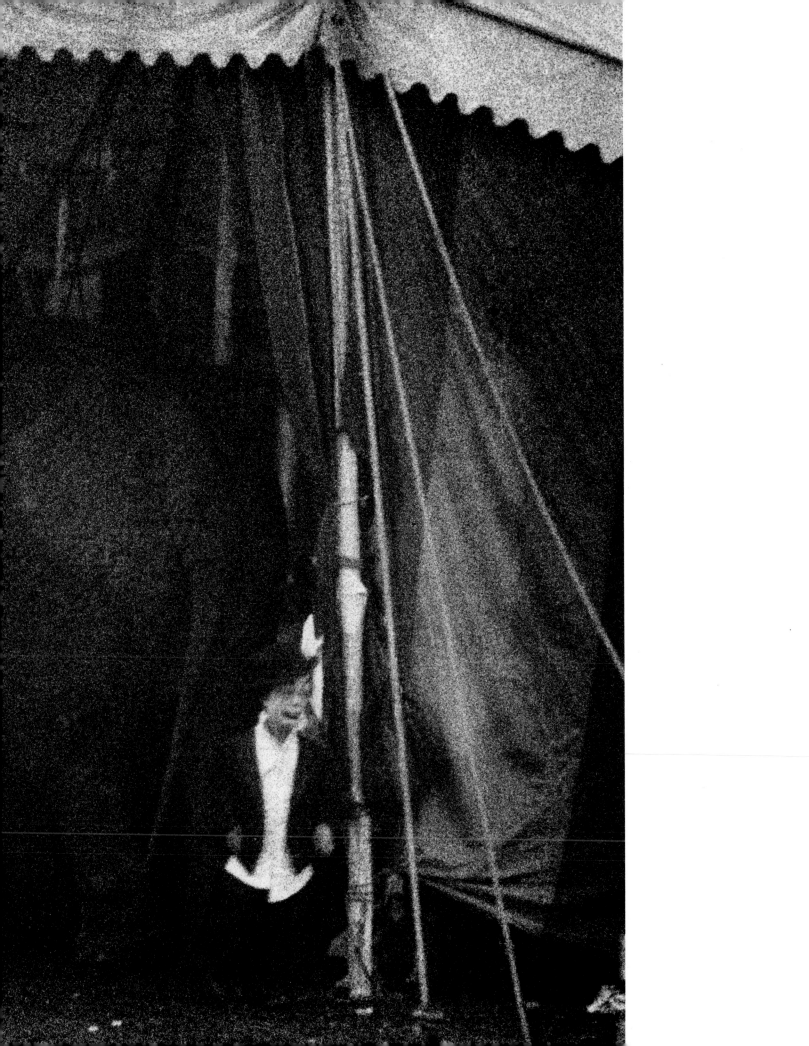

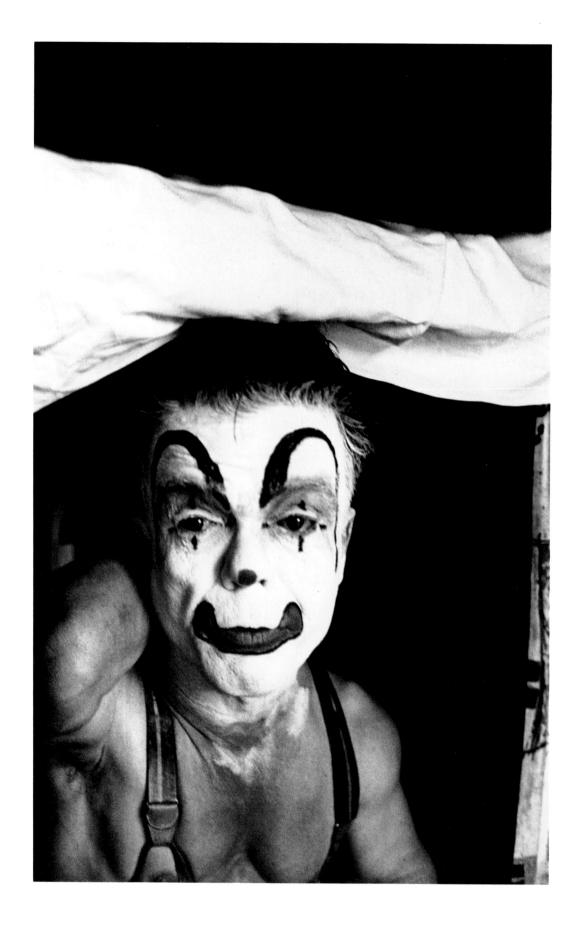

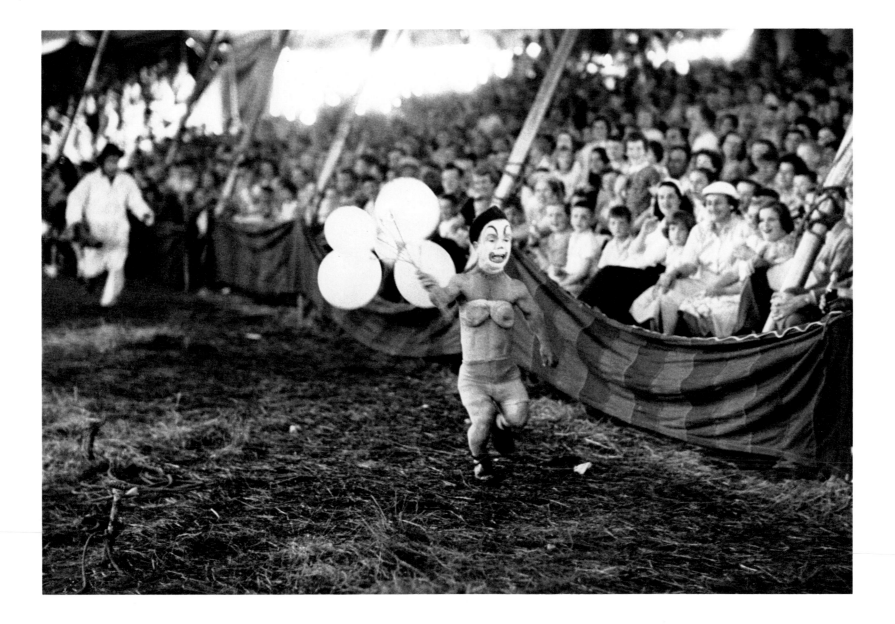

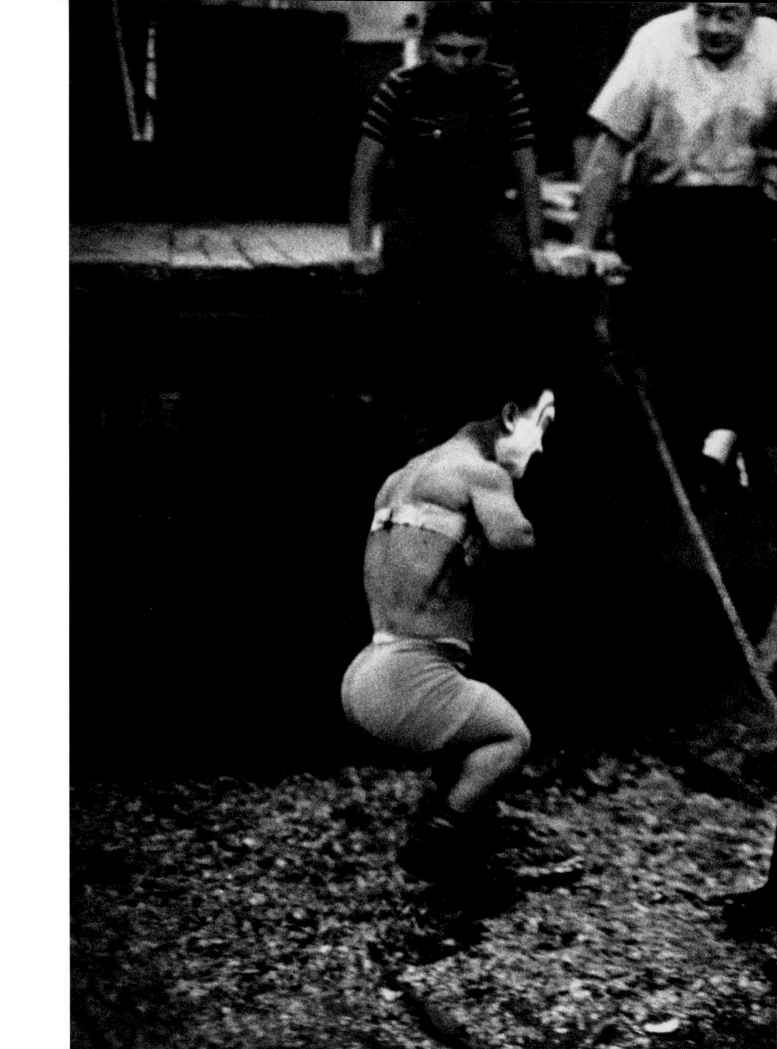

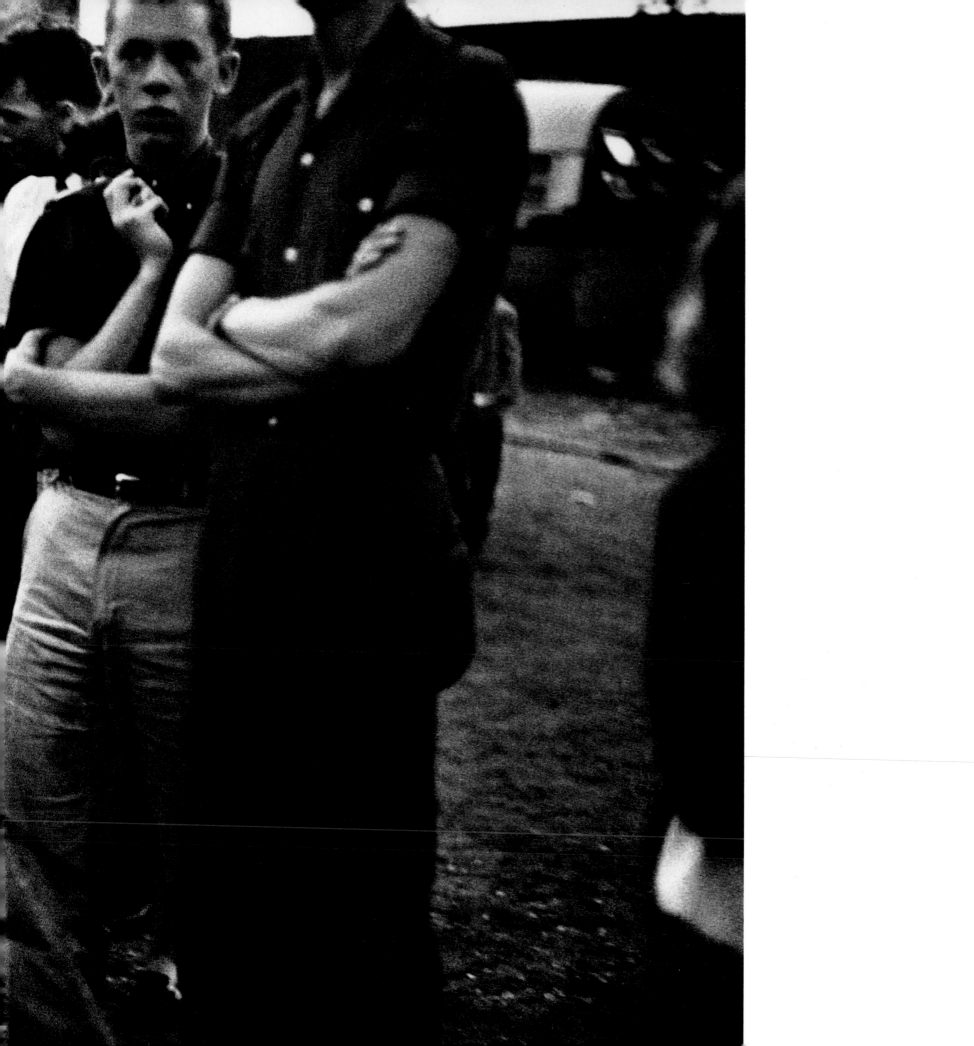

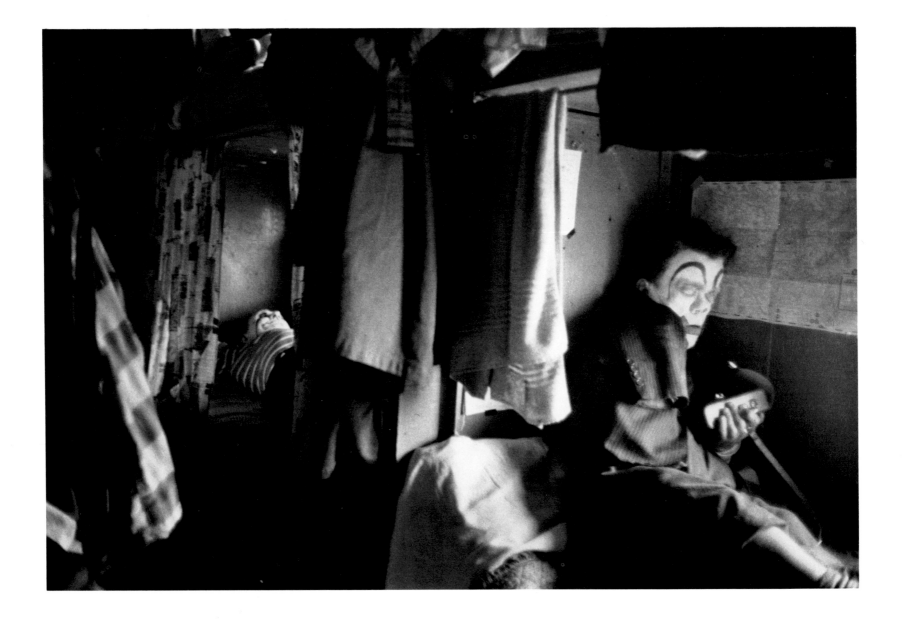

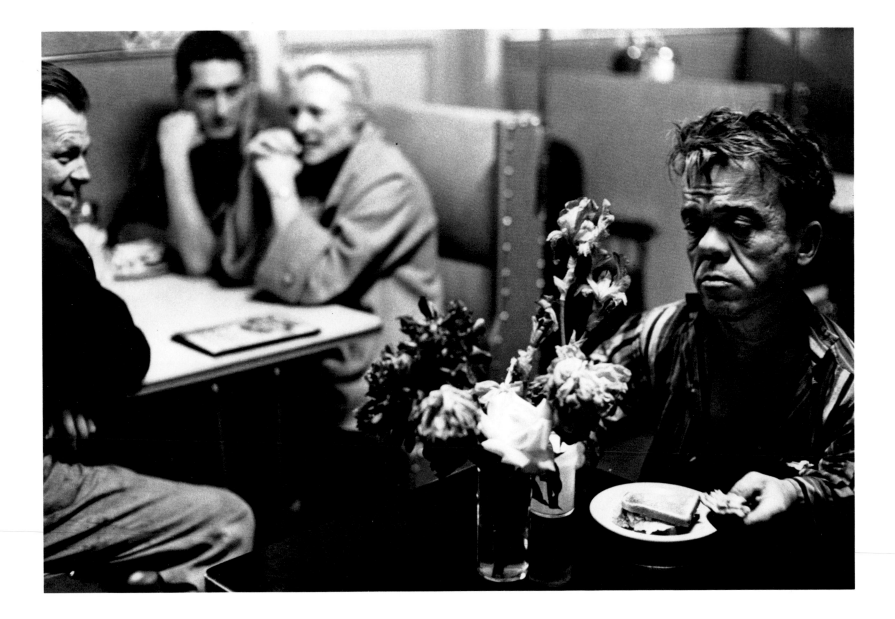

Brooklyn Gang

1959

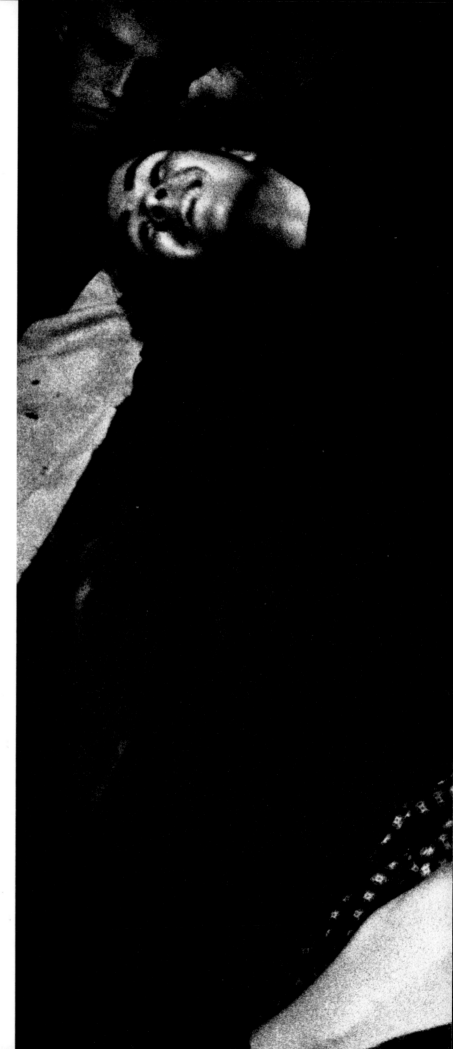

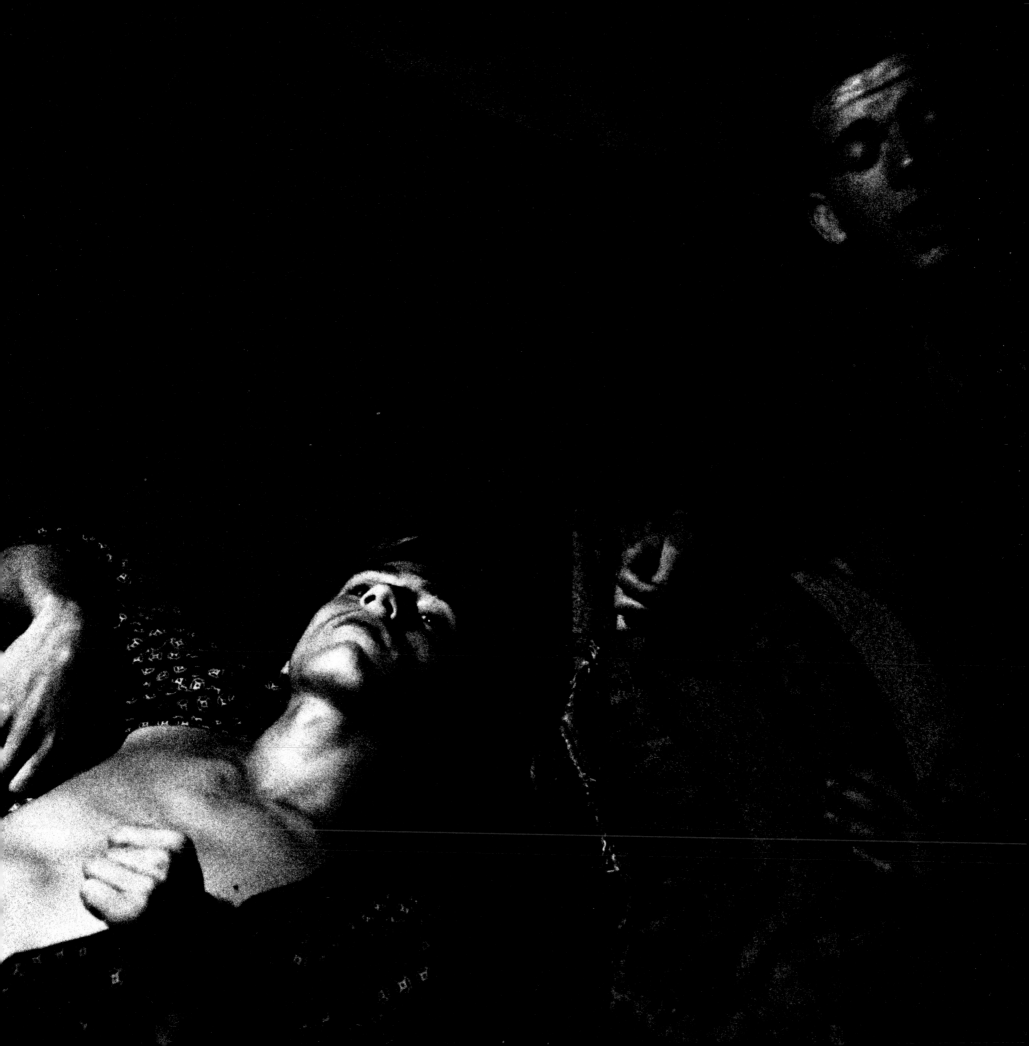

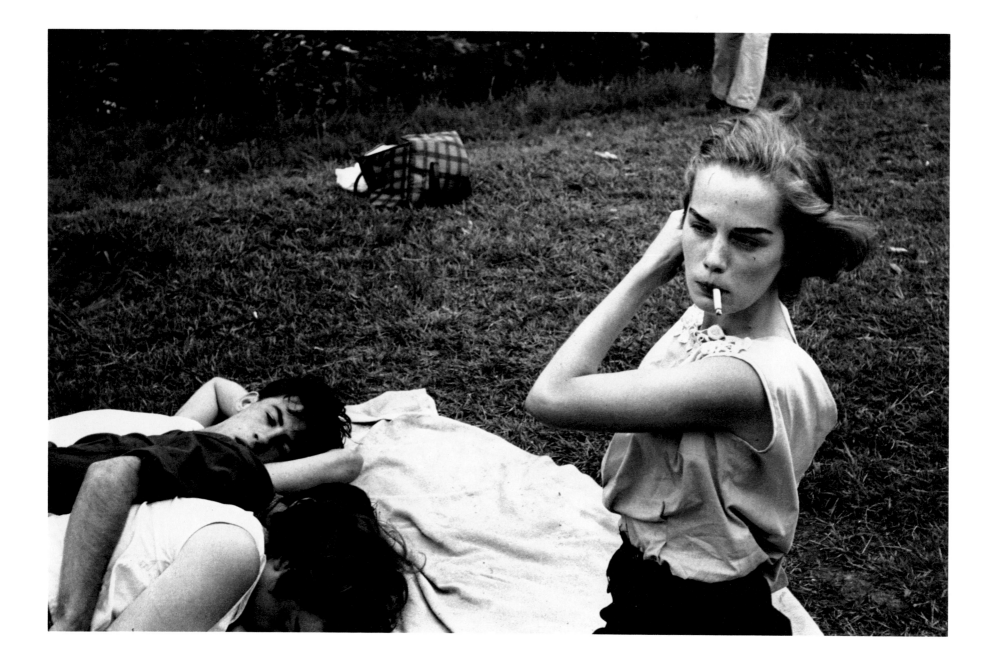

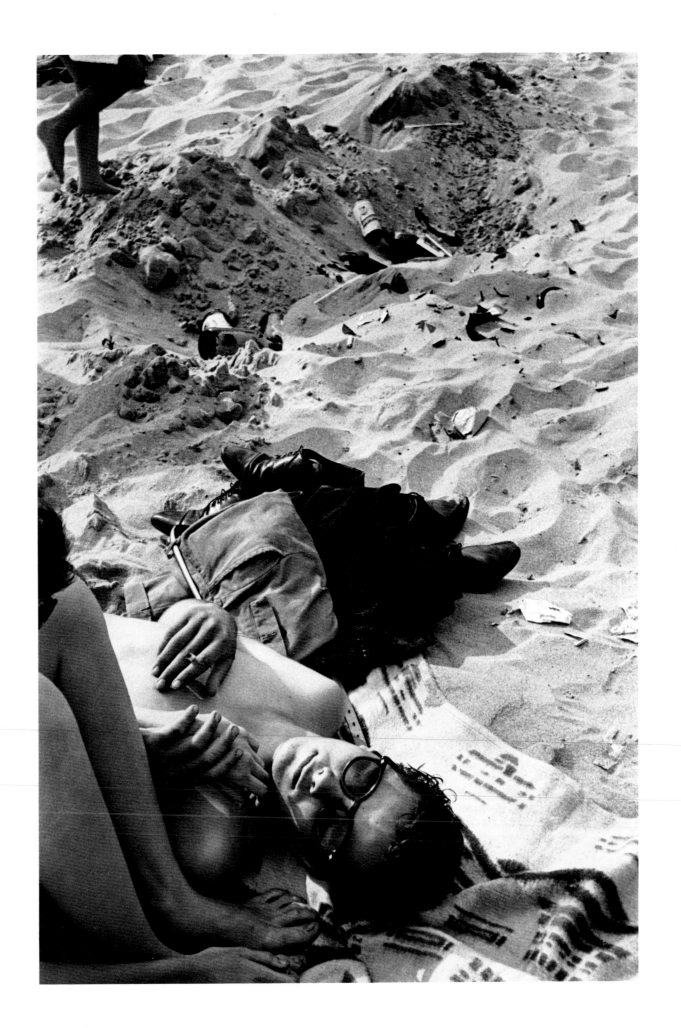

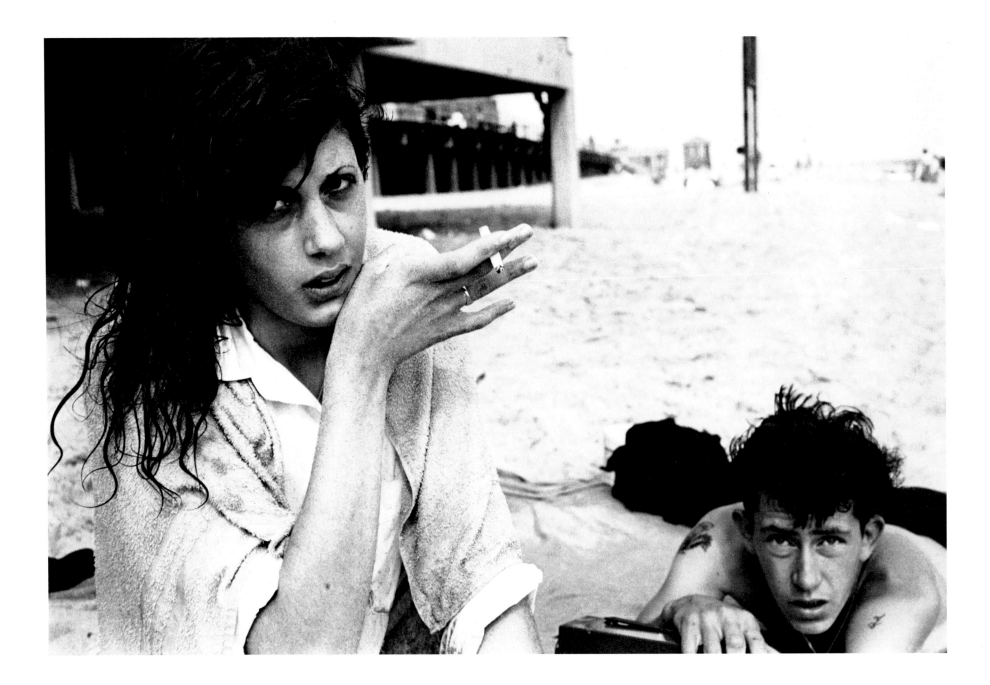

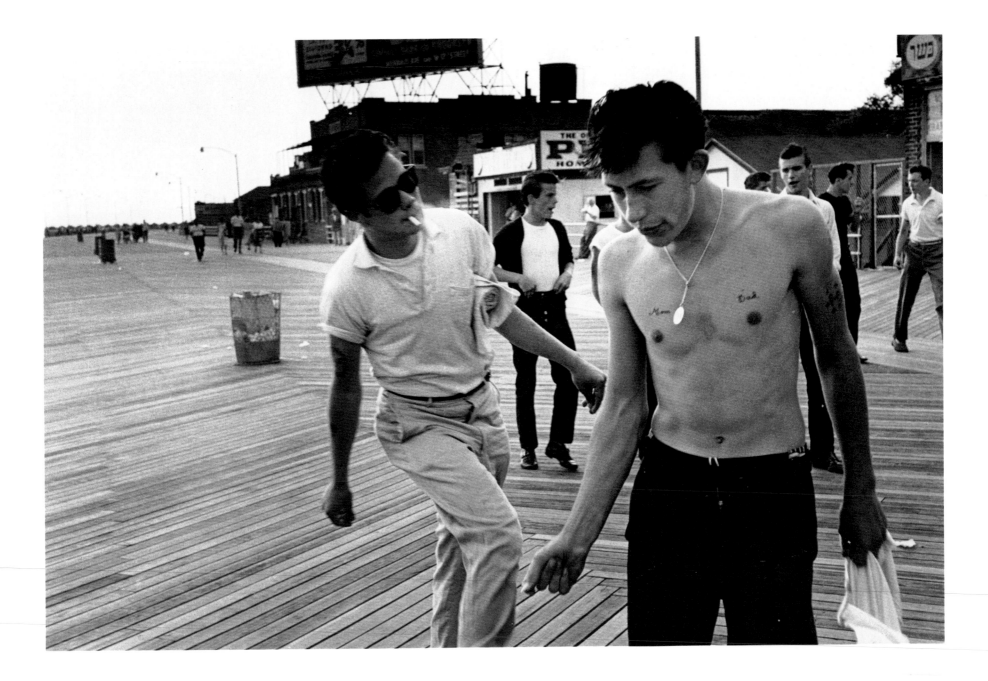

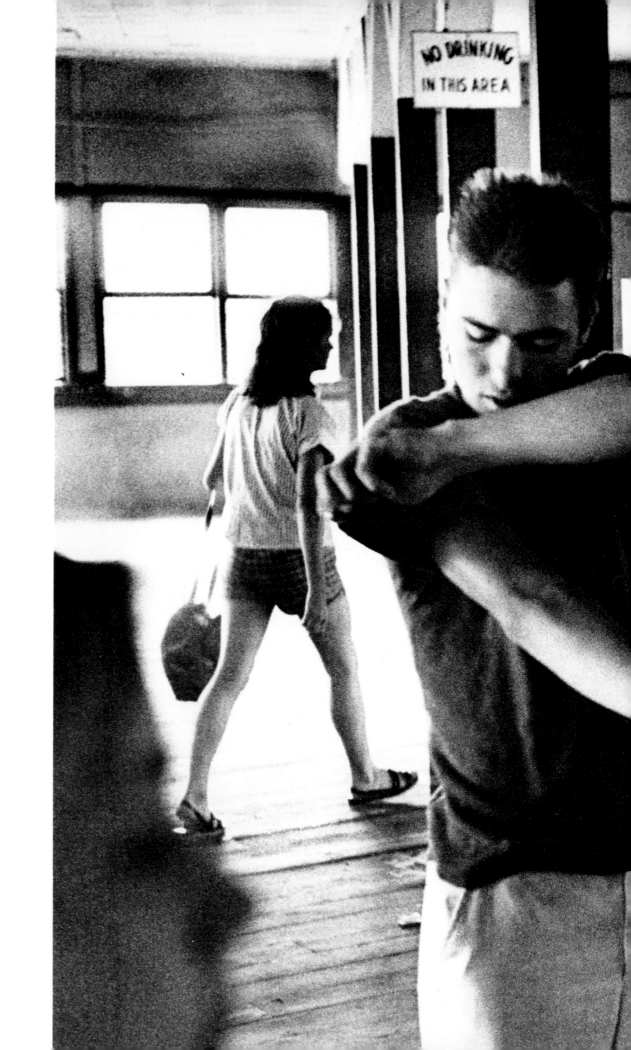

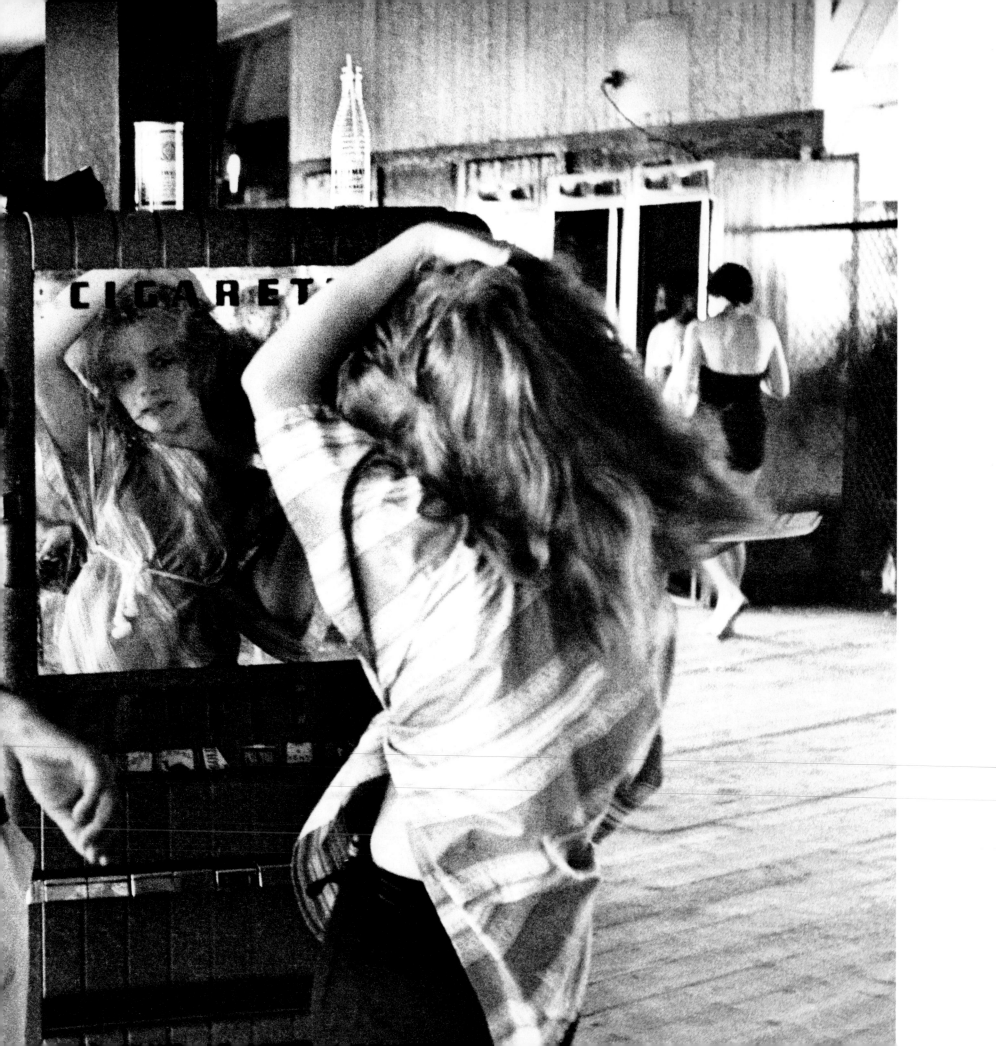

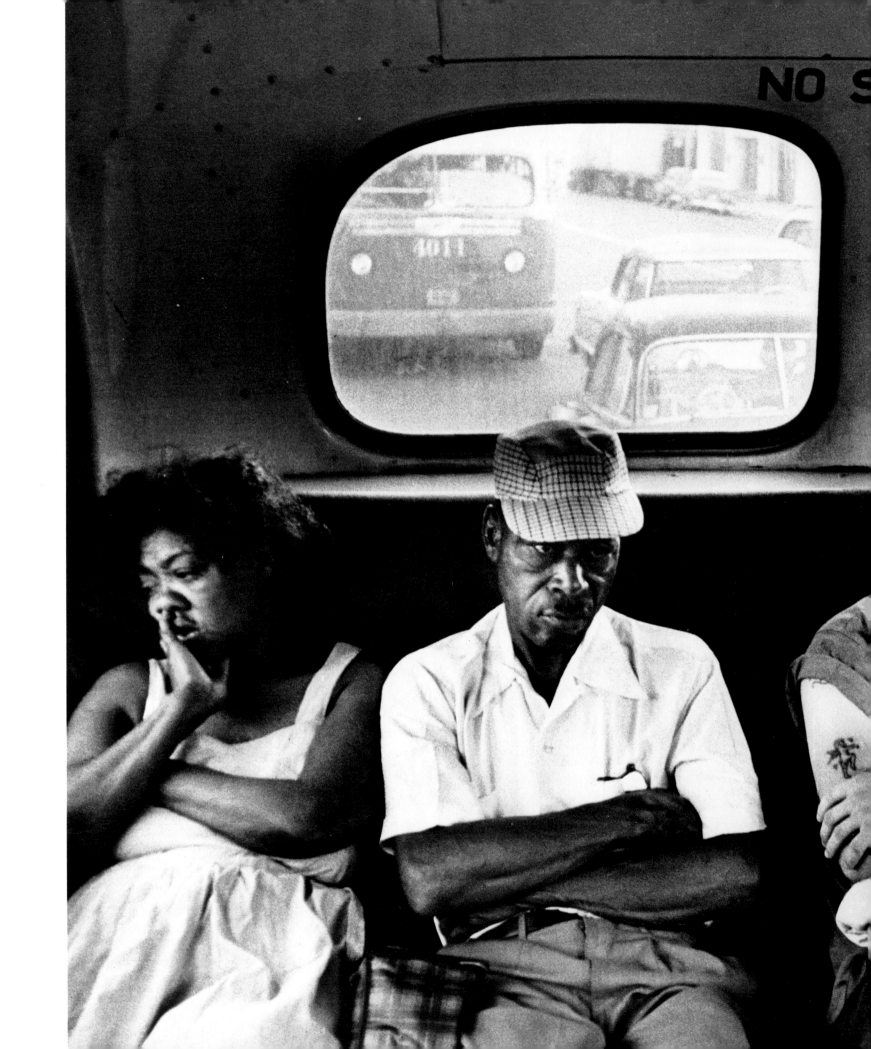

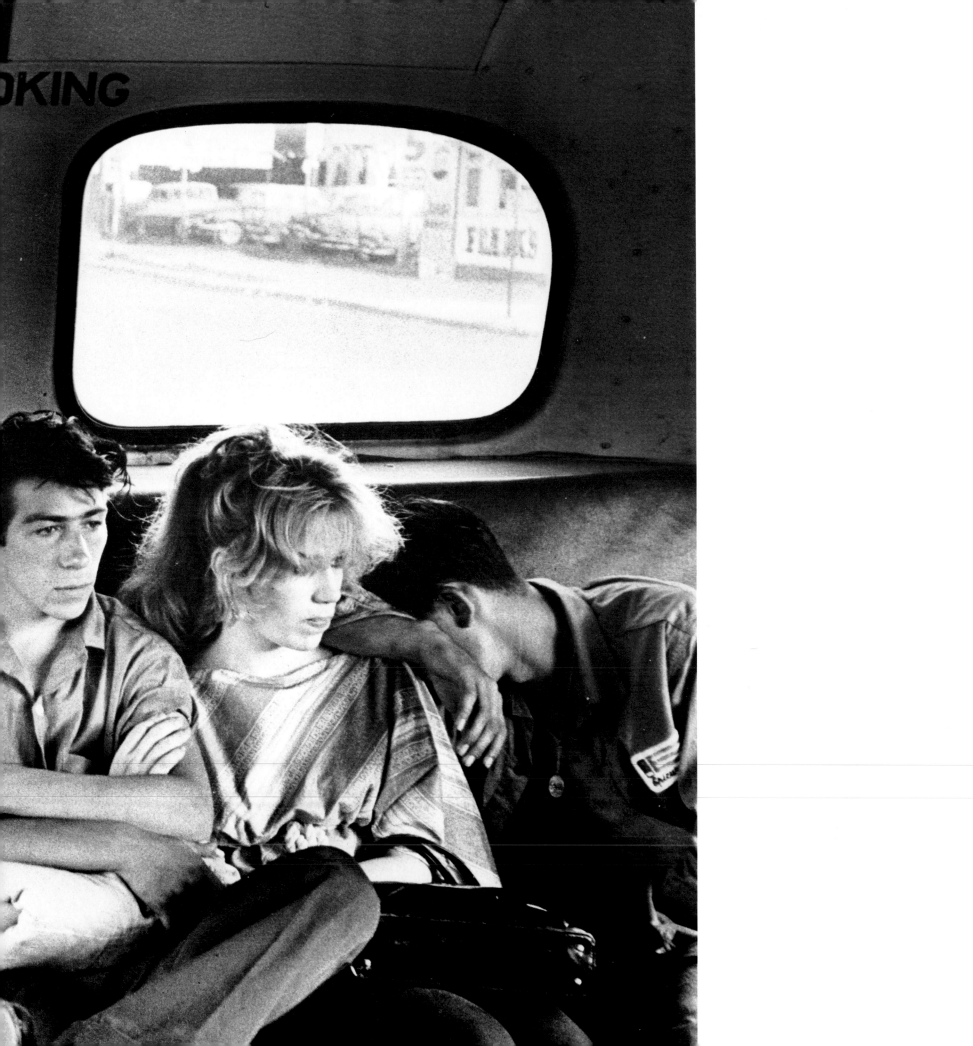

England and Scotland

1960

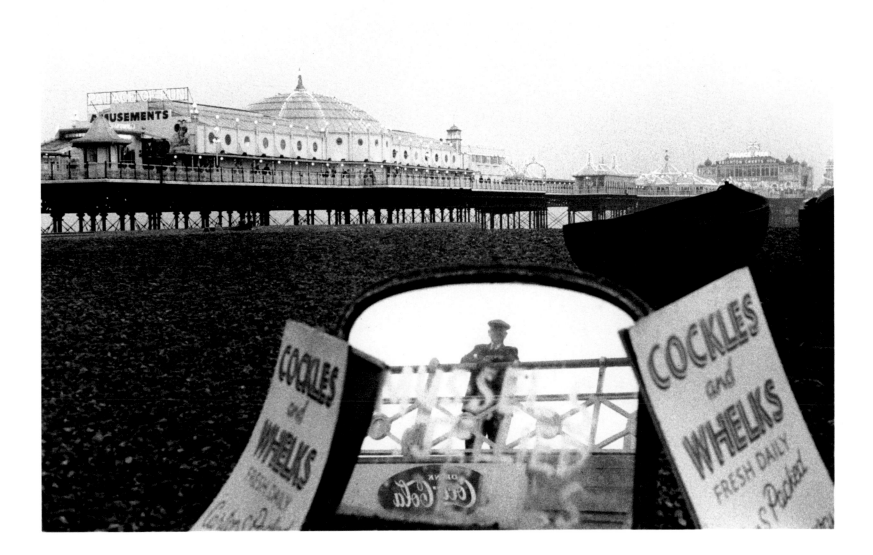

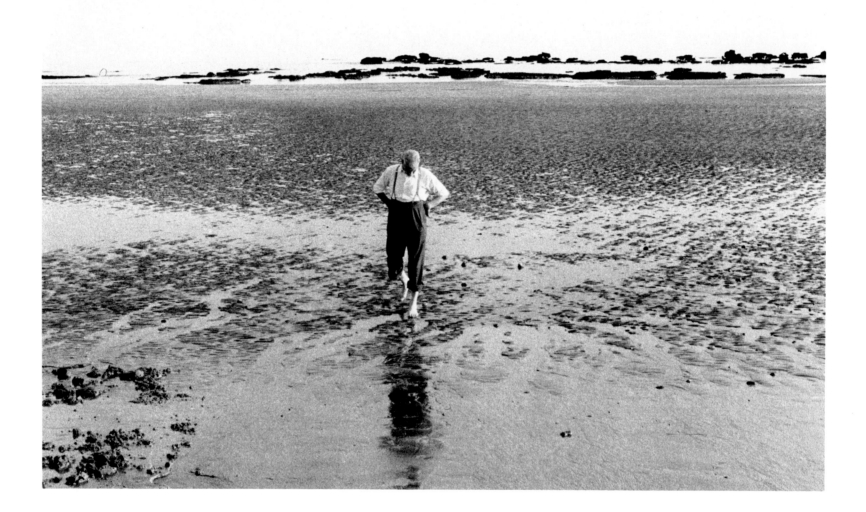

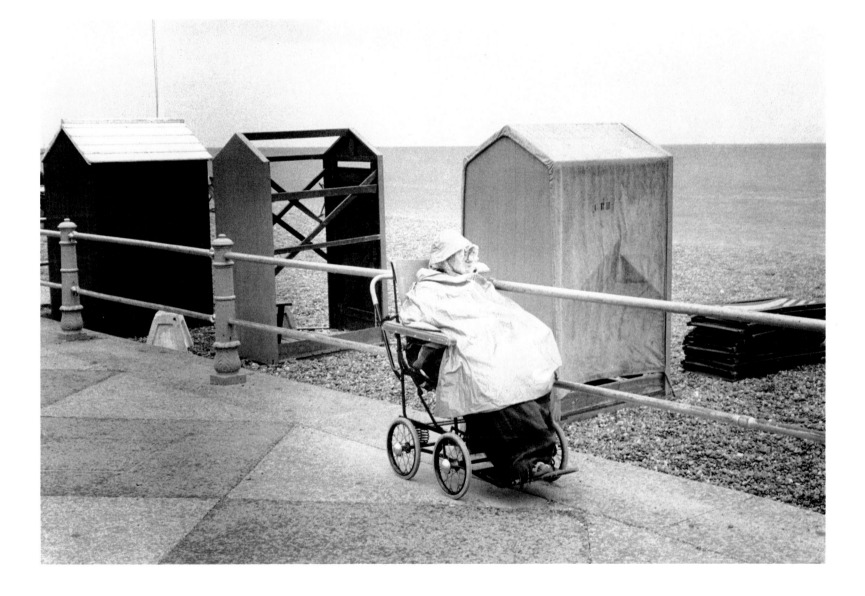

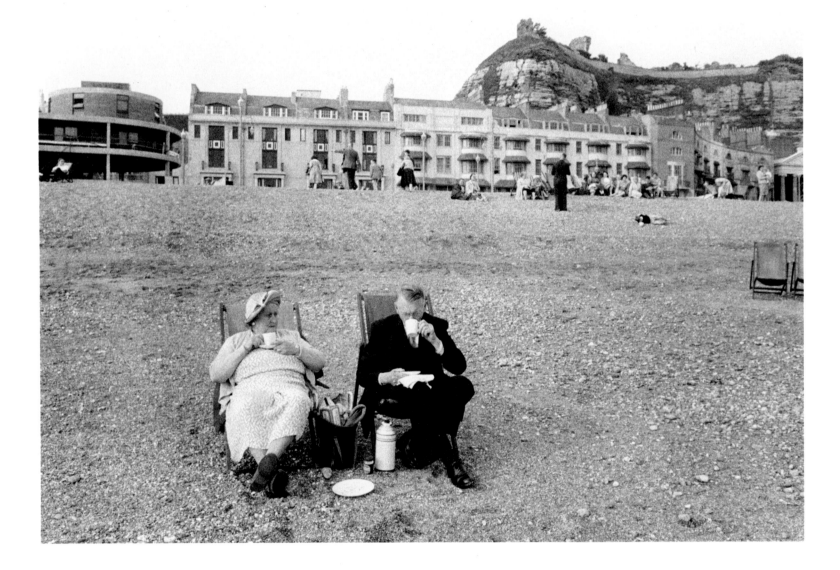

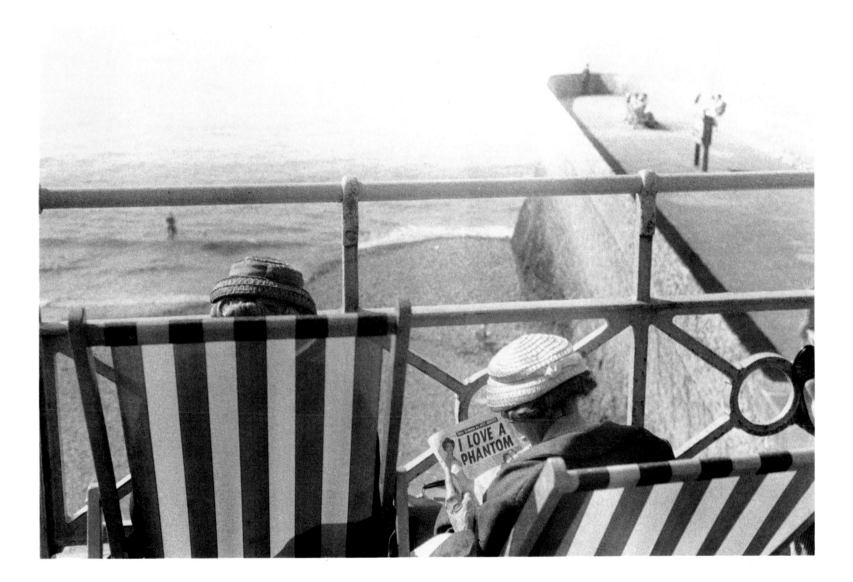

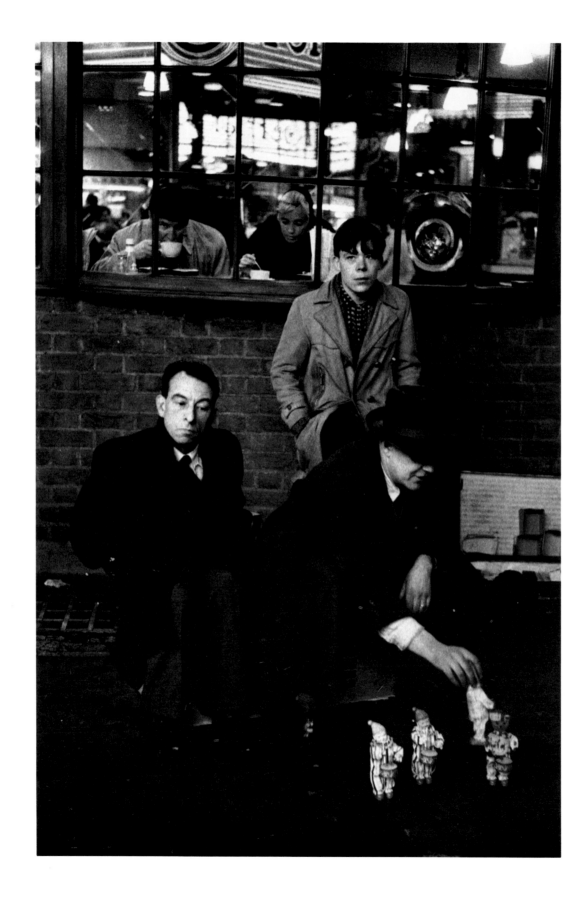

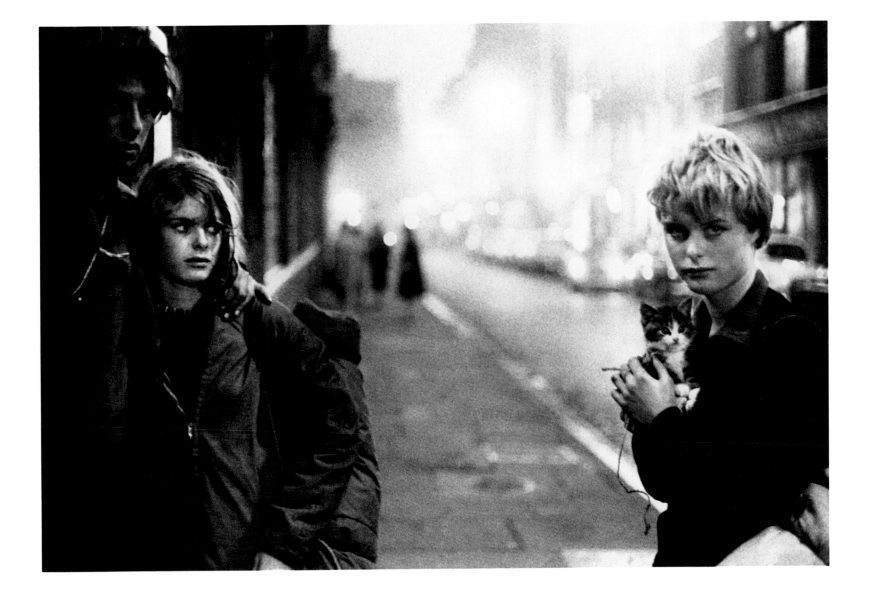

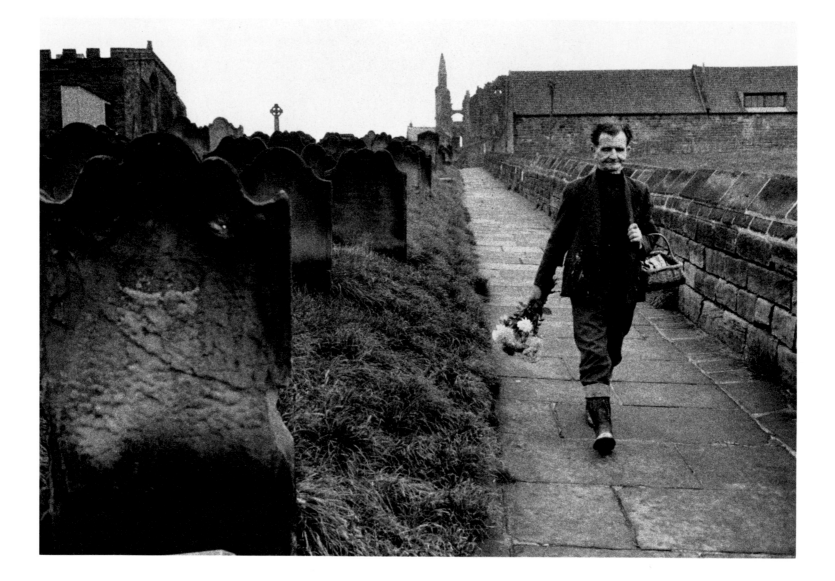

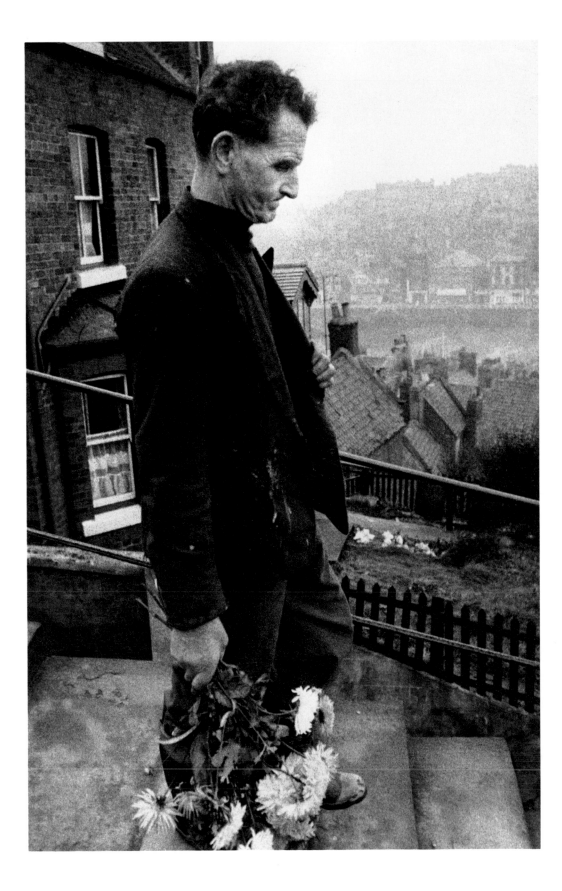

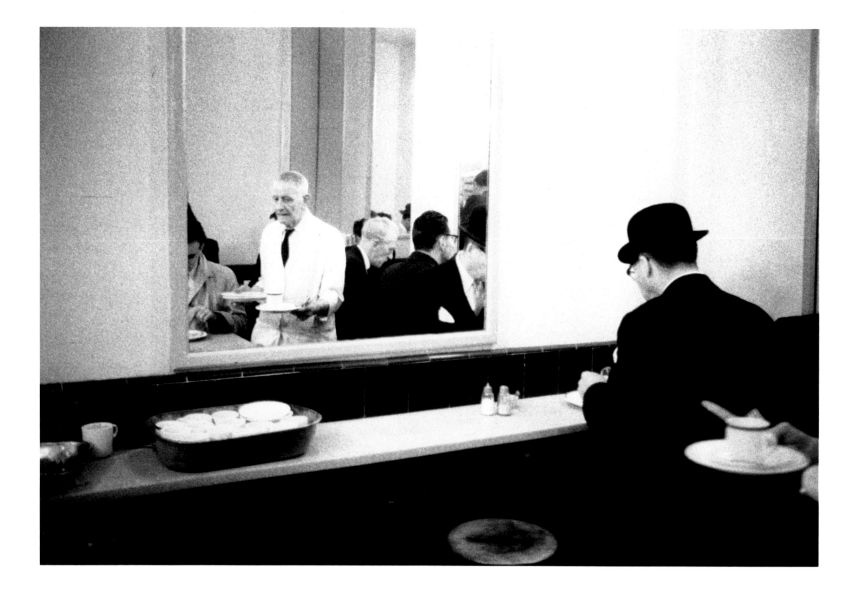

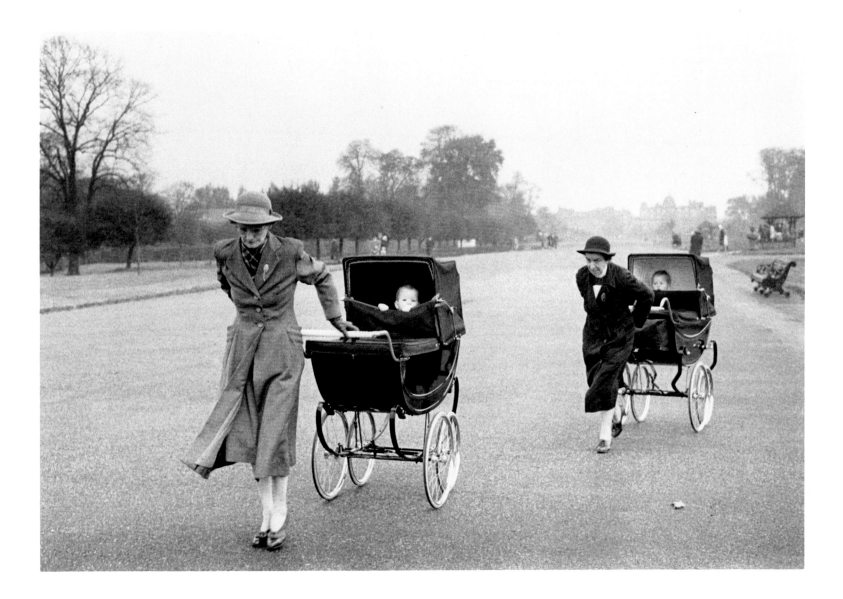

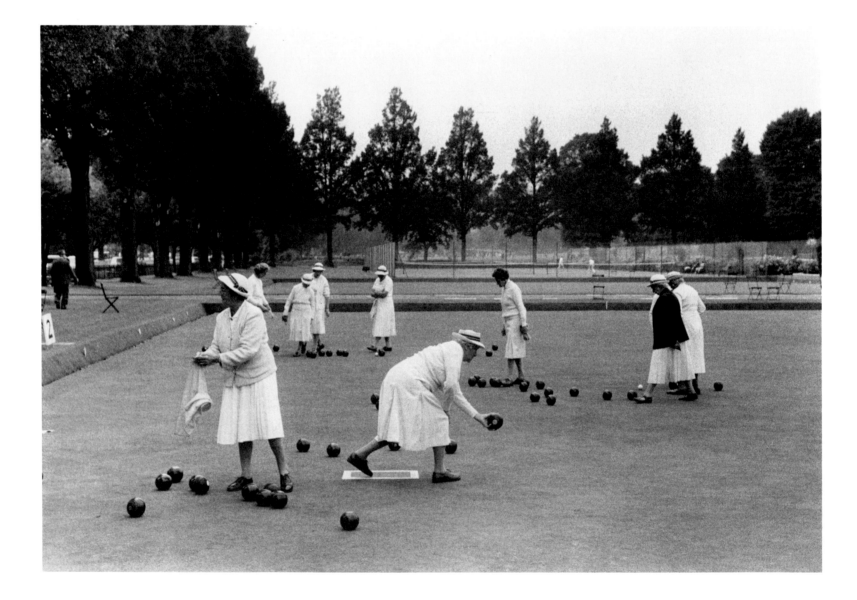

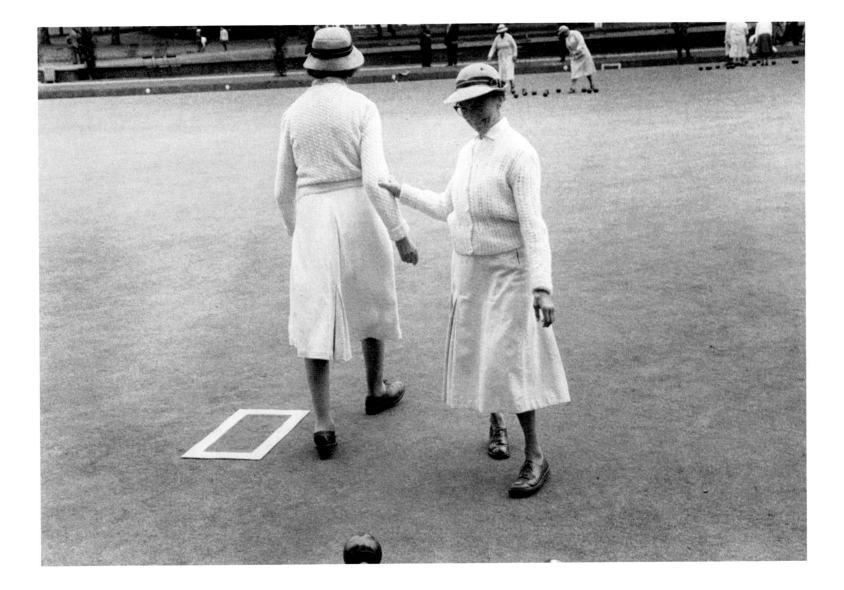

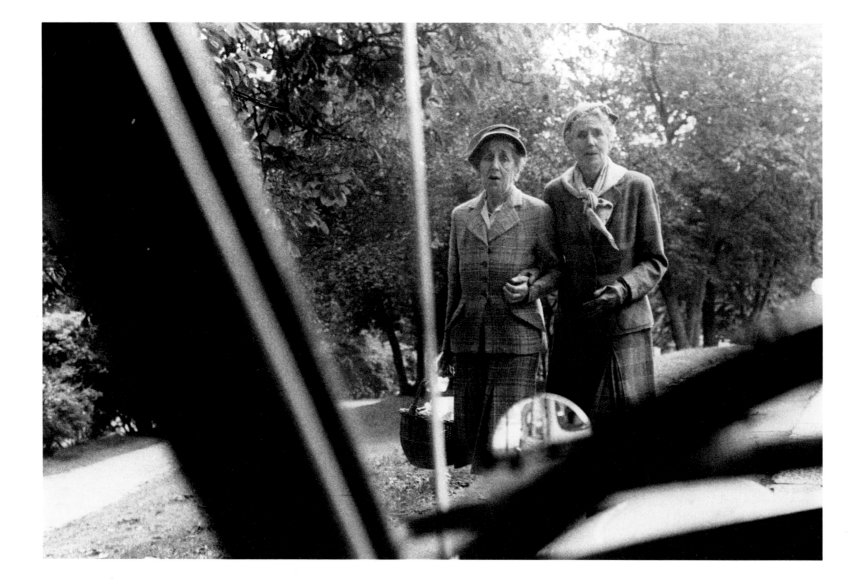

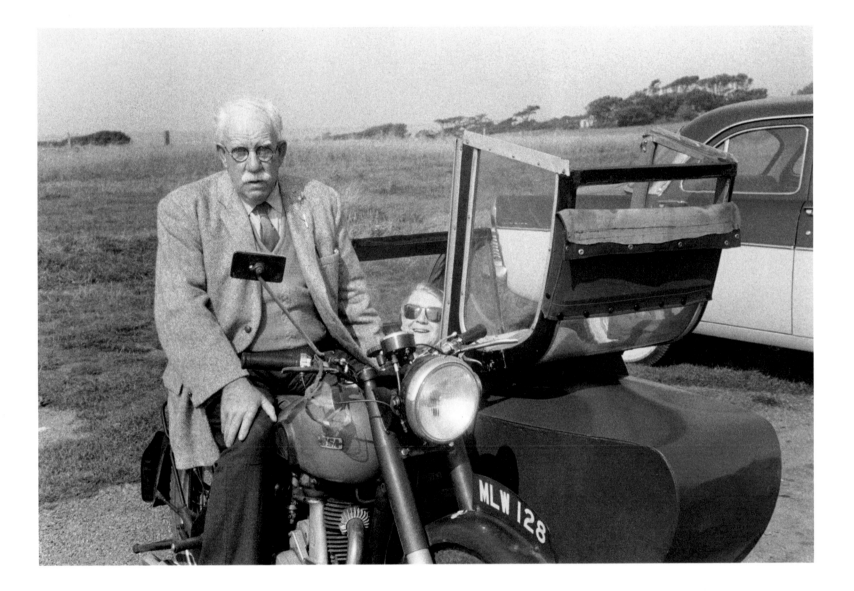

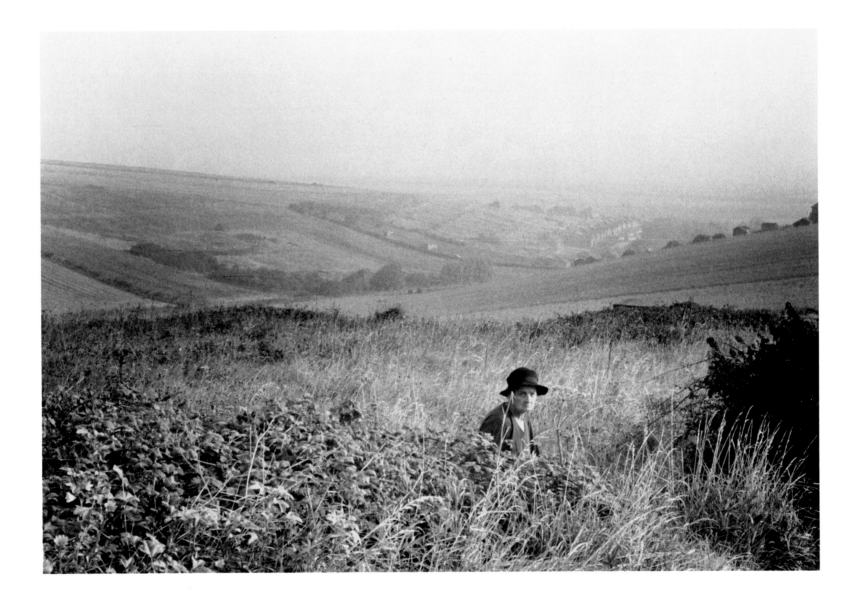

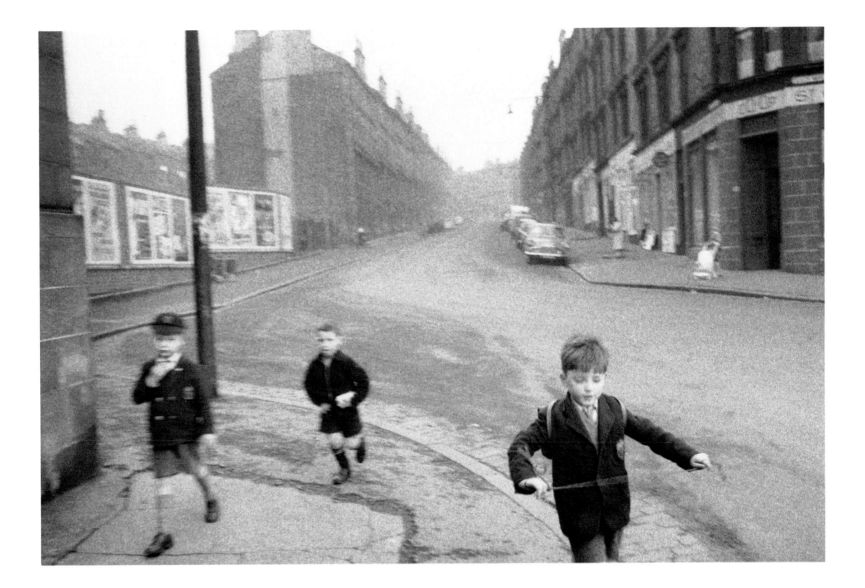

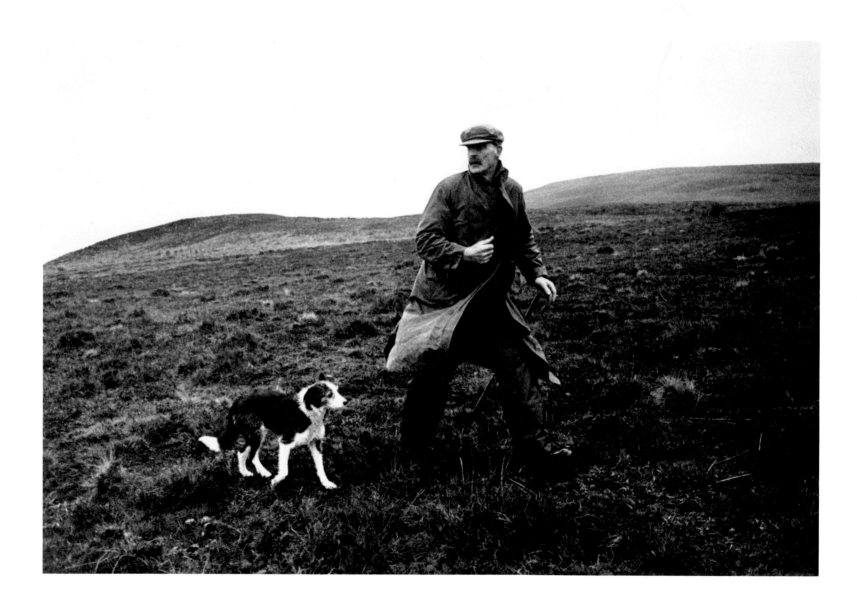

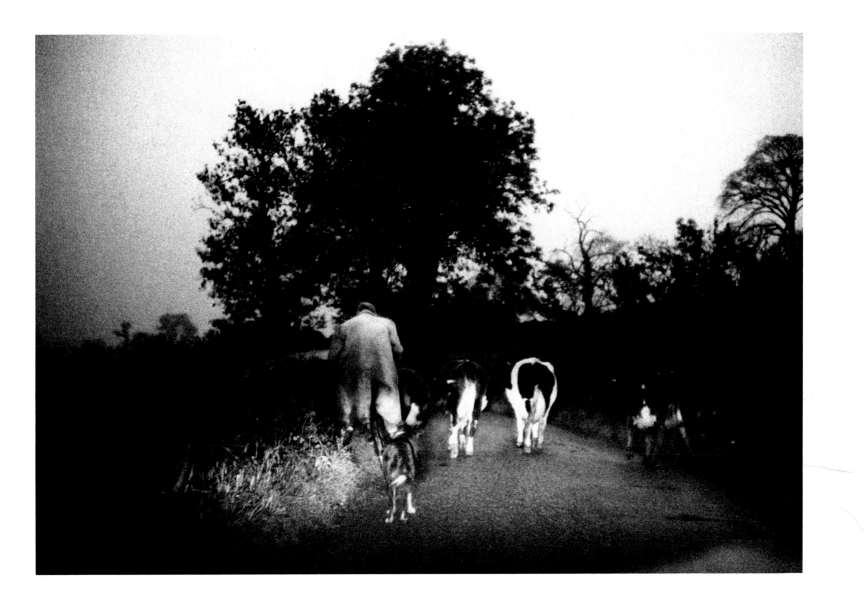

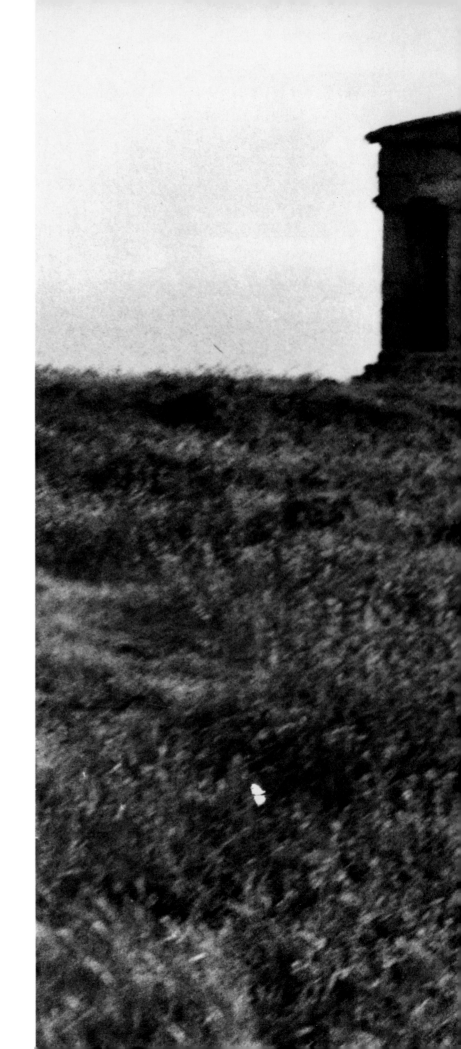

Sicily

1961

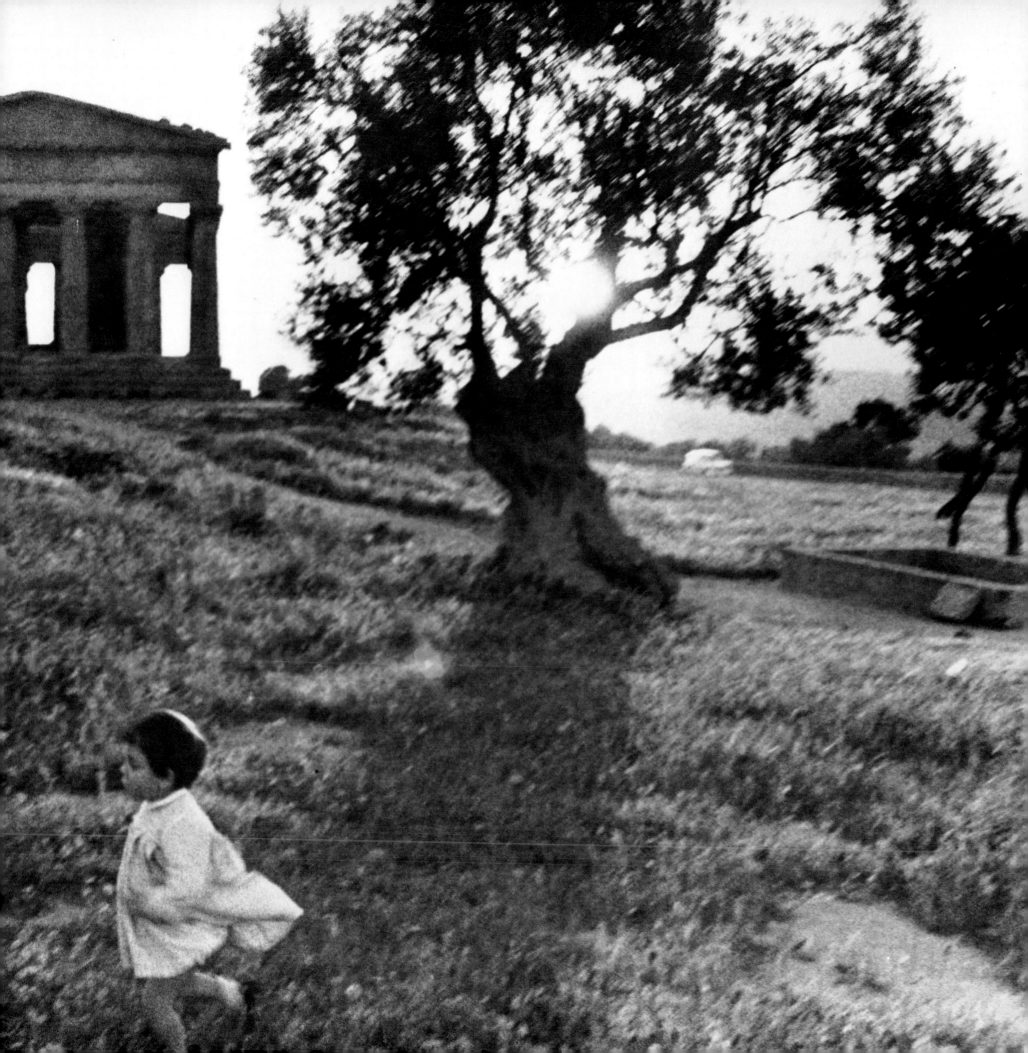

Black Americans

1962 – 1965

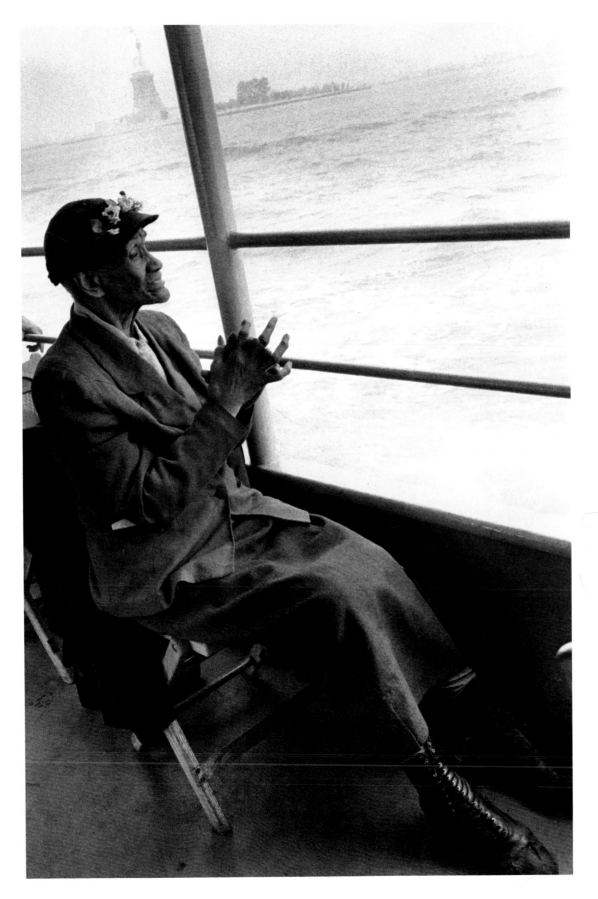

New York City 1962

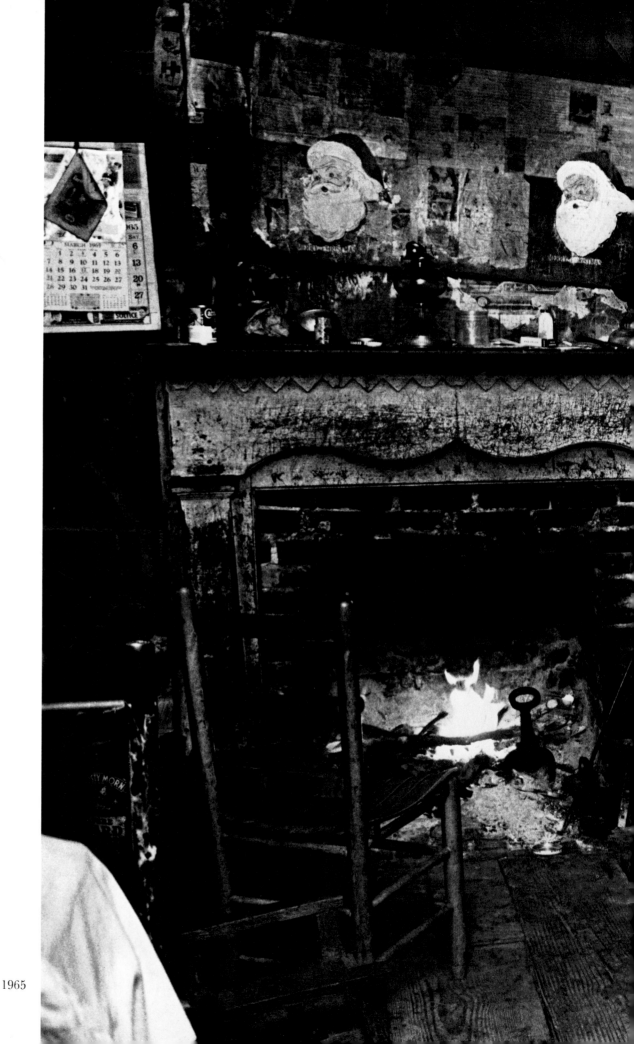

Alabama 1965

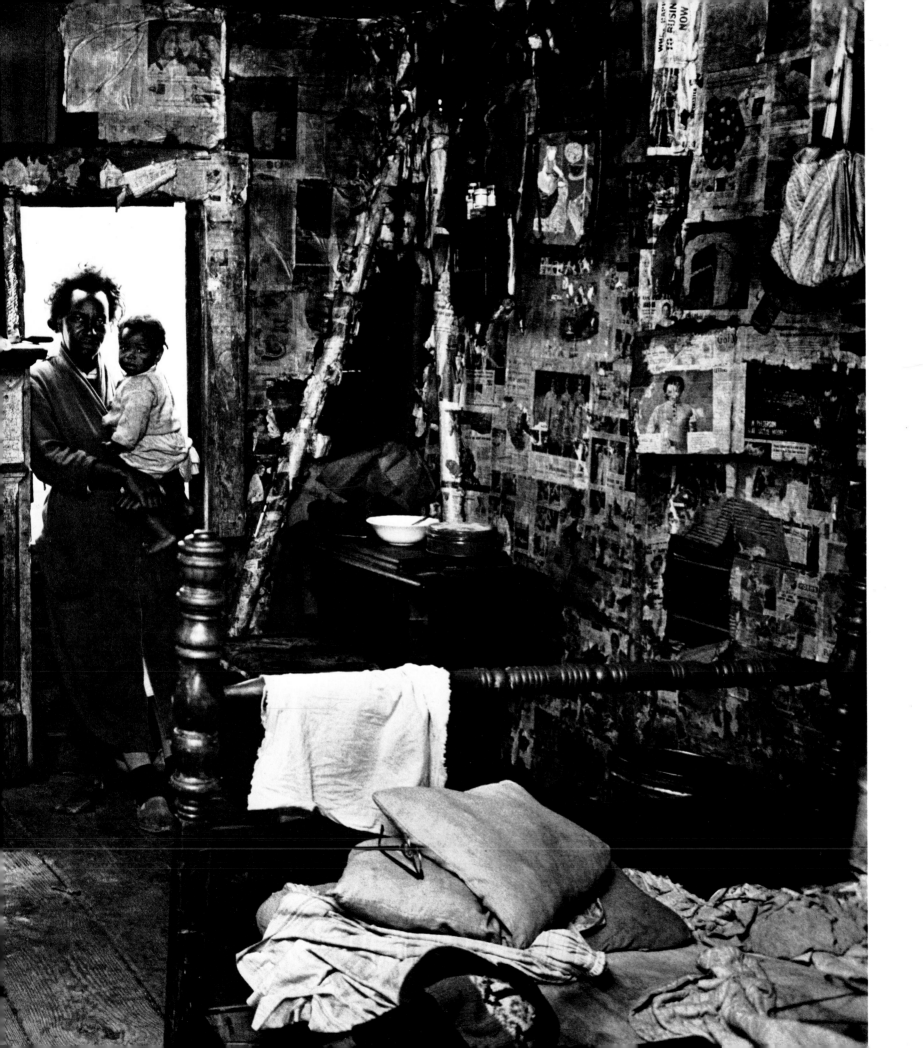

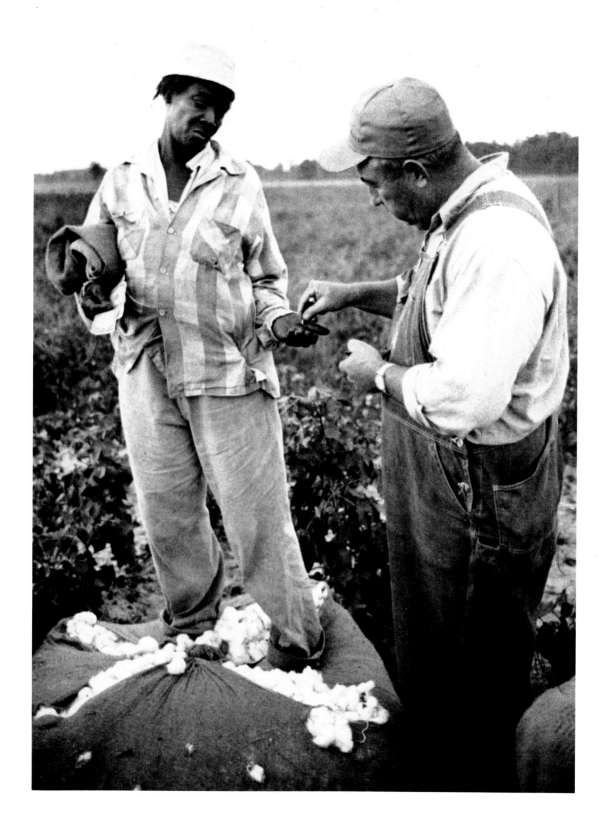

South Carolina 1962

70

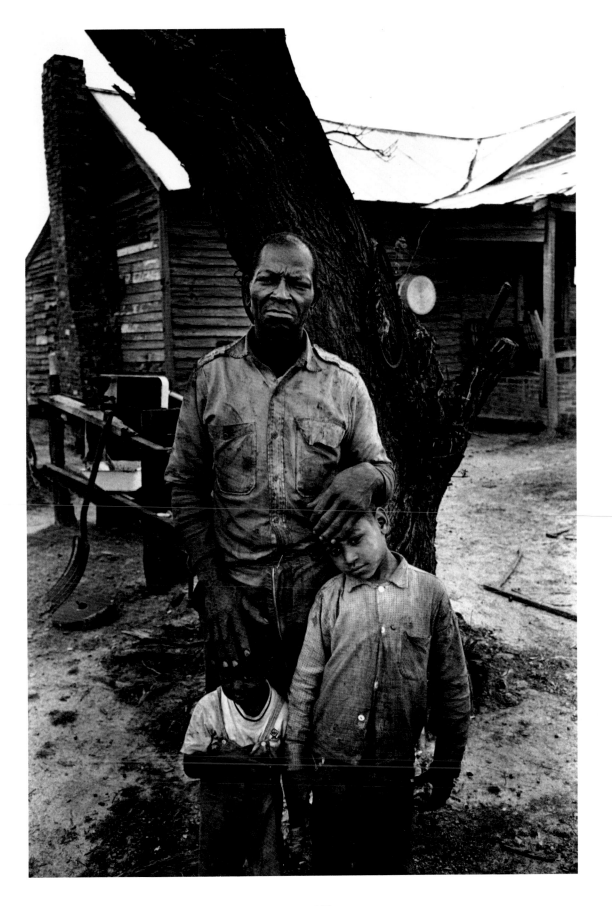

Alabama 1965

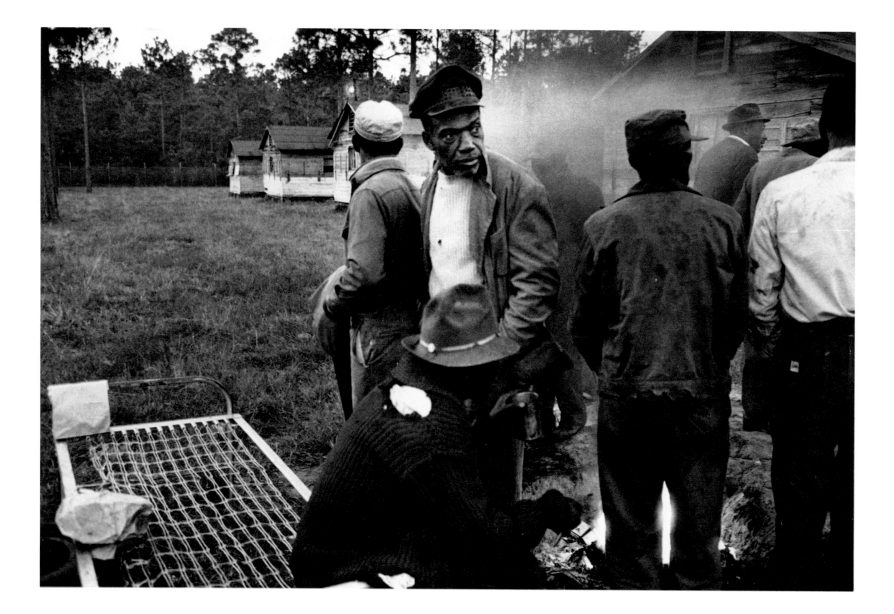

South Carolina 1962

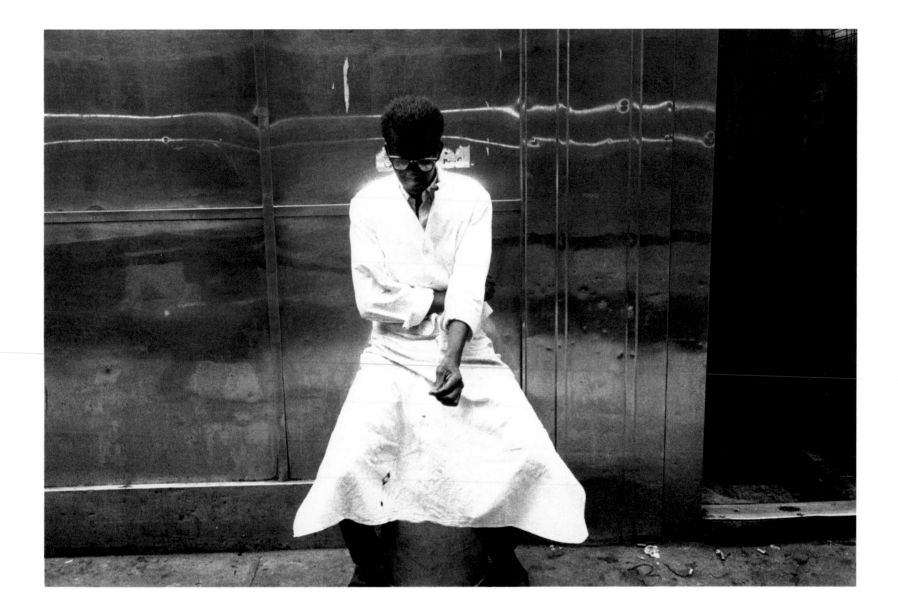

New York City 1962

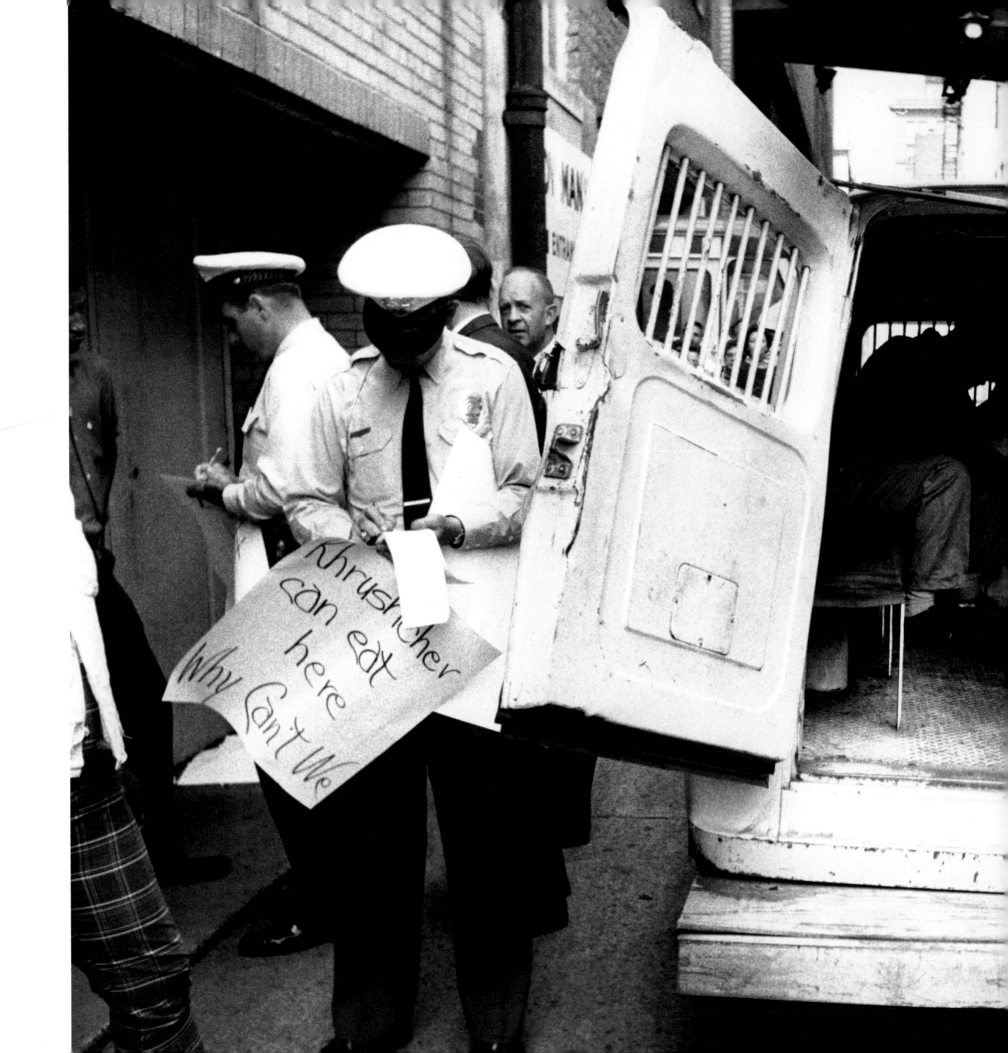

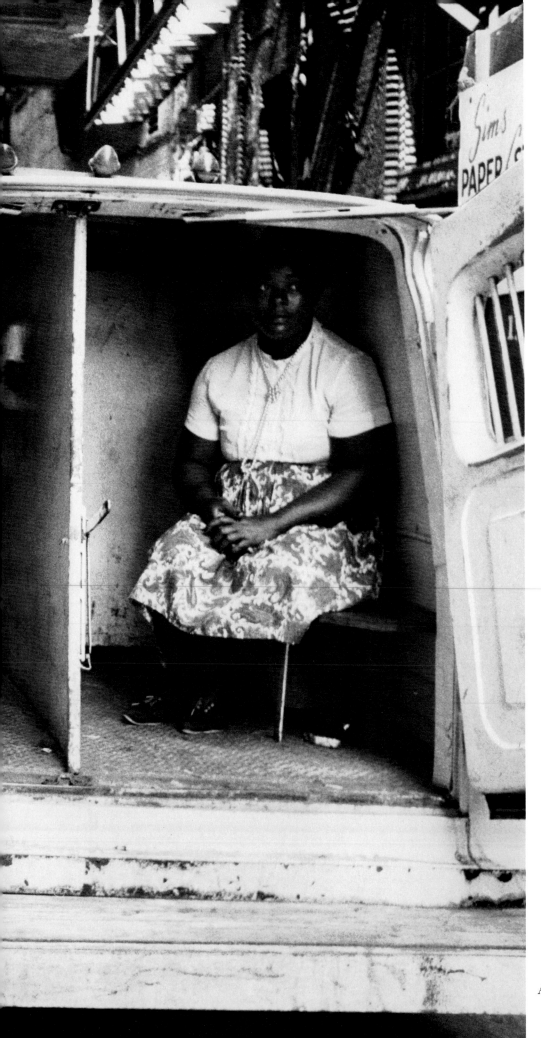

Alabama 1963

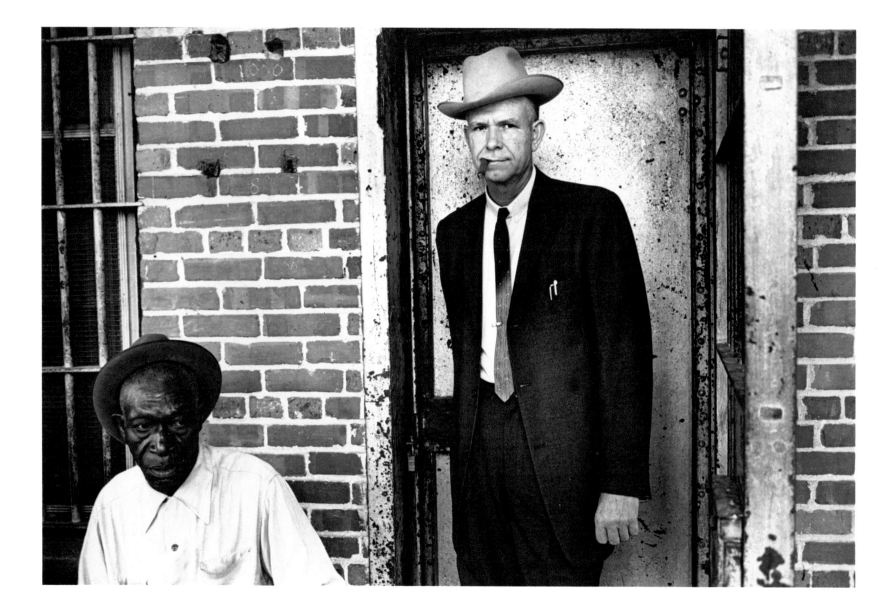

Alabama 1965

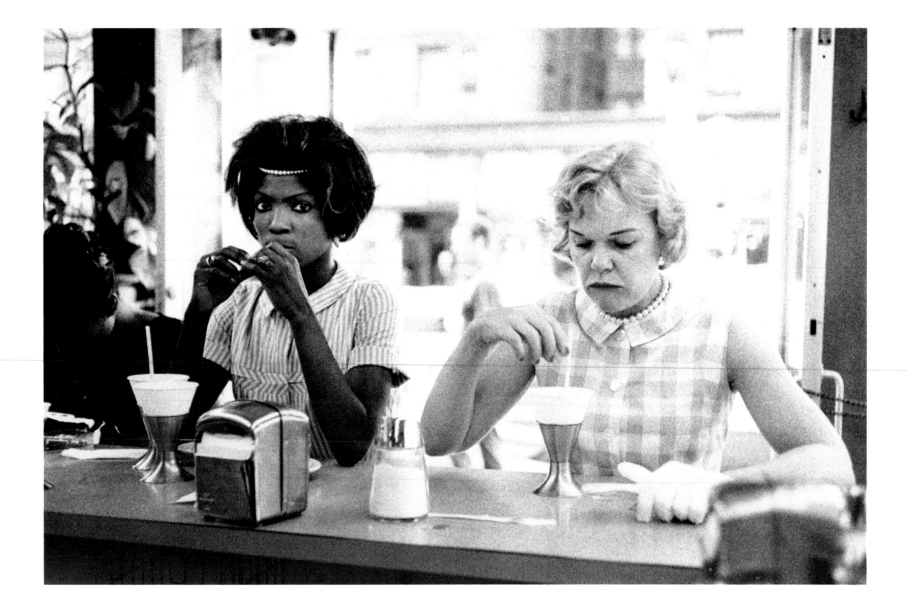

New York City 1962

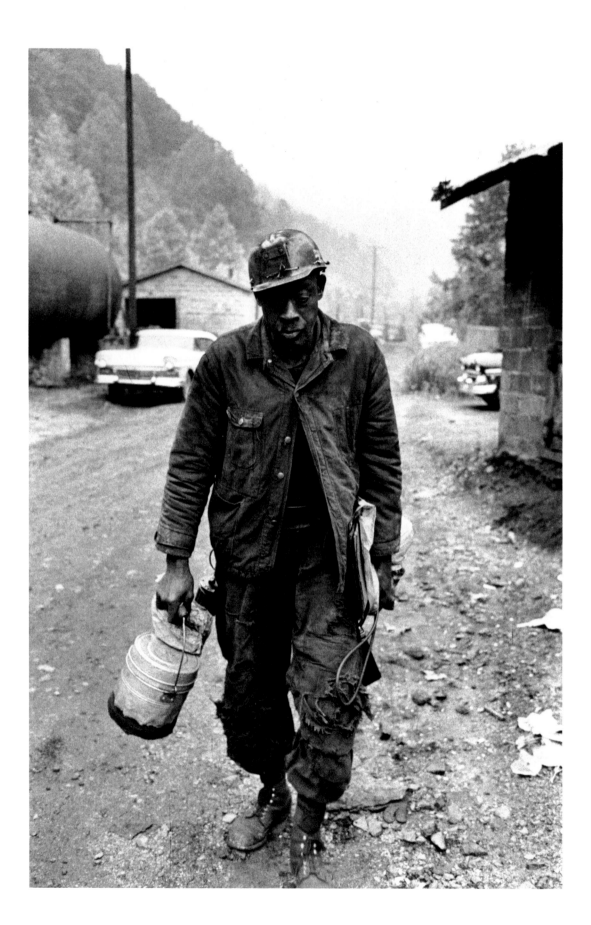

West Virginia 1963

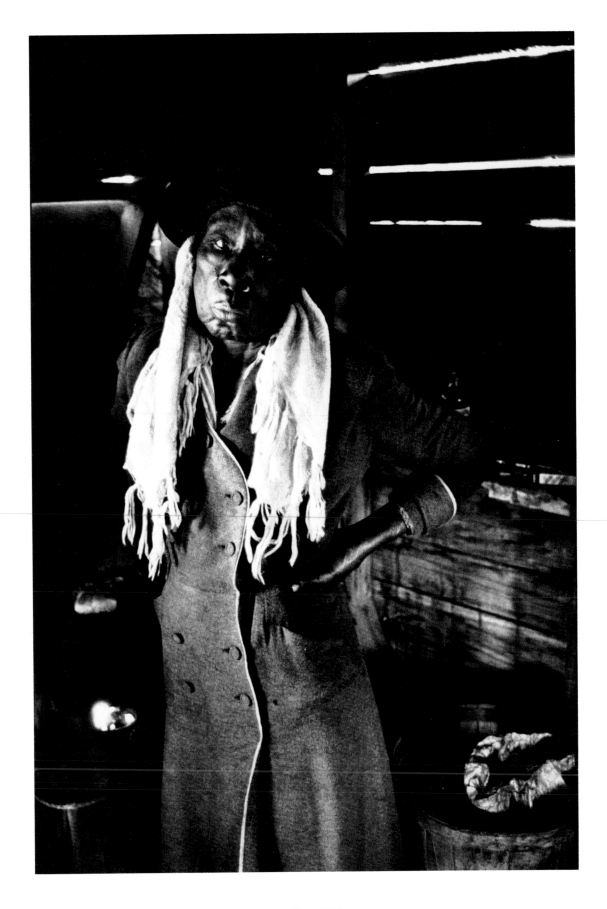

South Carolina 1962

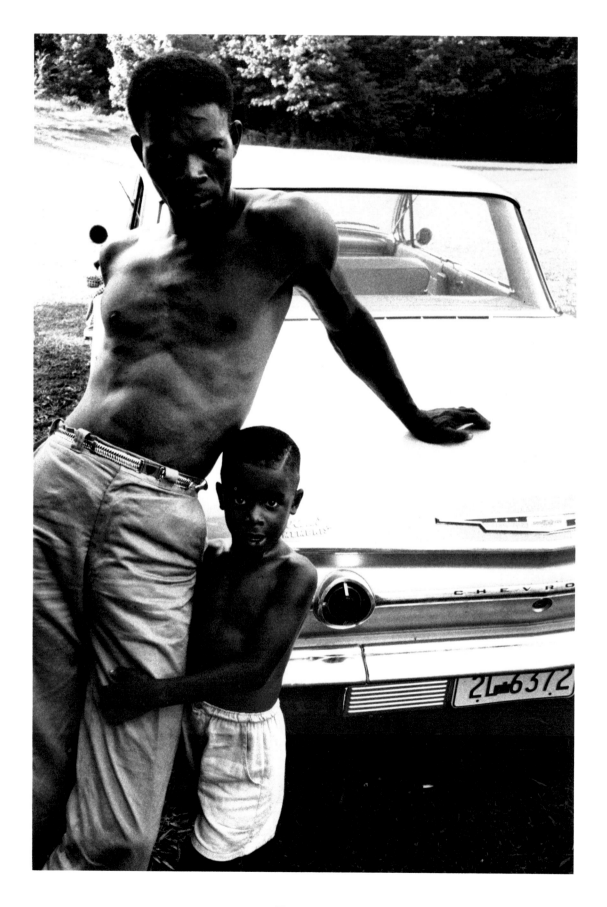

Tennessee 1962

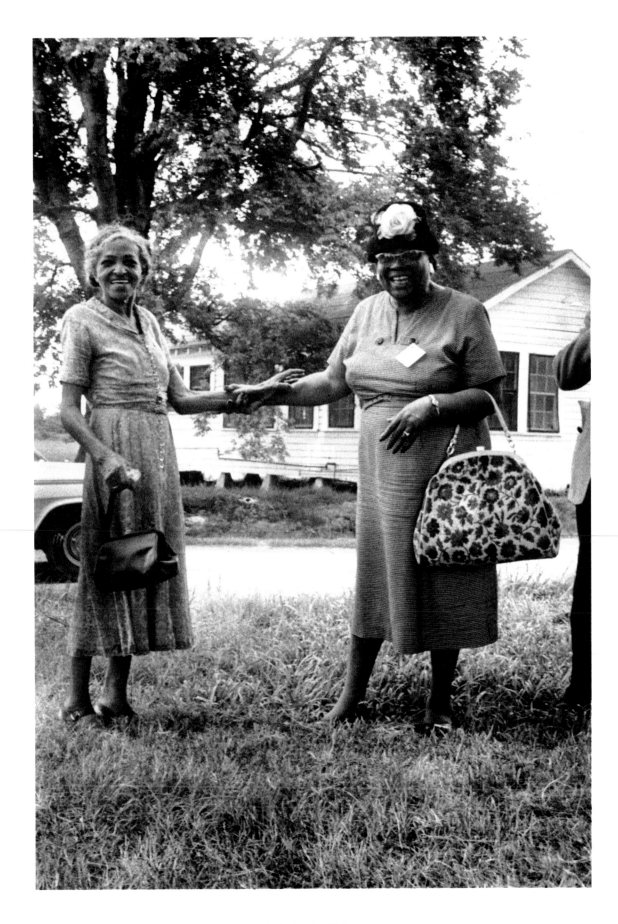

Mississippi 1963

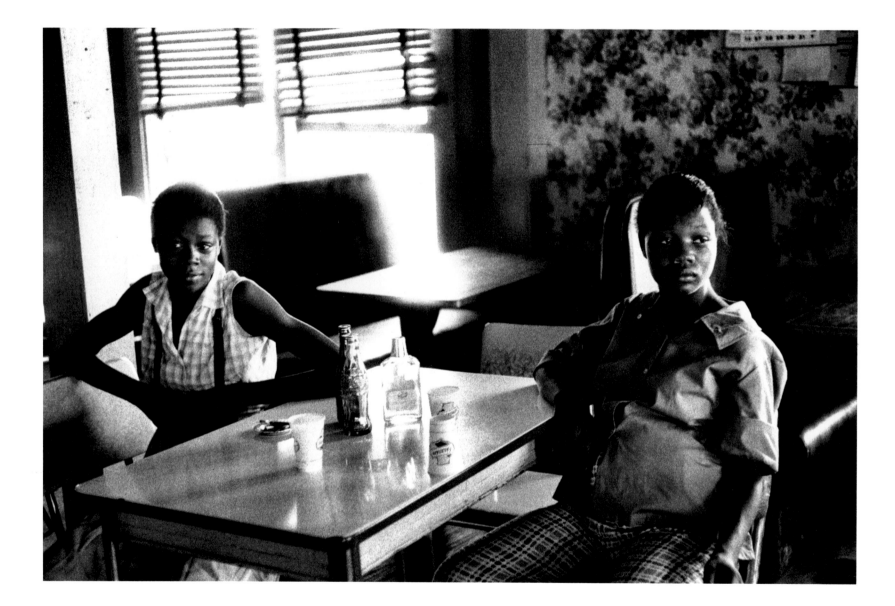

Mississippi 1963

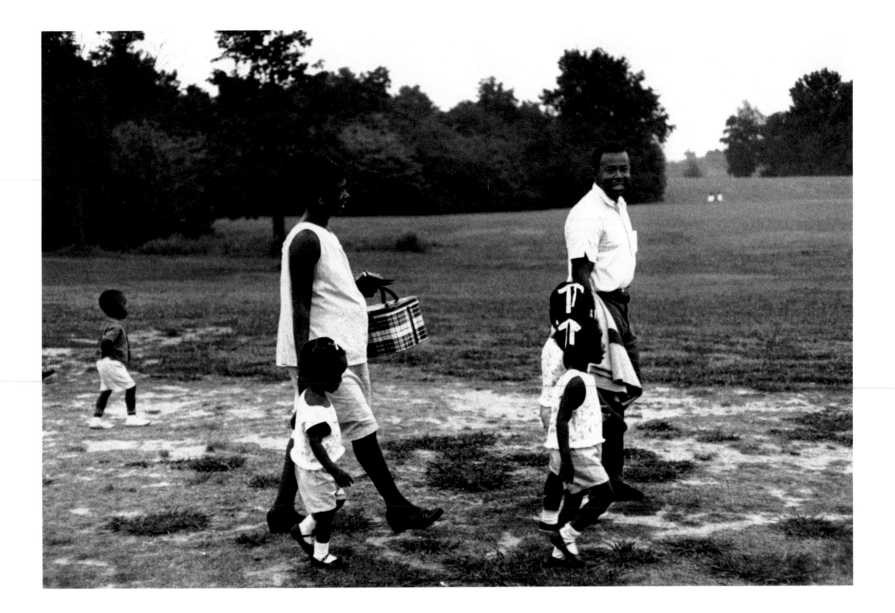

Tennessee 1963

The Bridge
1963

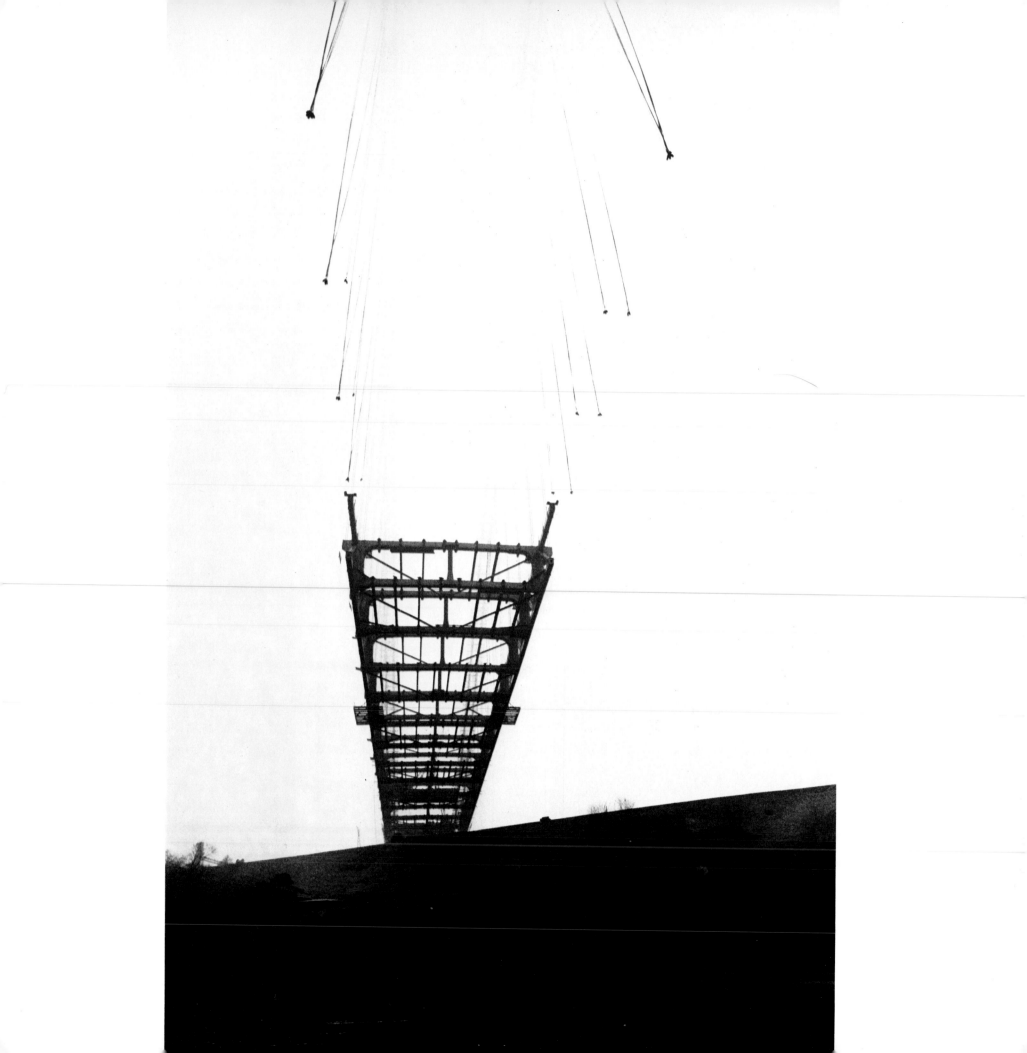

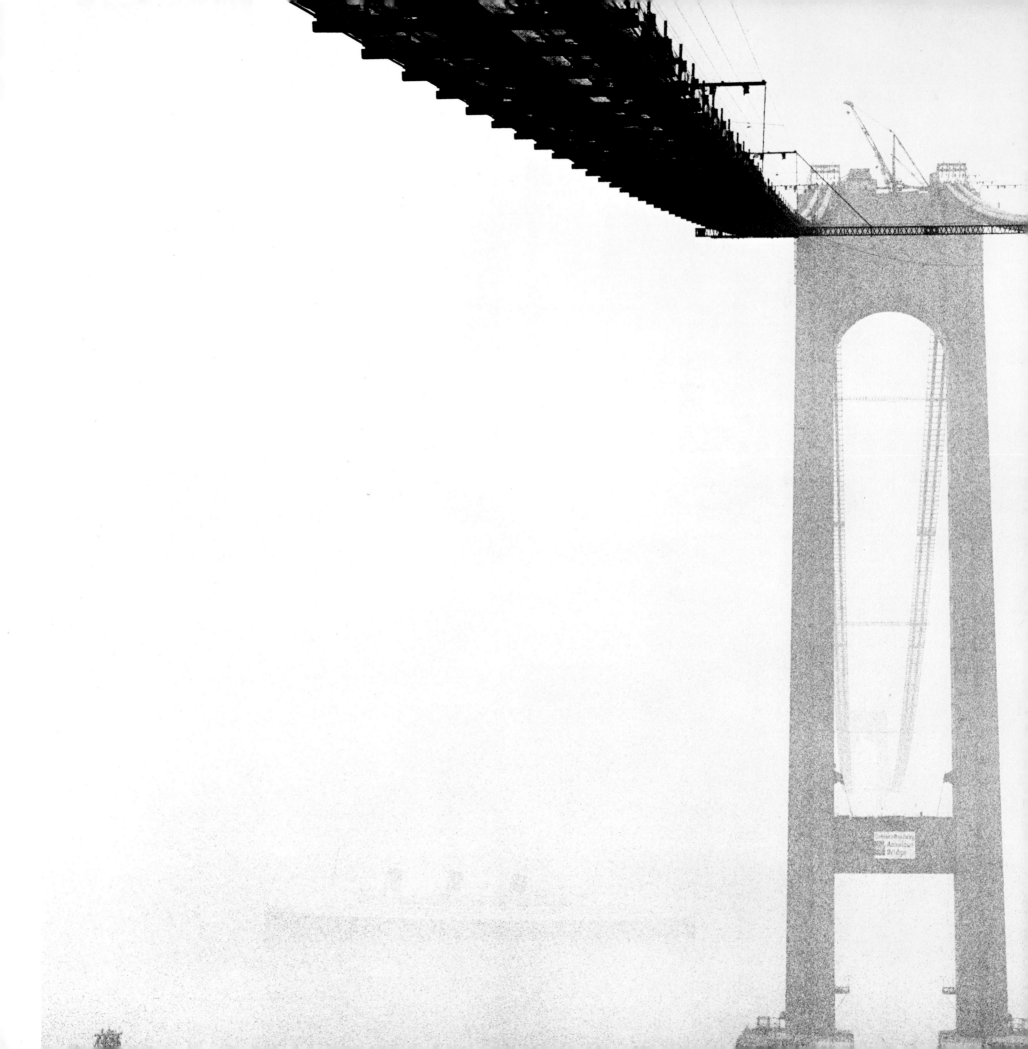

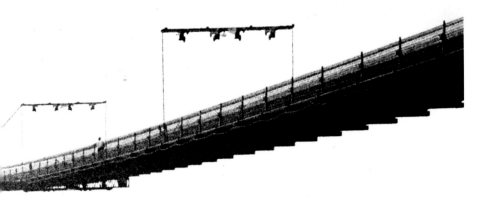

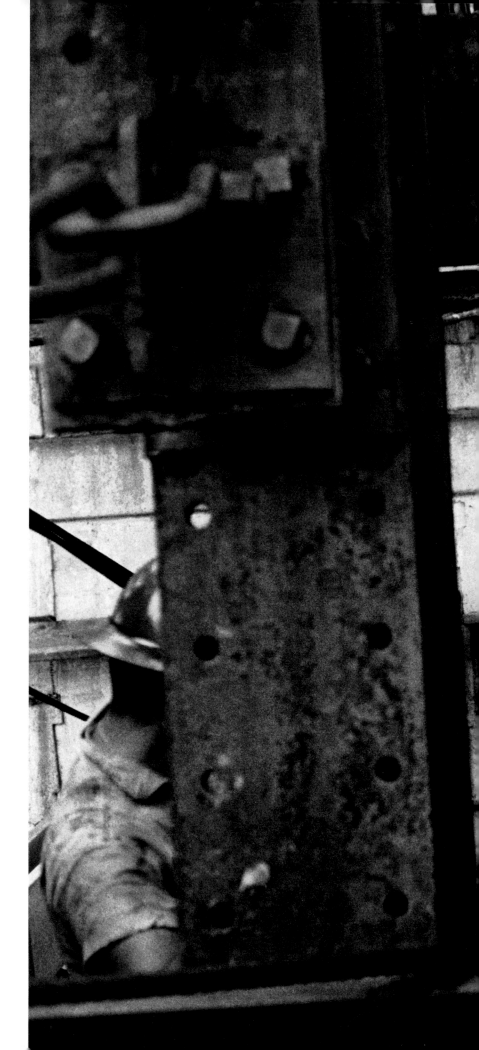

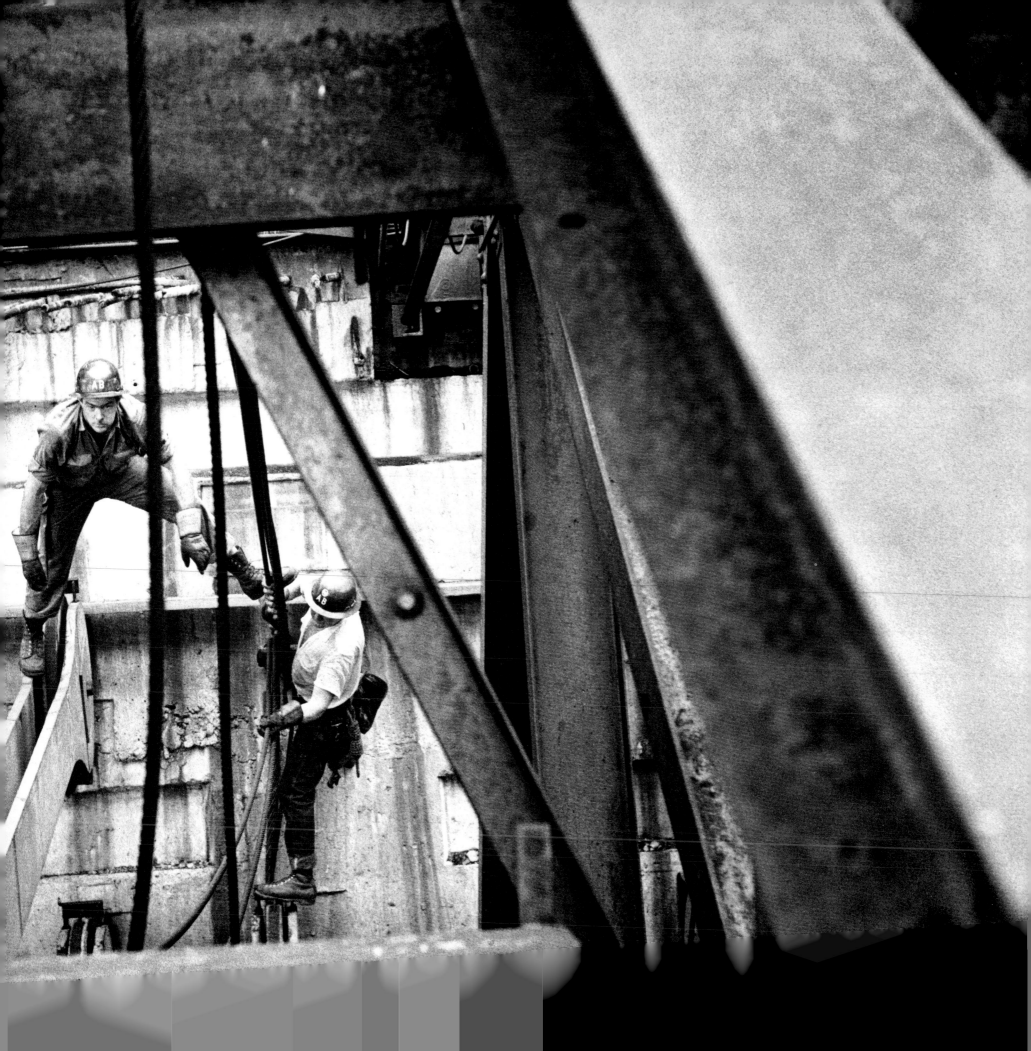

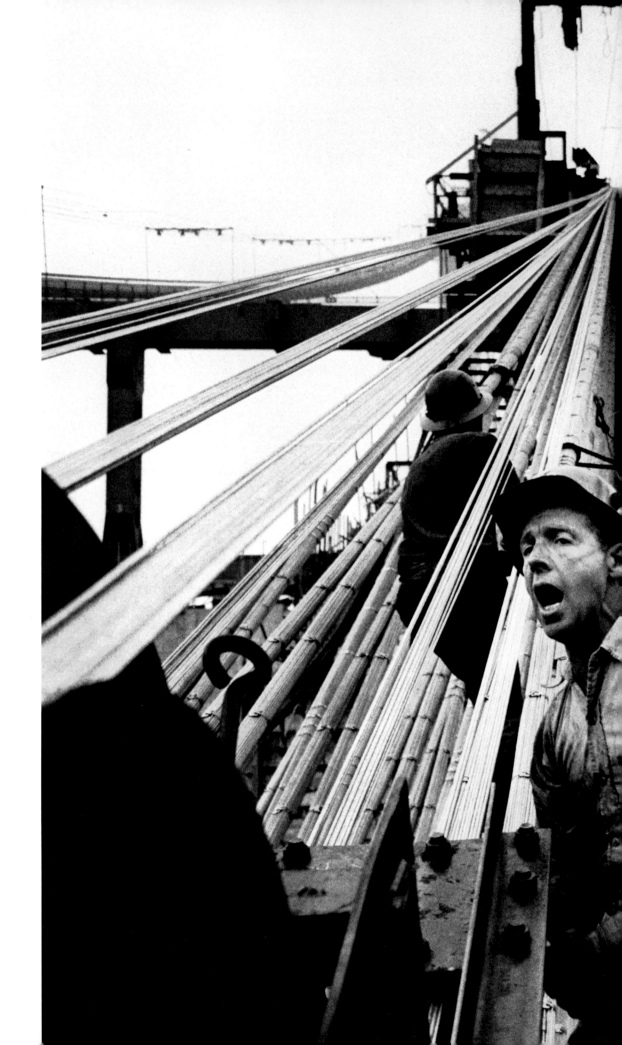

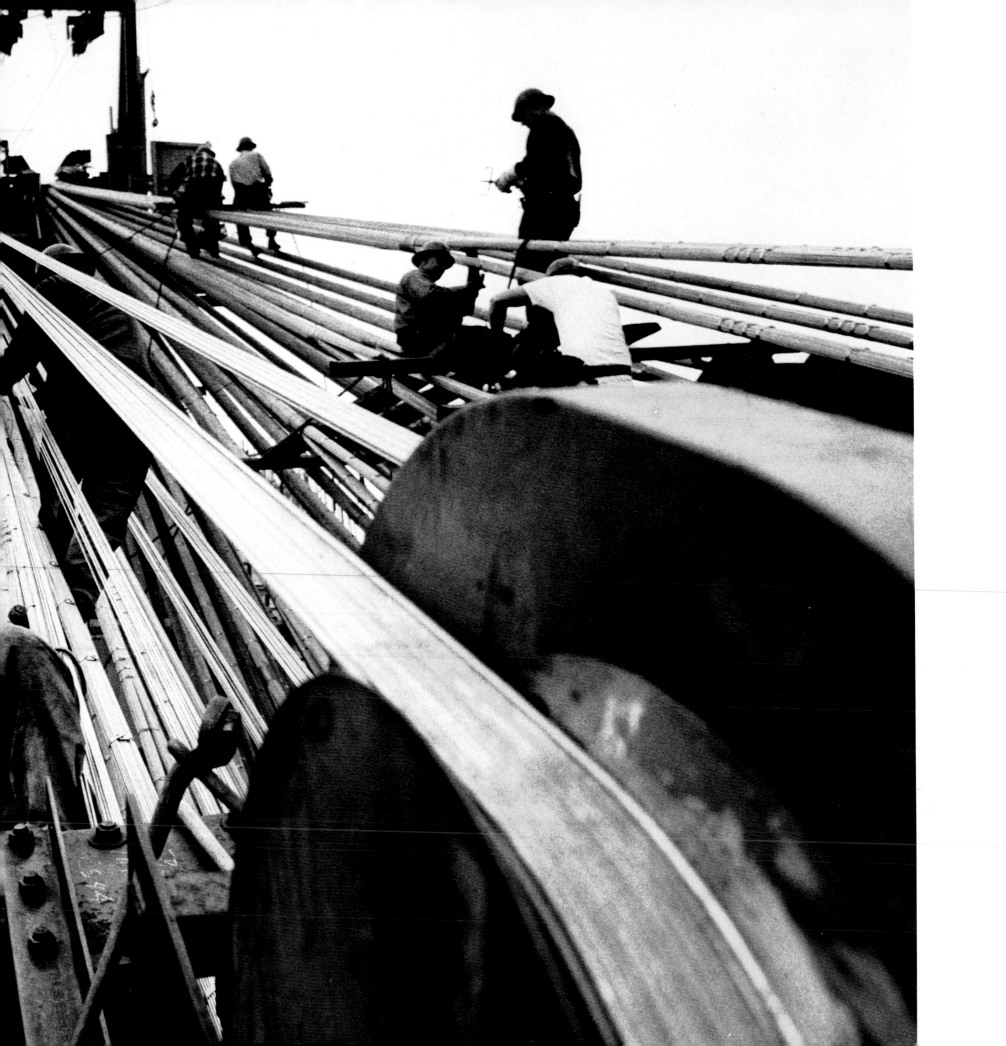

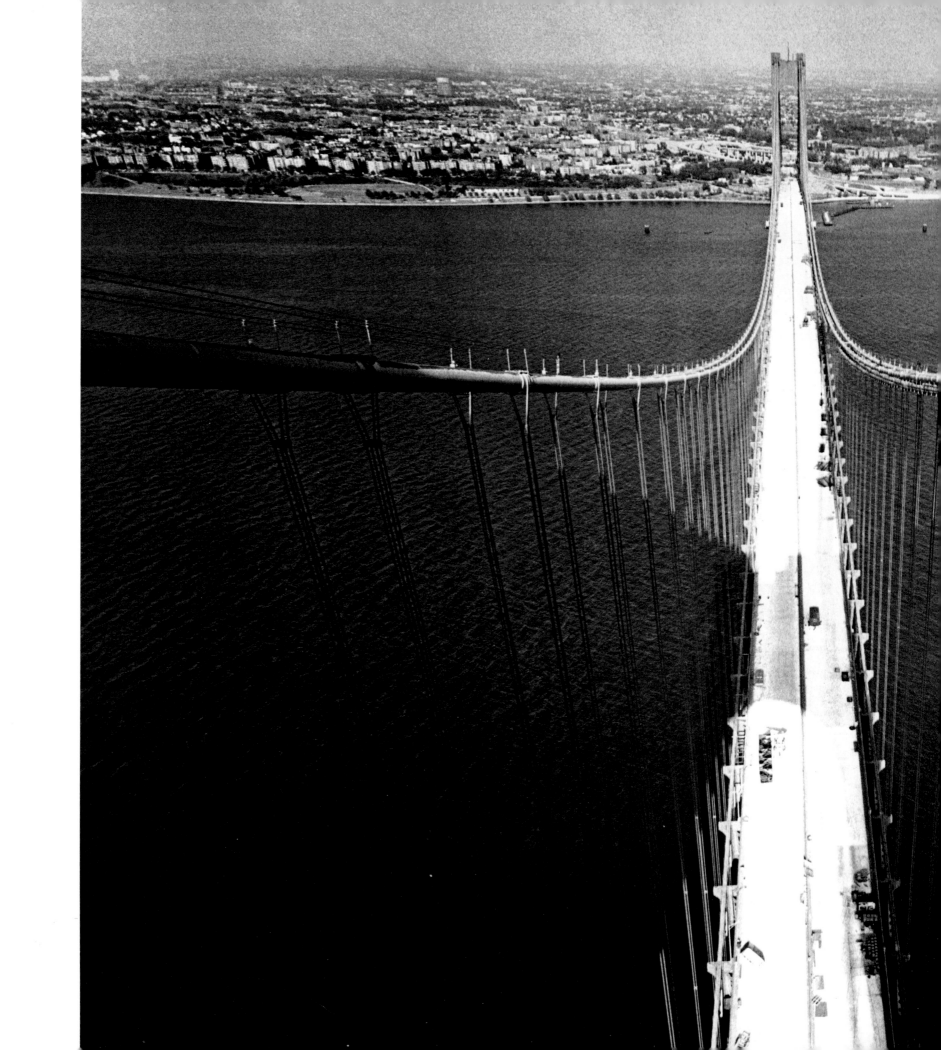

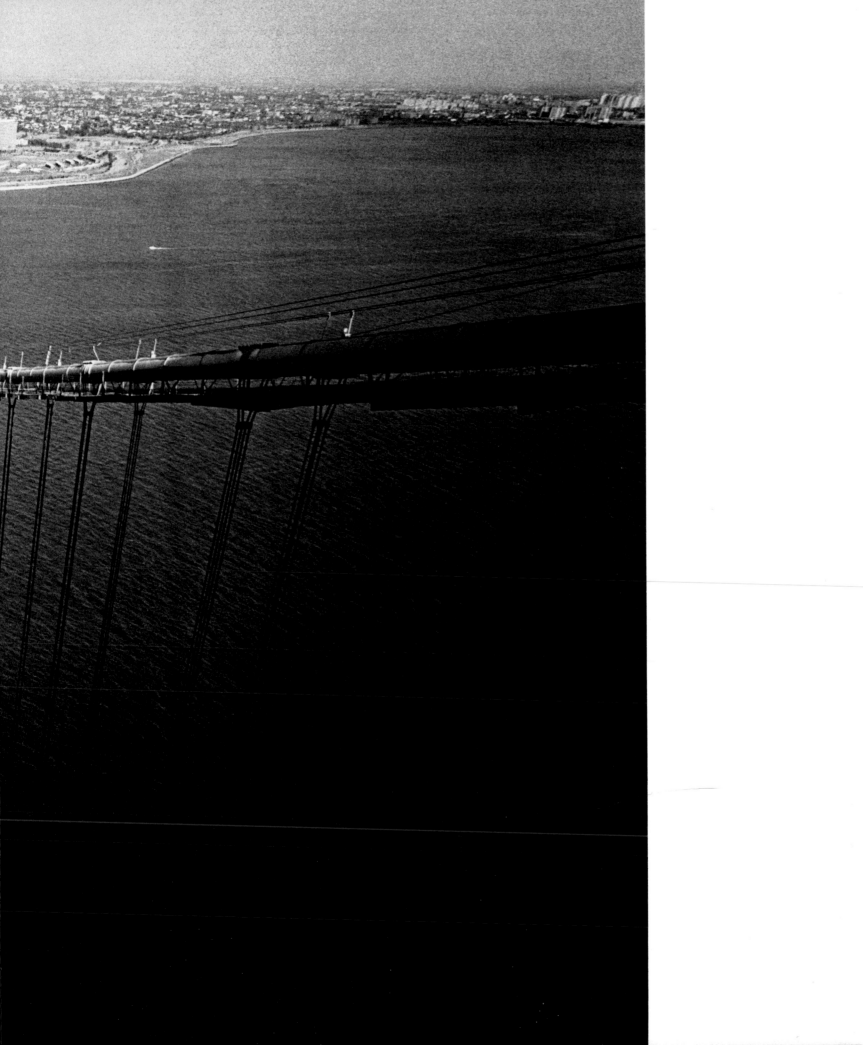

Los Angeles

1964

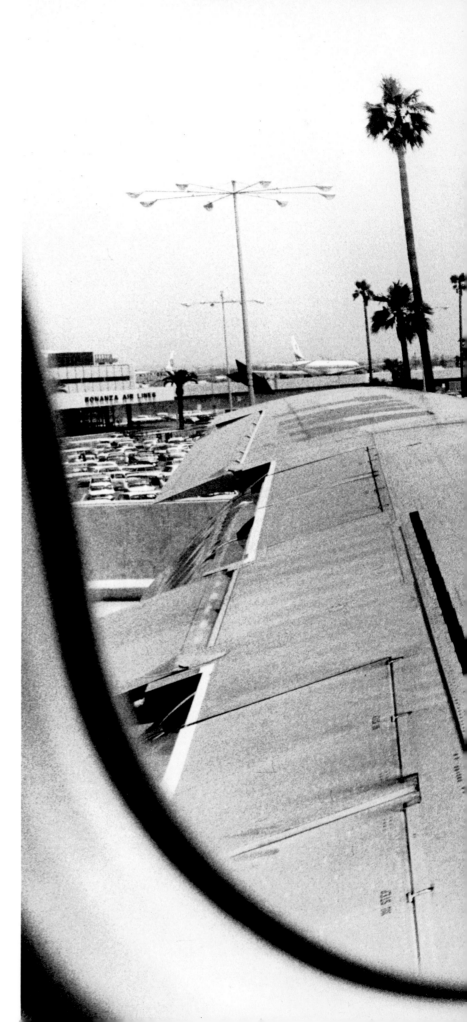

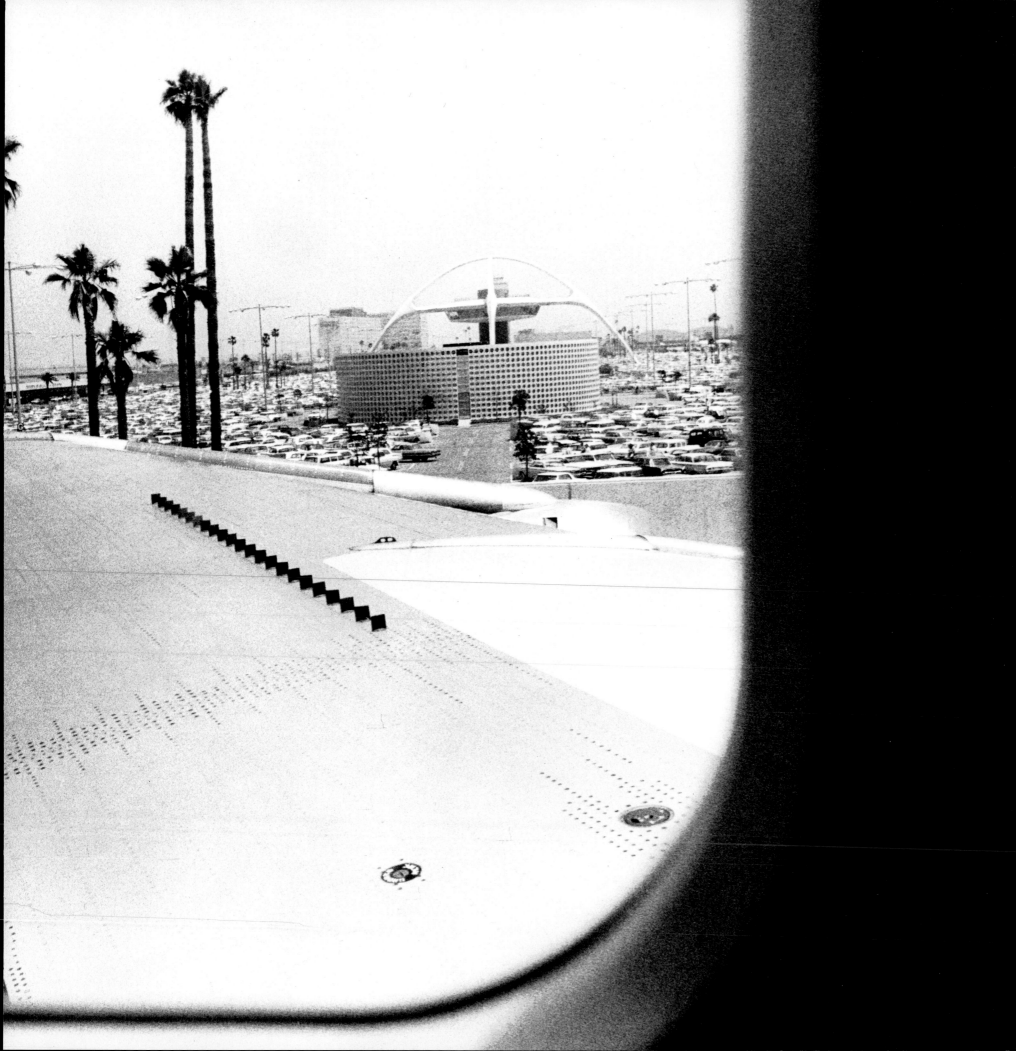

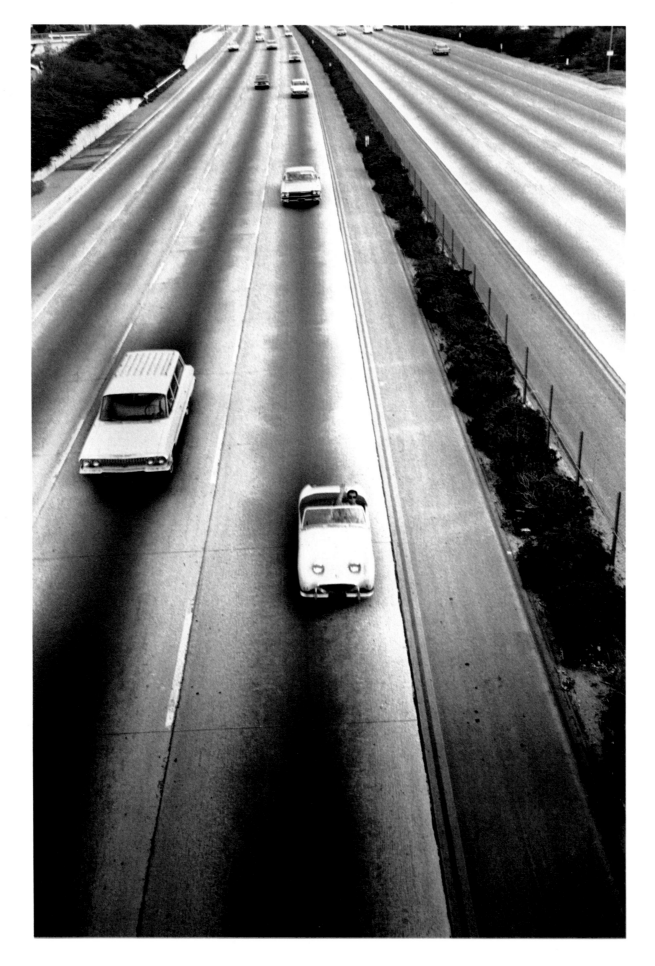

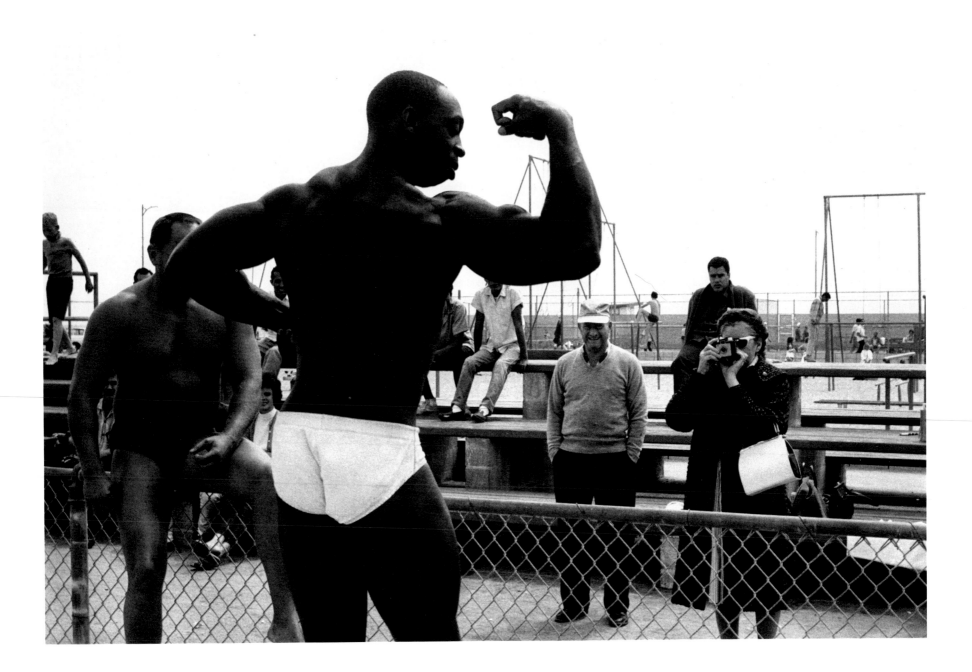

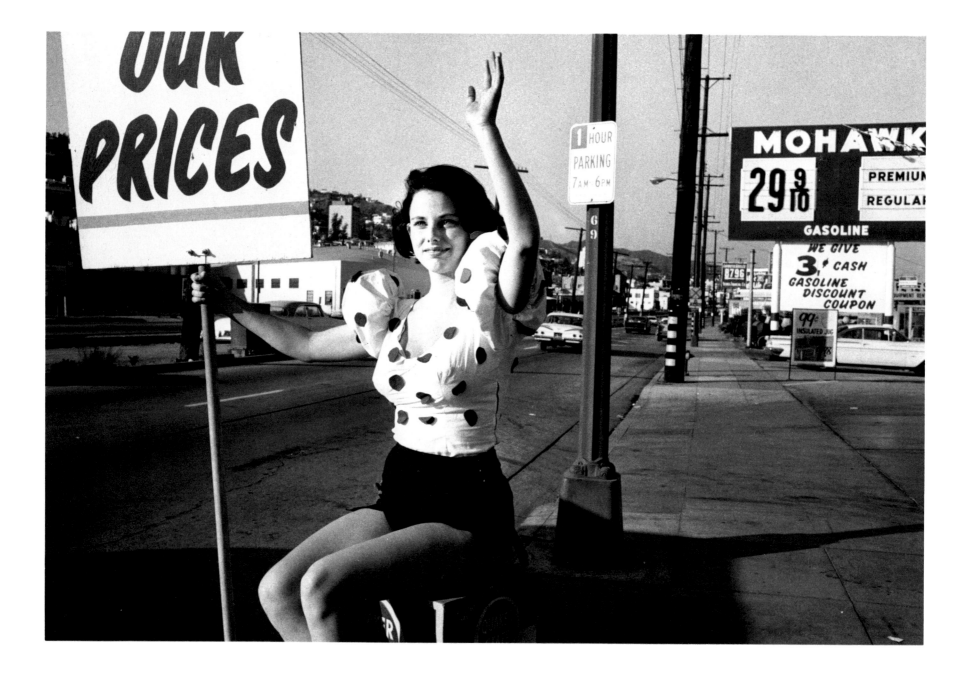

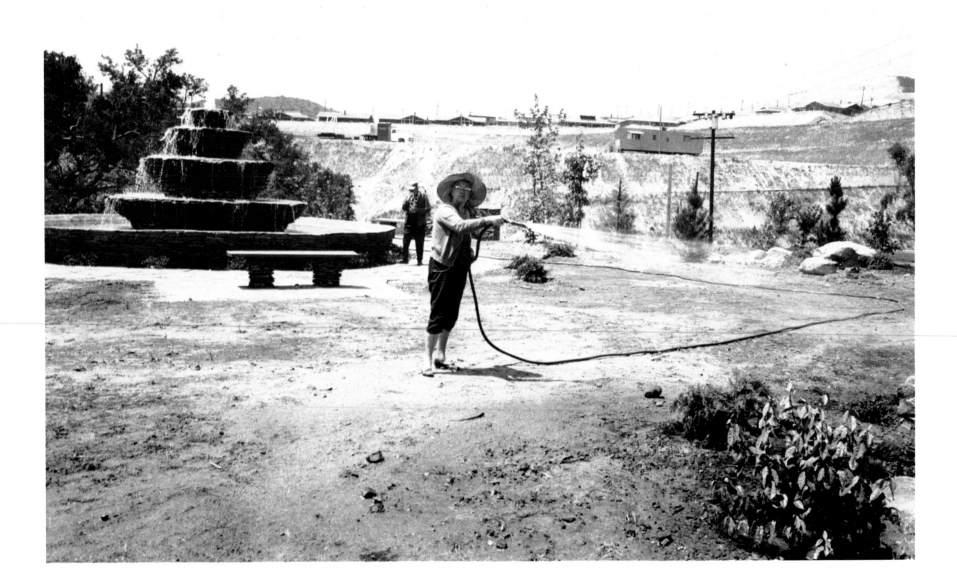

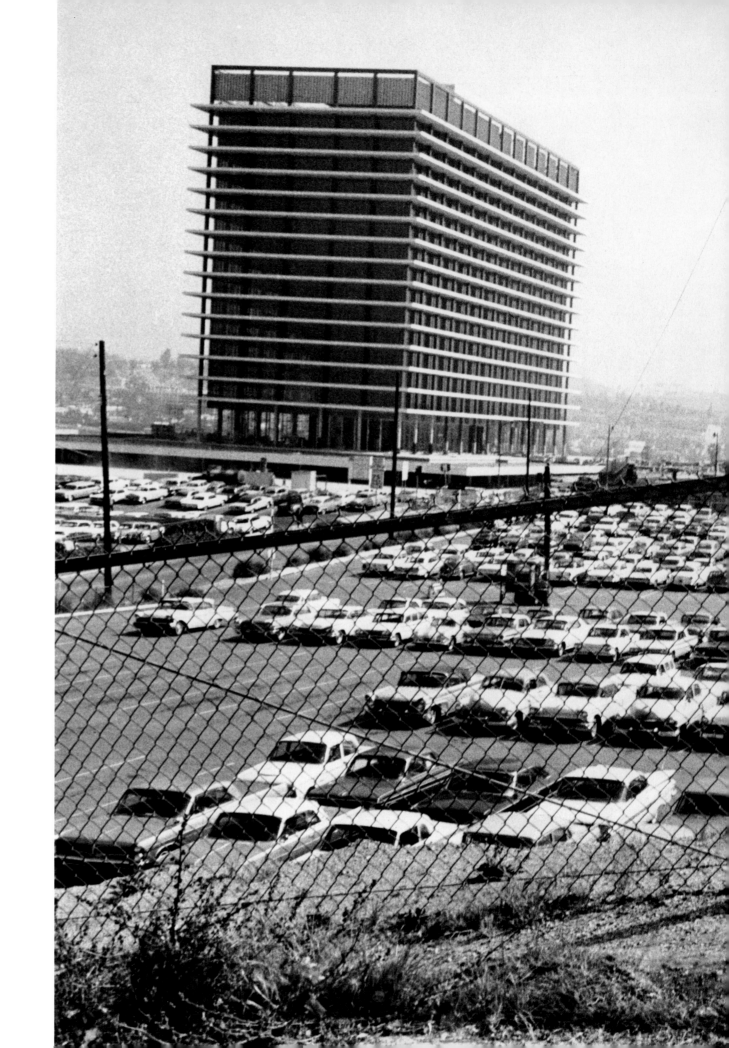

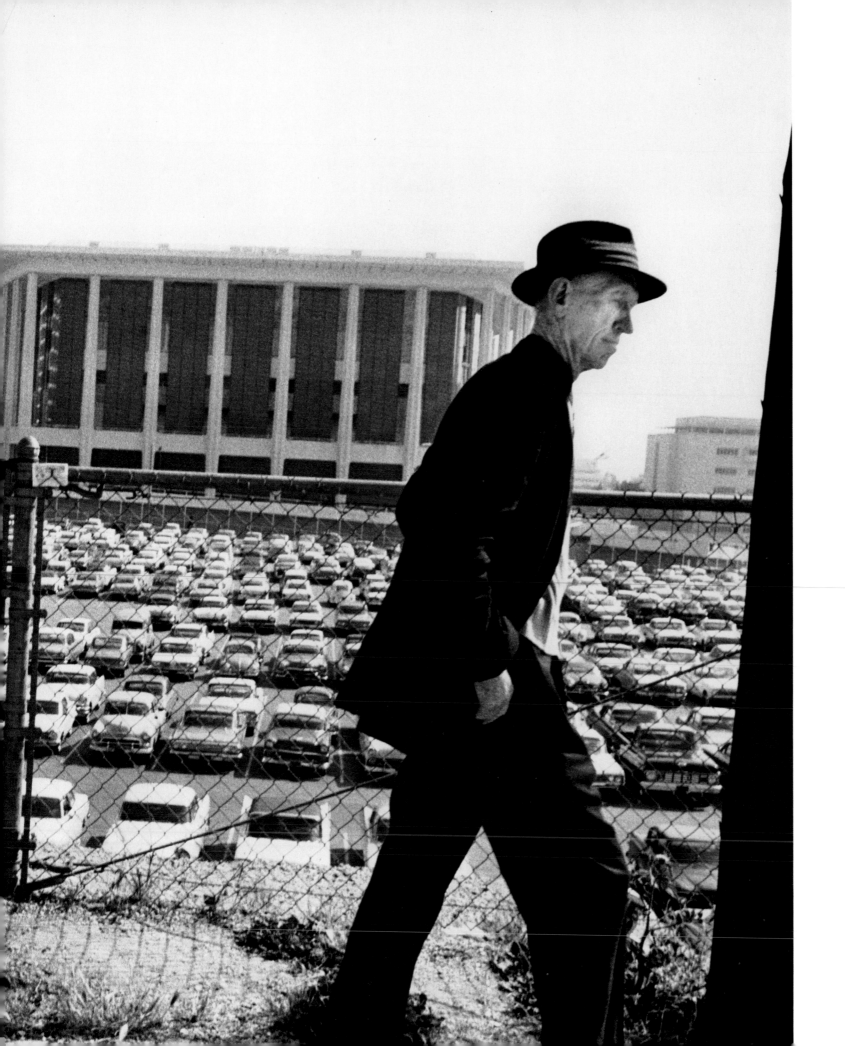

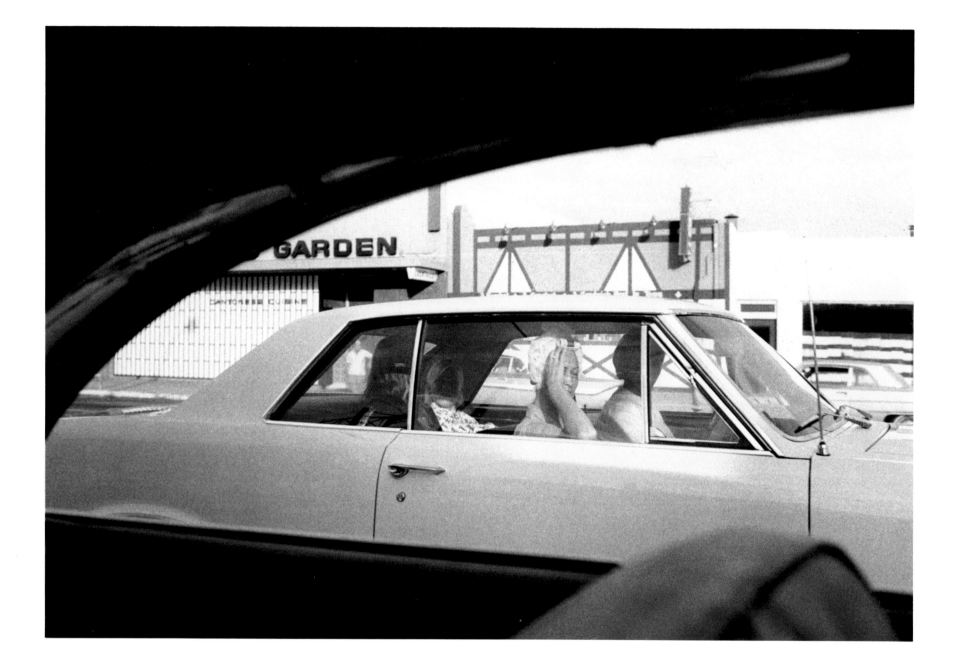

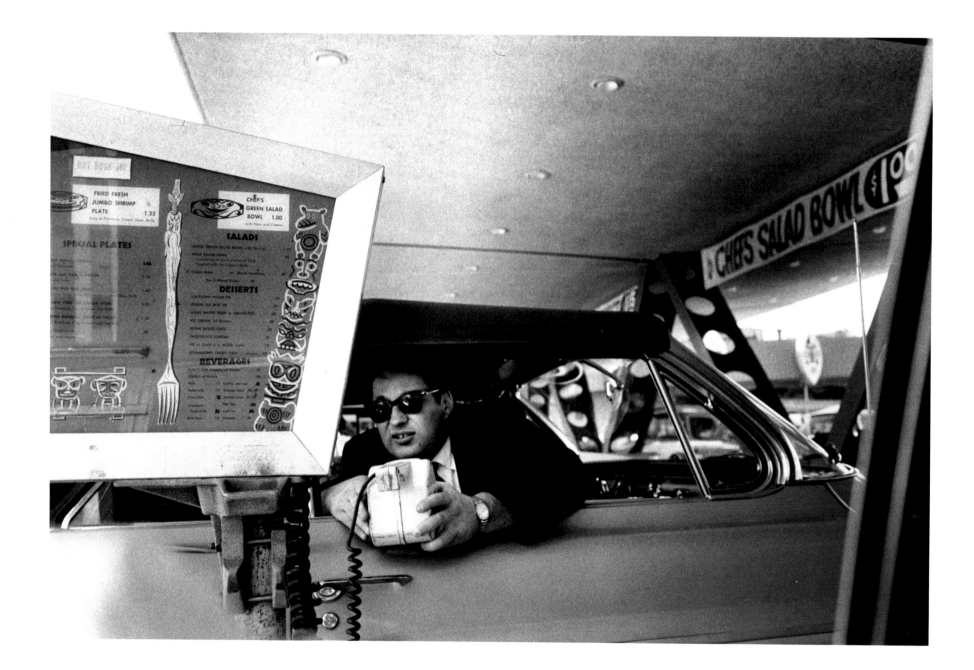

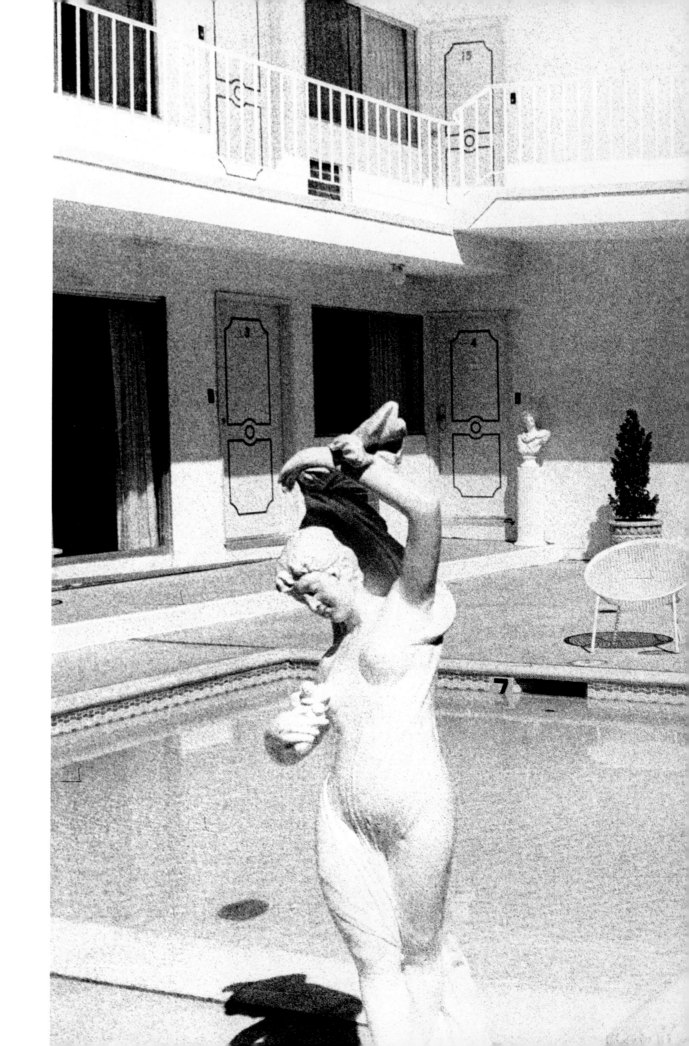

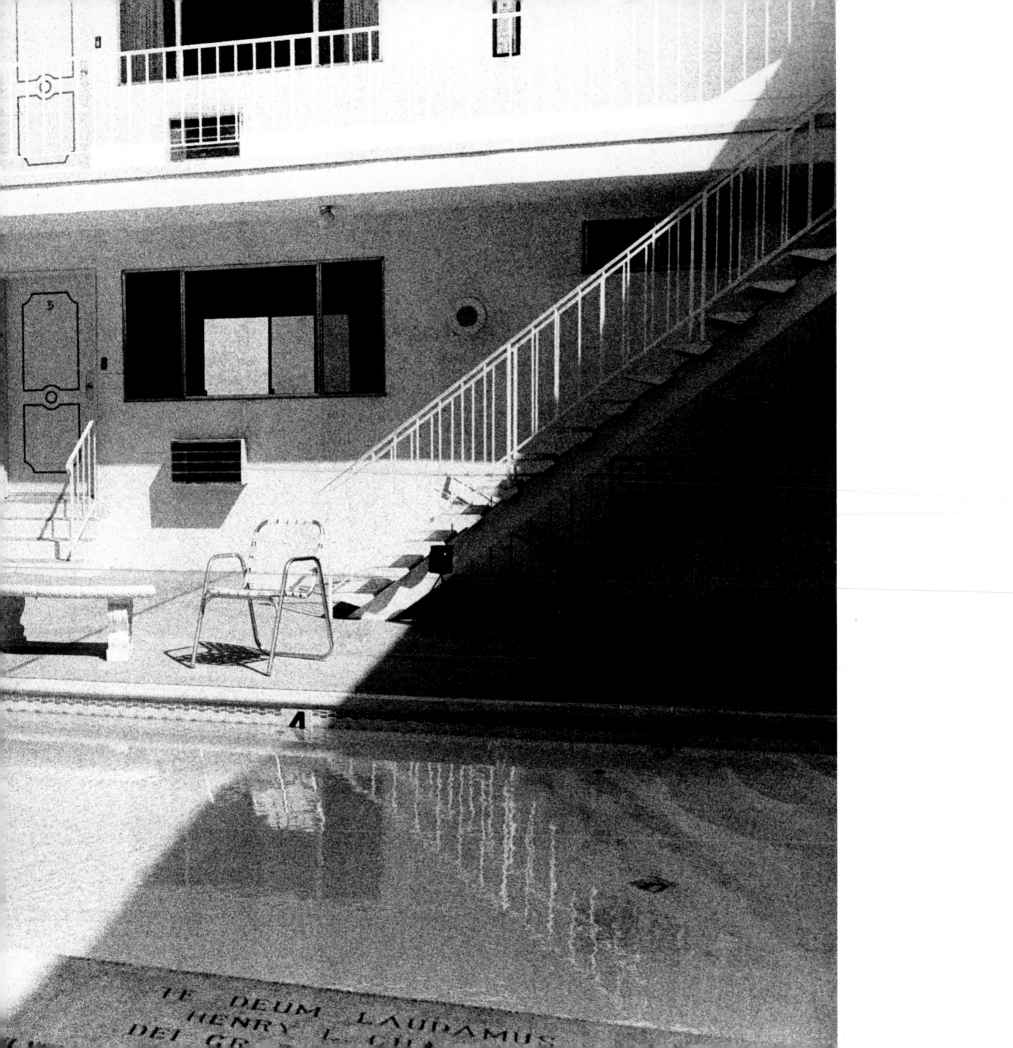

The New Jersey Meadows
1965

A Trip West
1965

Topless Restaurant
1965

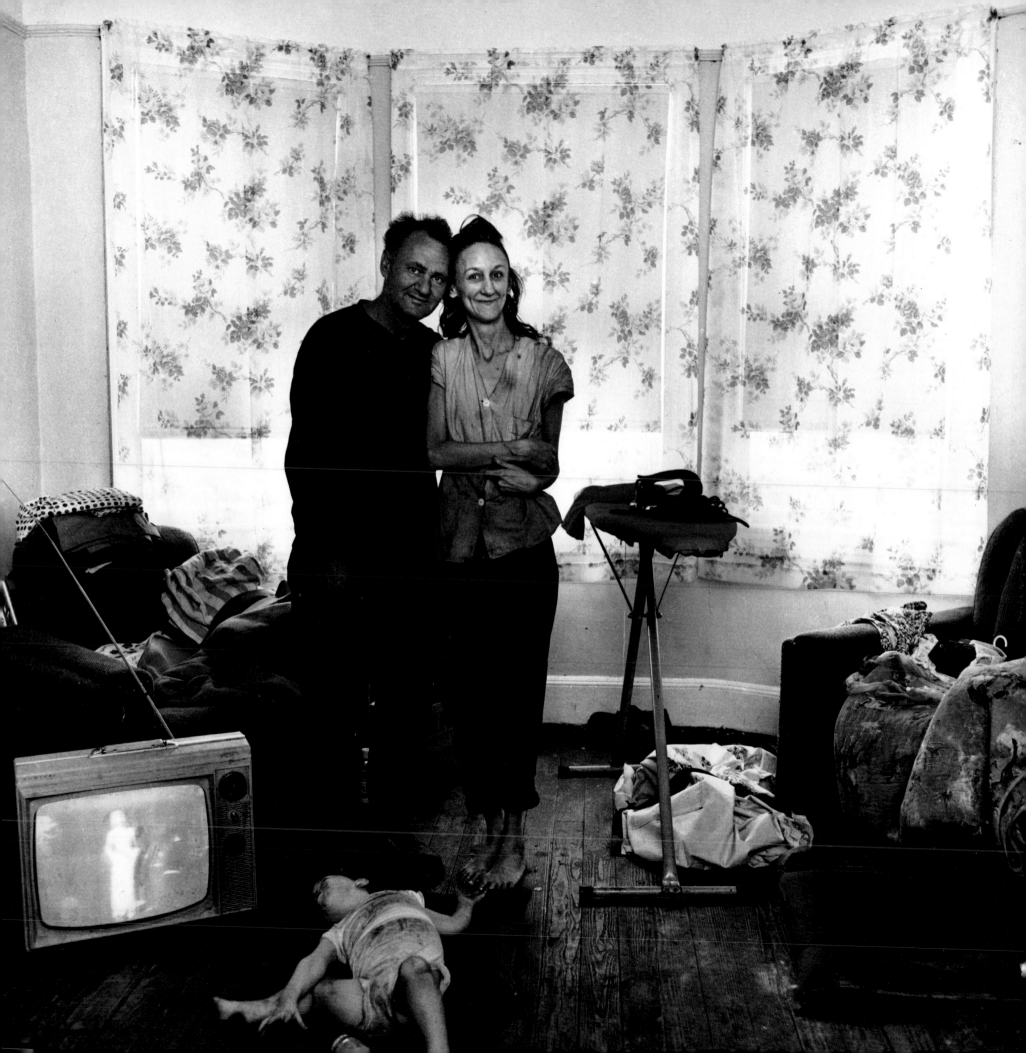

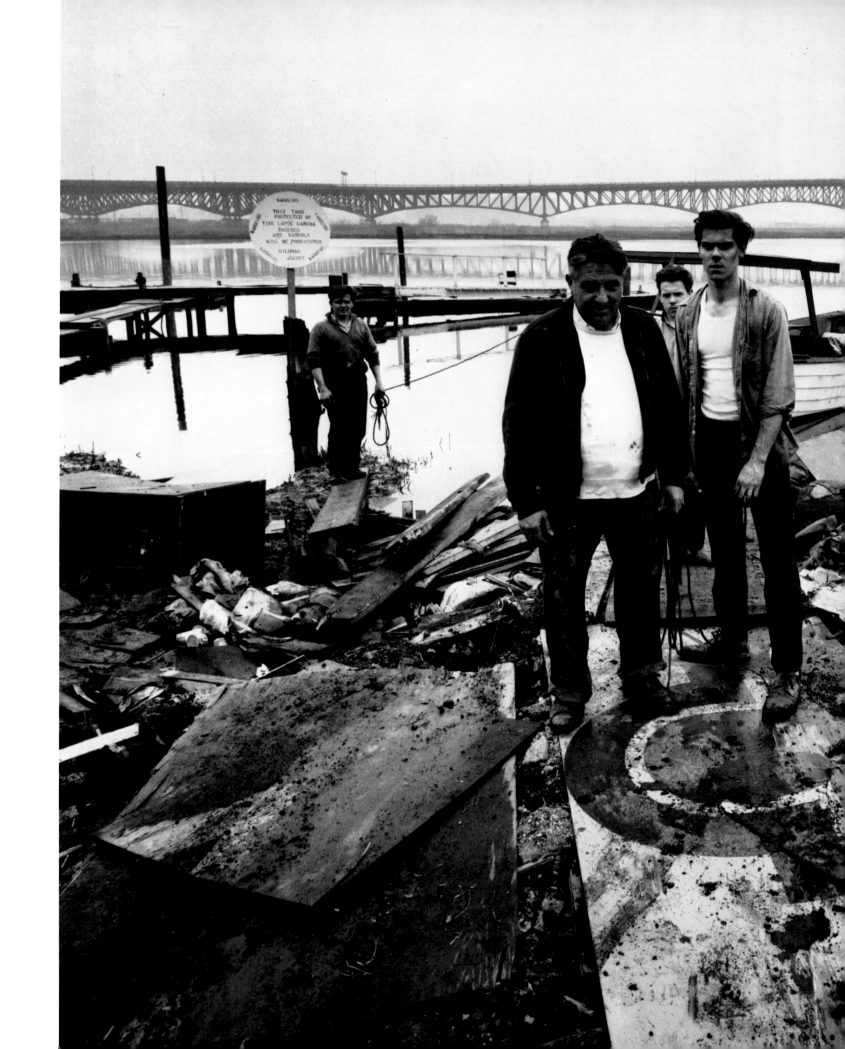

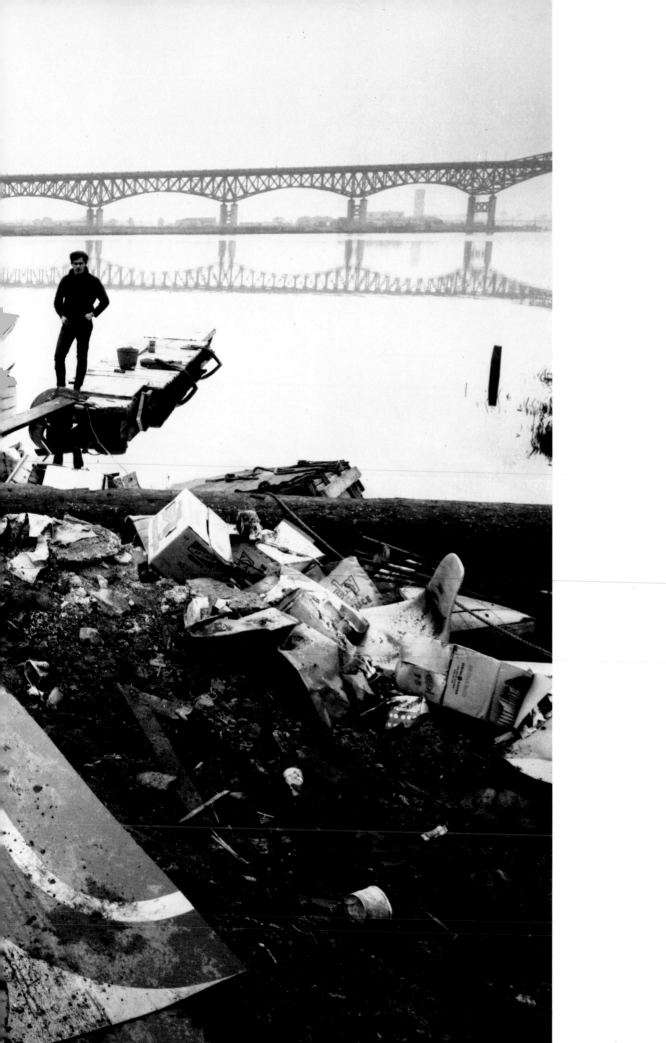

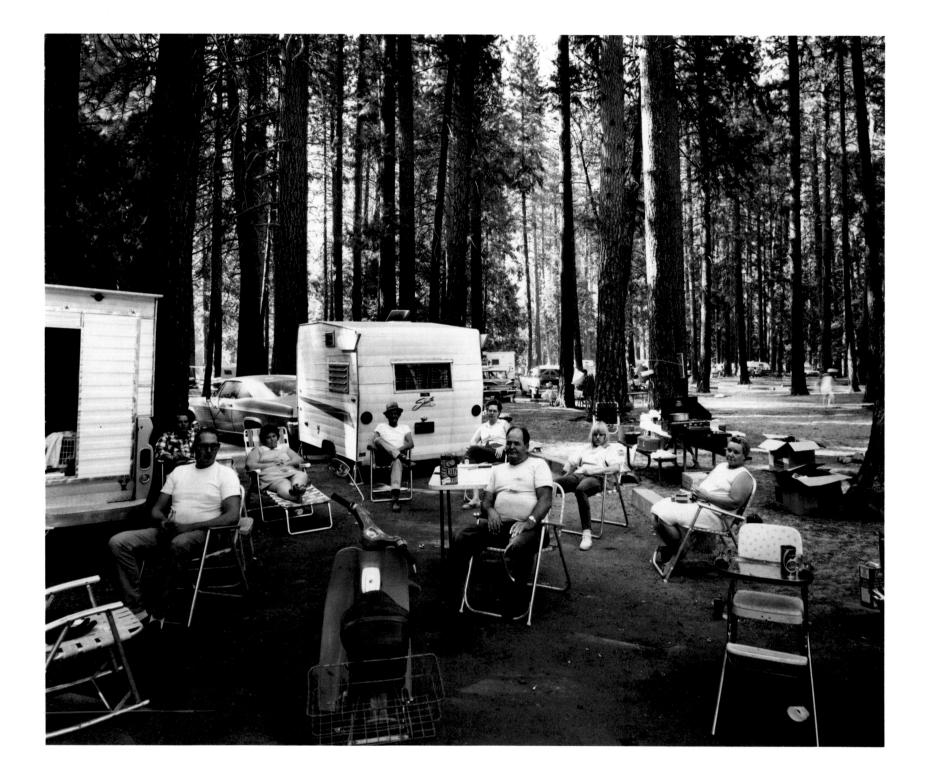

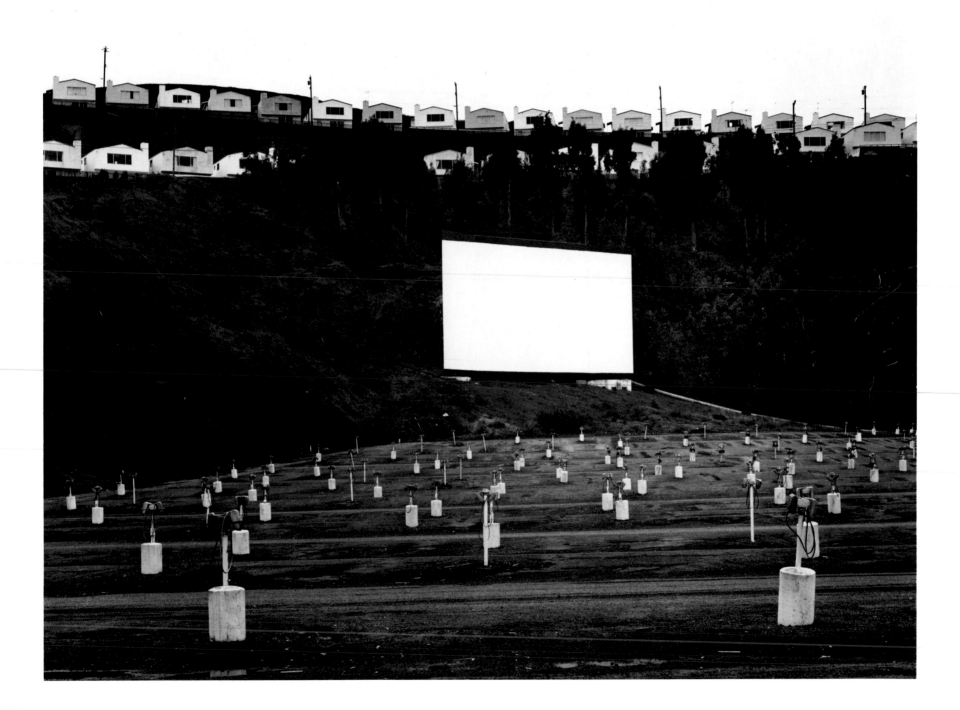

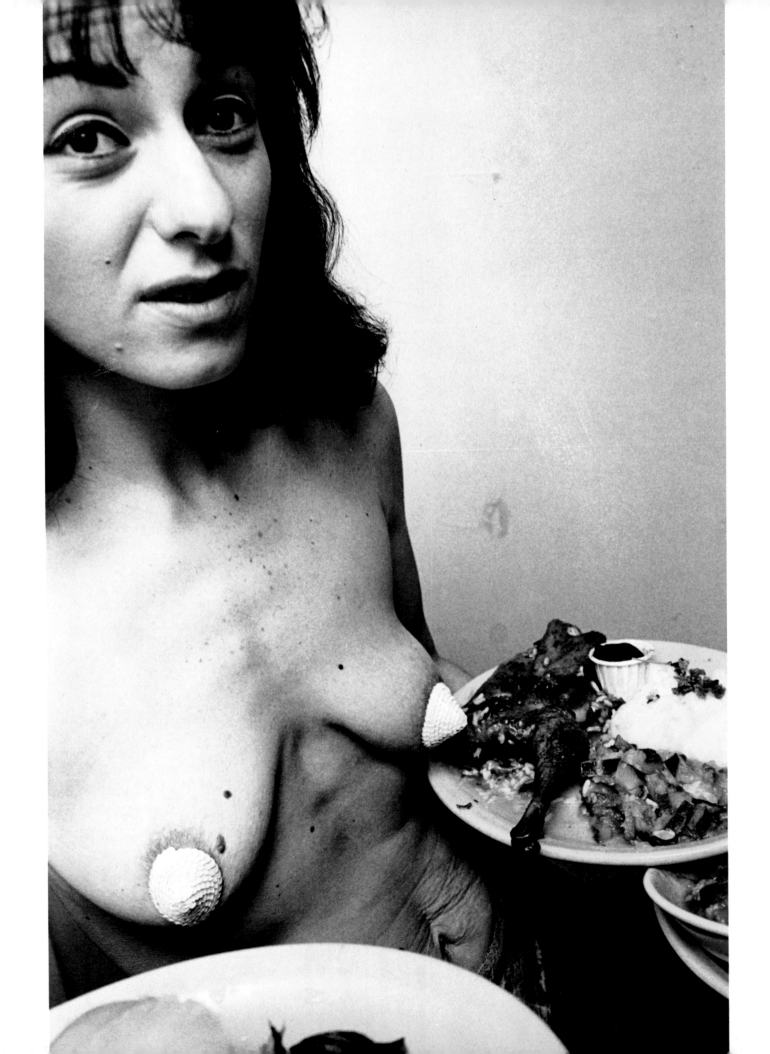

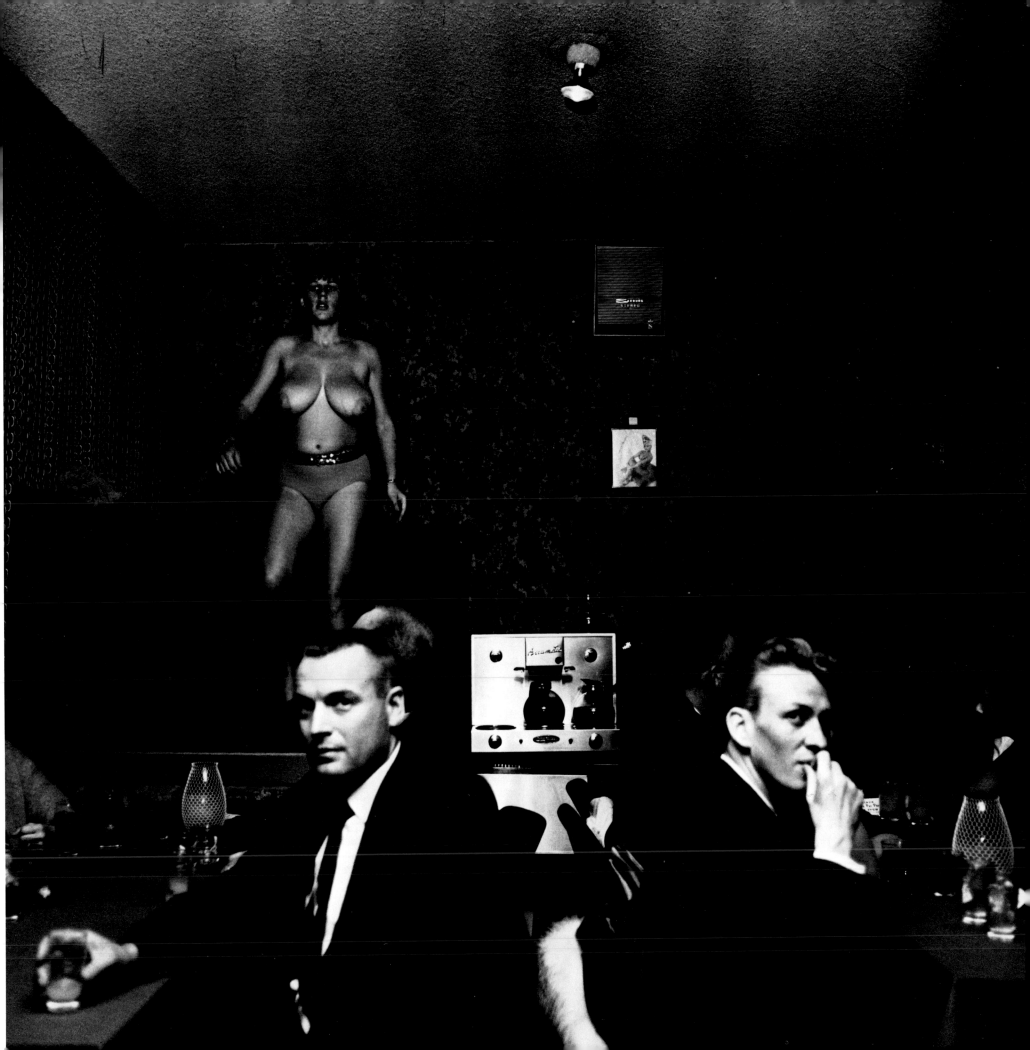

Welsh Miners

1965

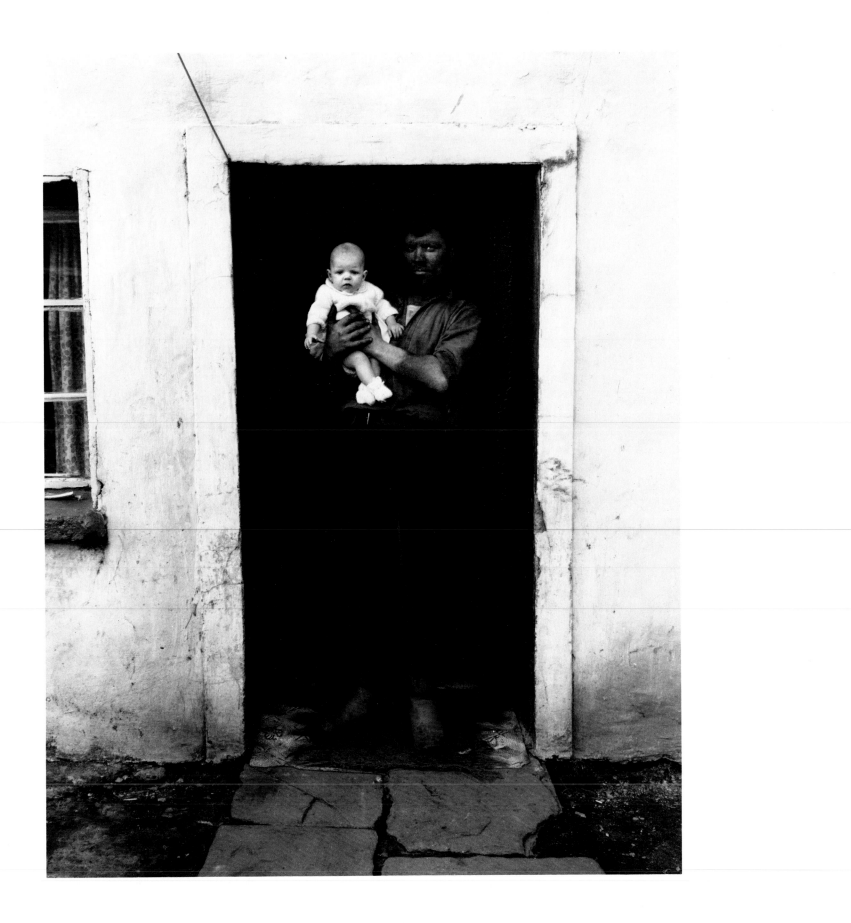

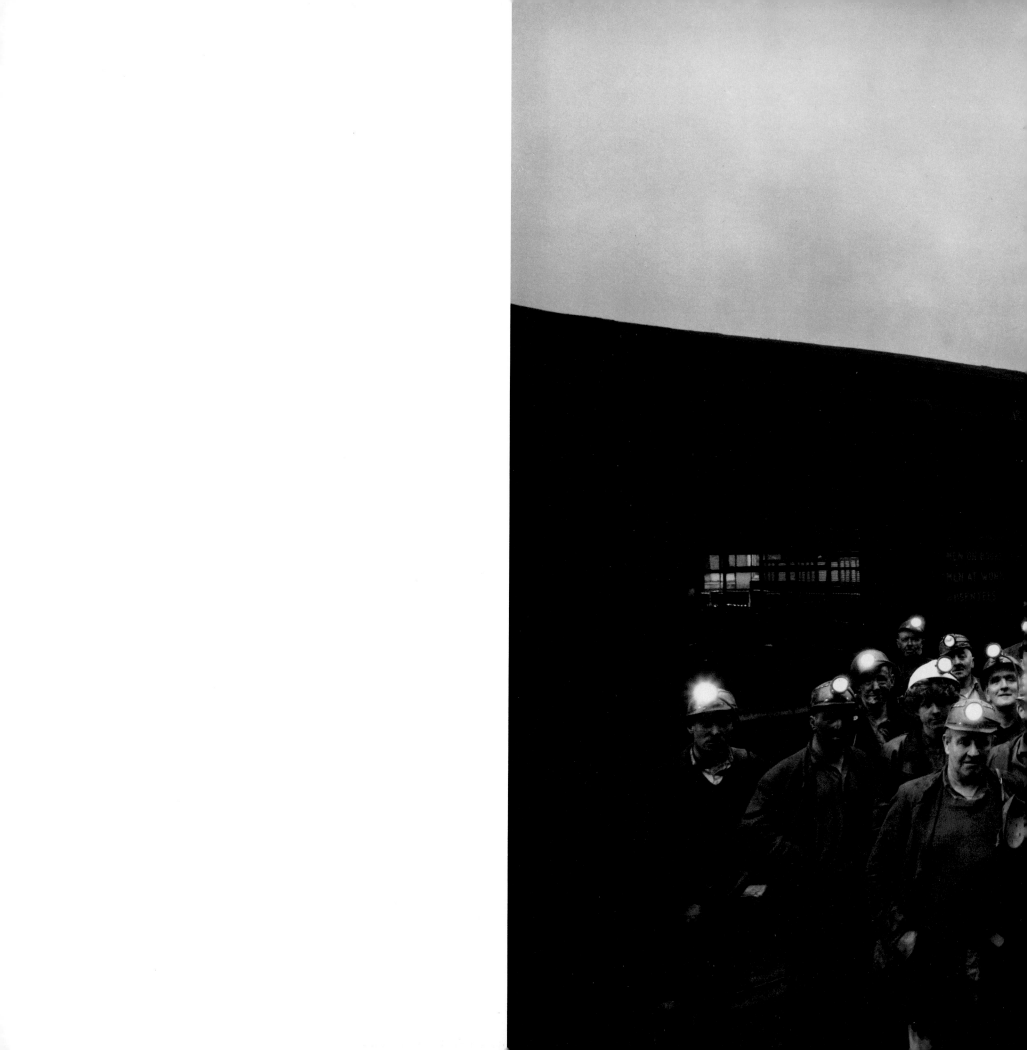

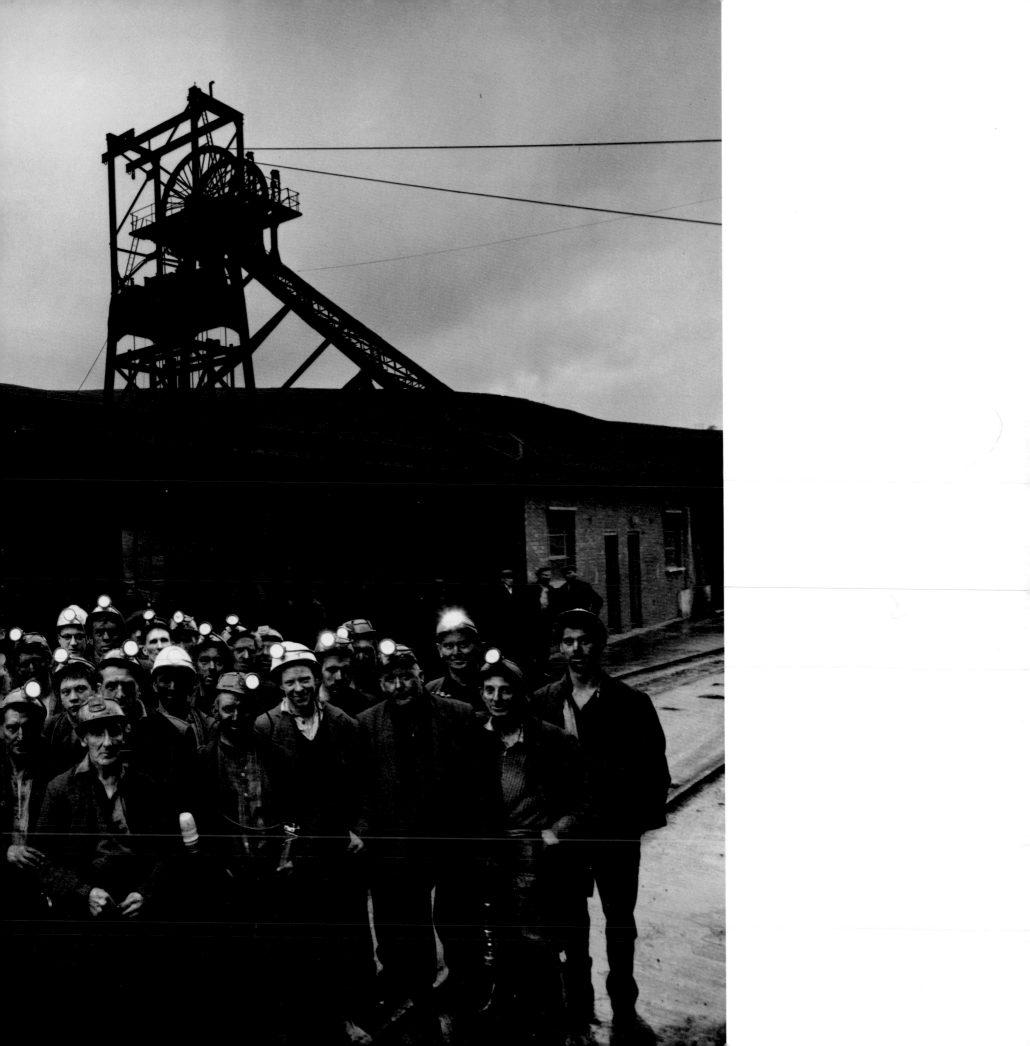

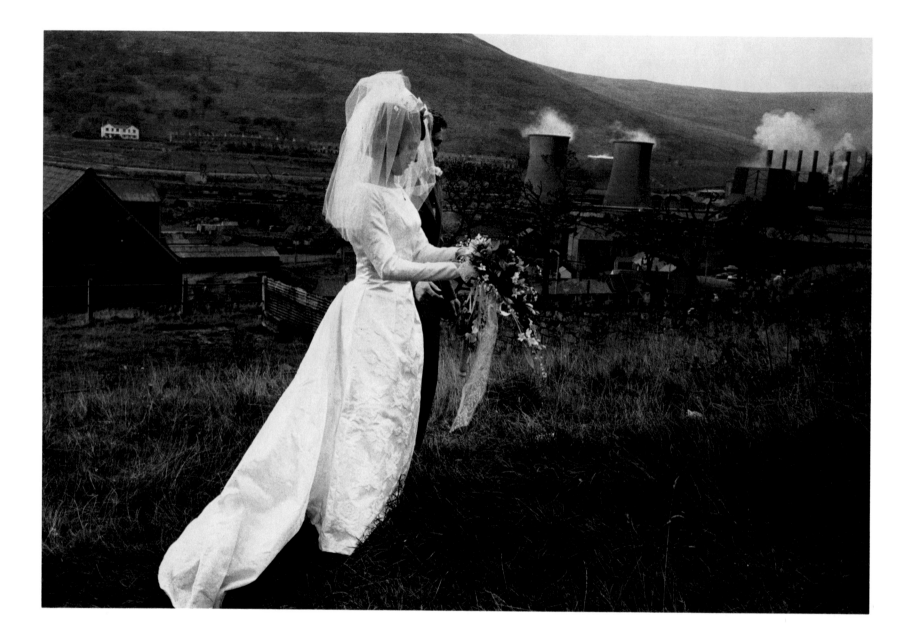

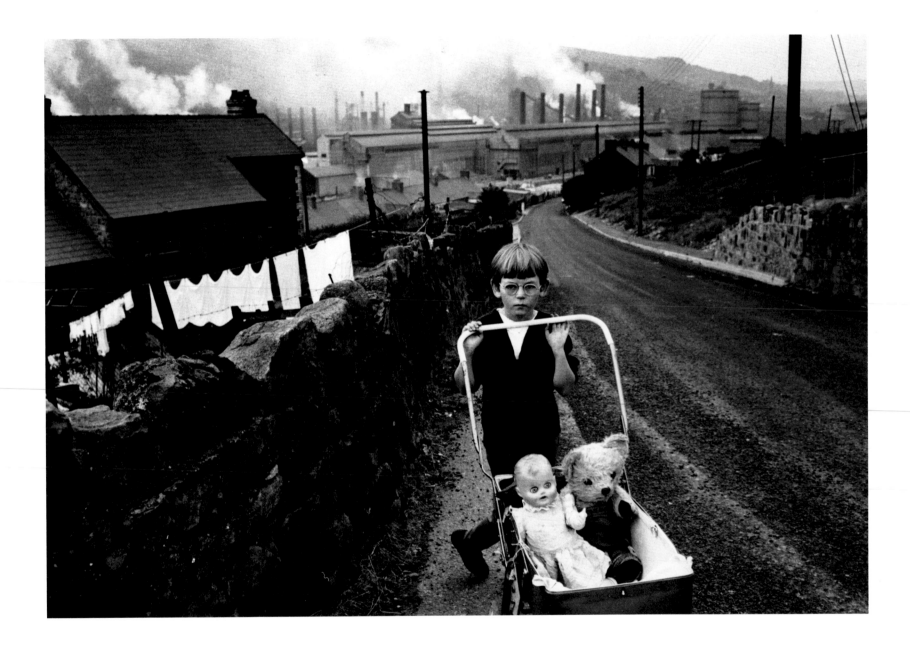

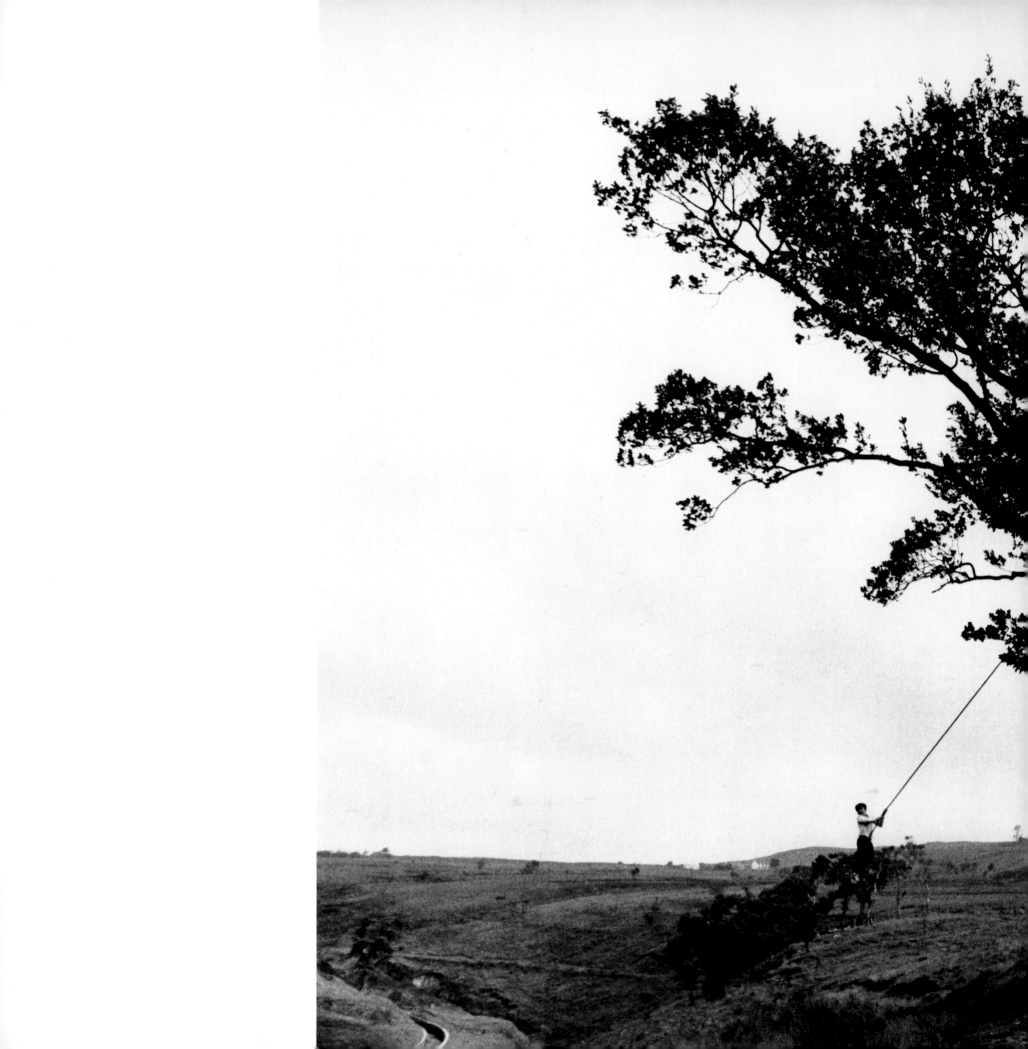

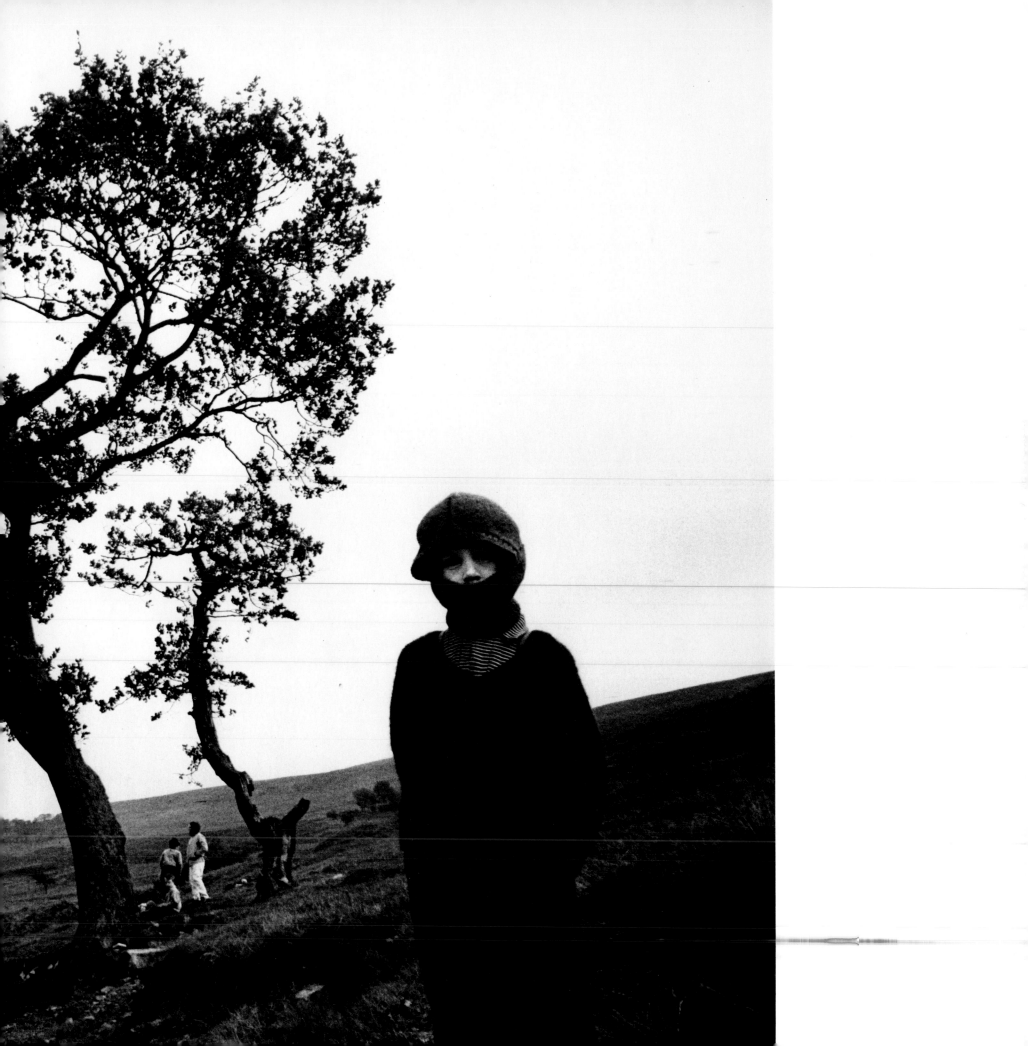

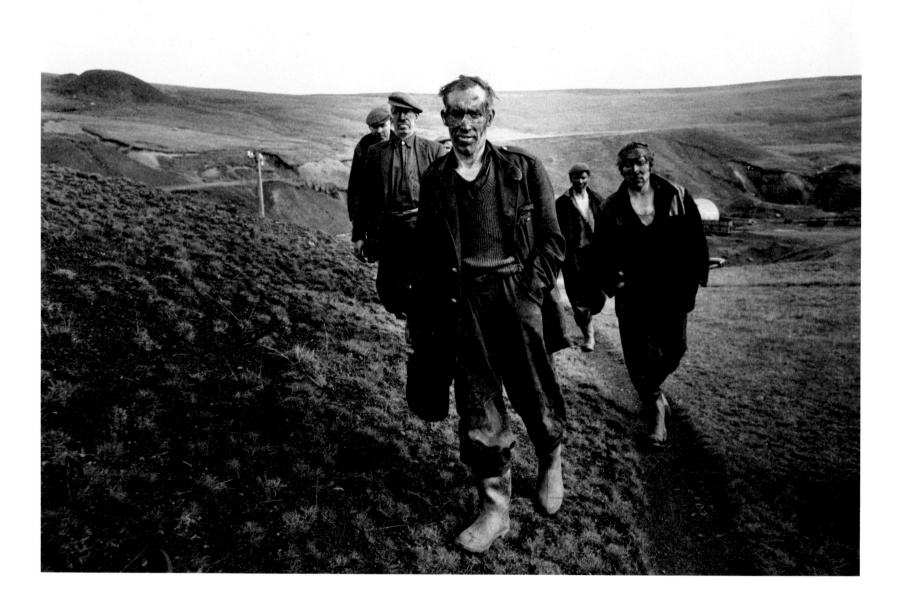

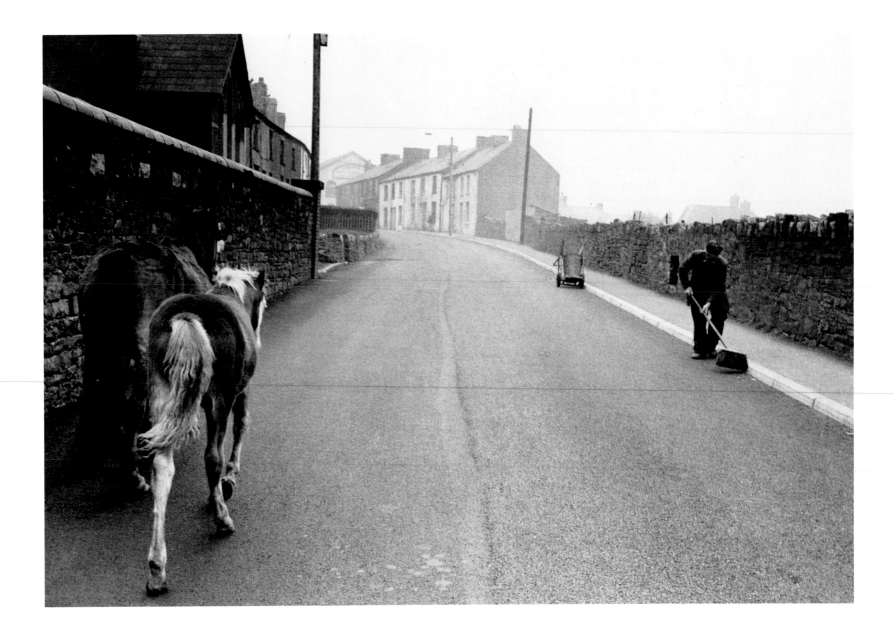

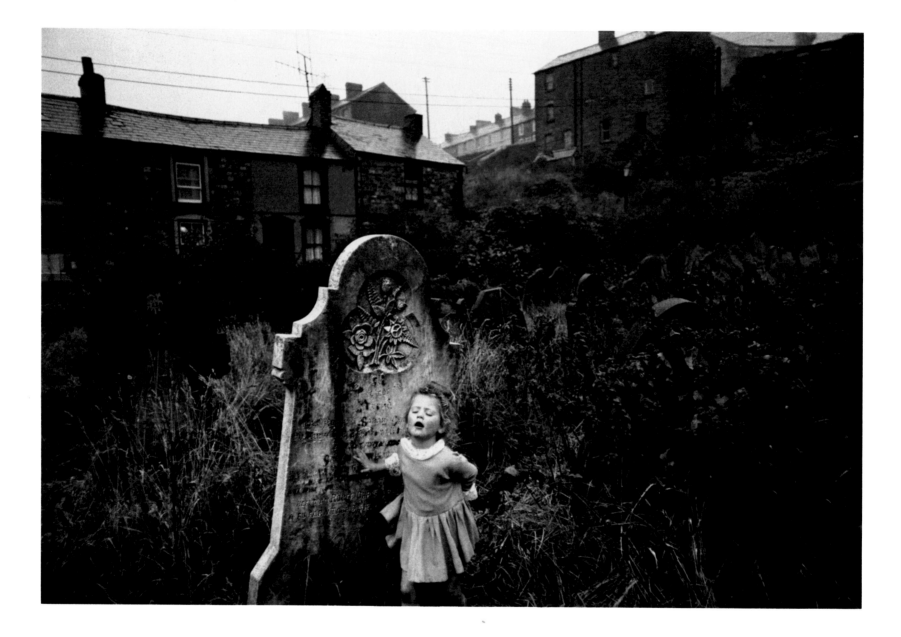

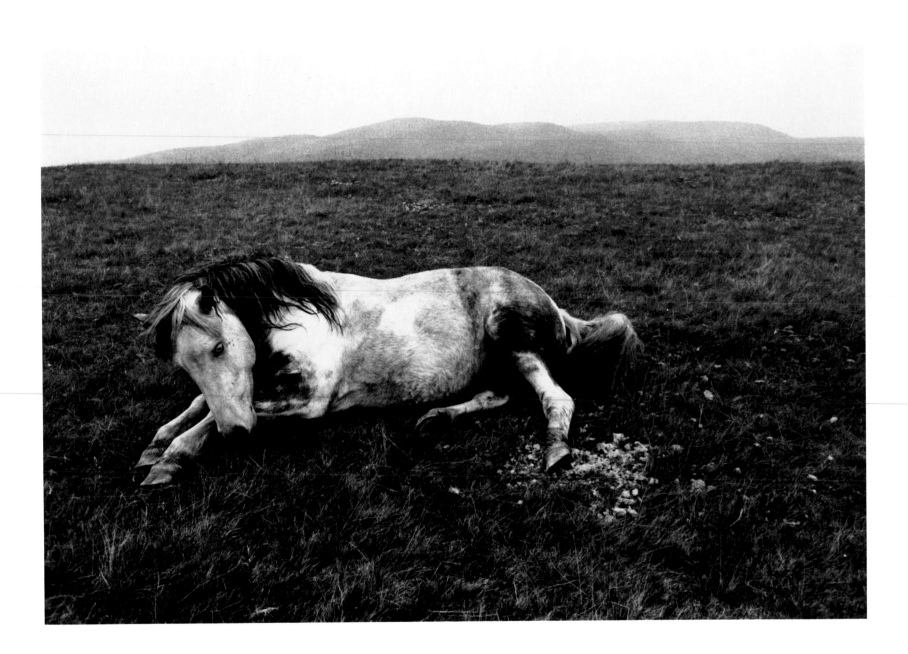

East 100th Street

1966 — 1968

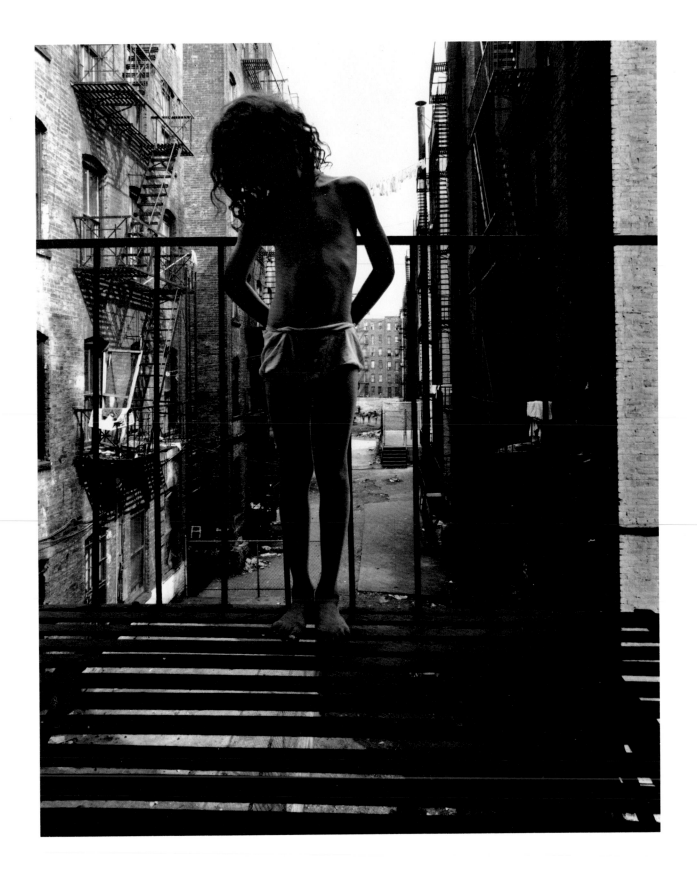

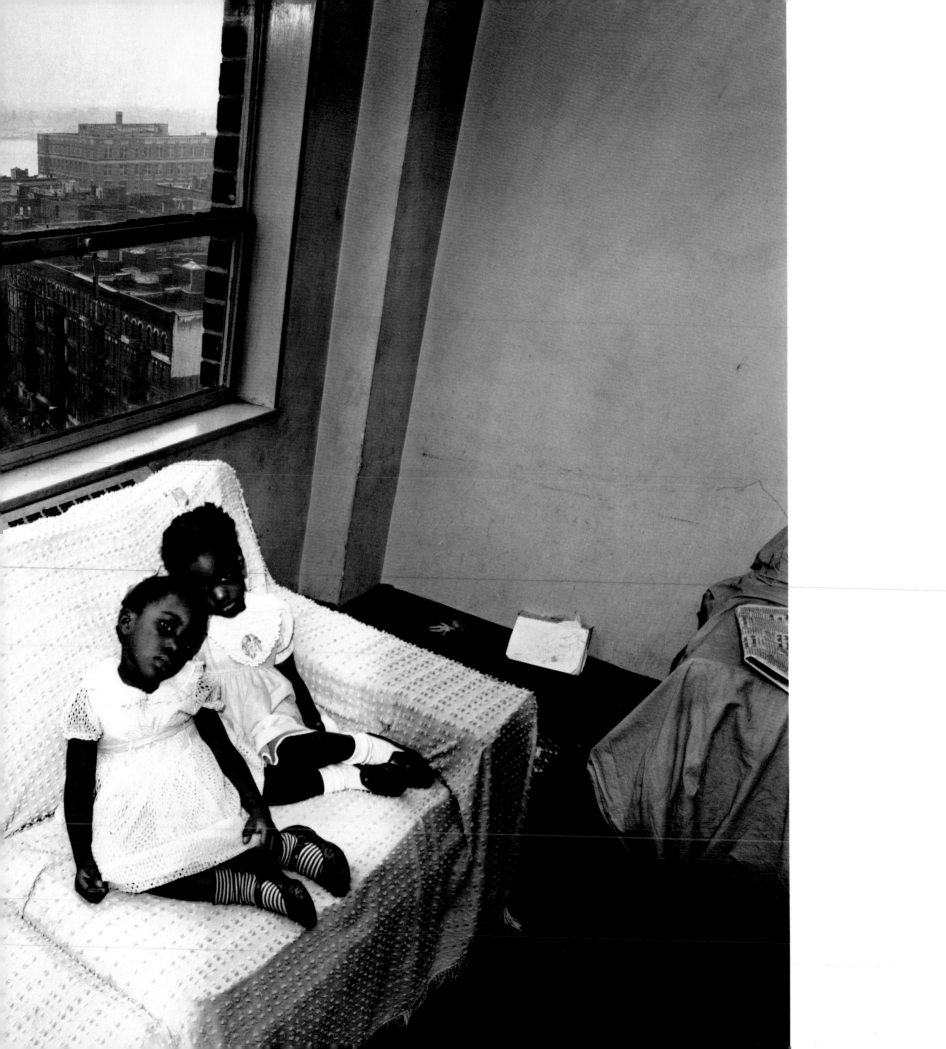

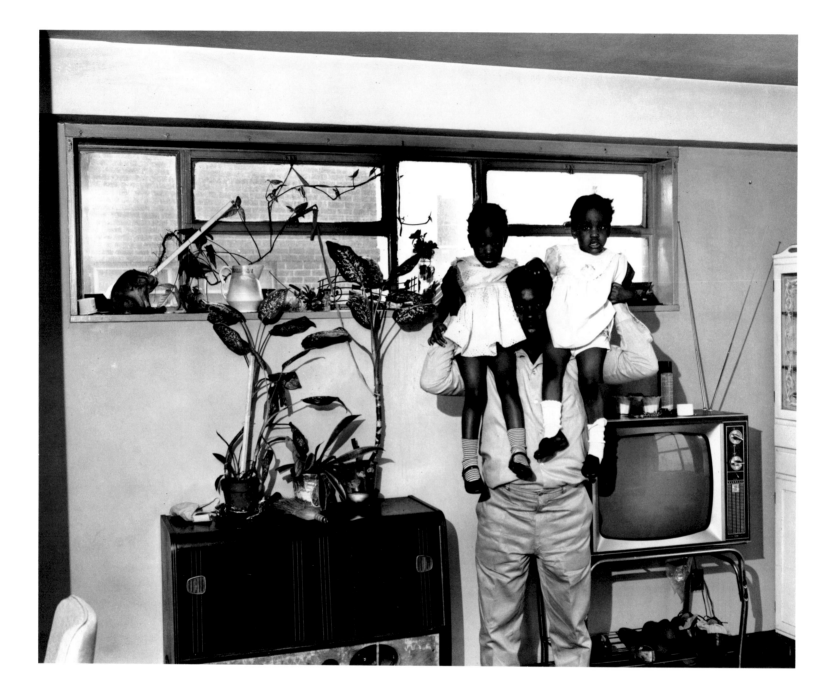

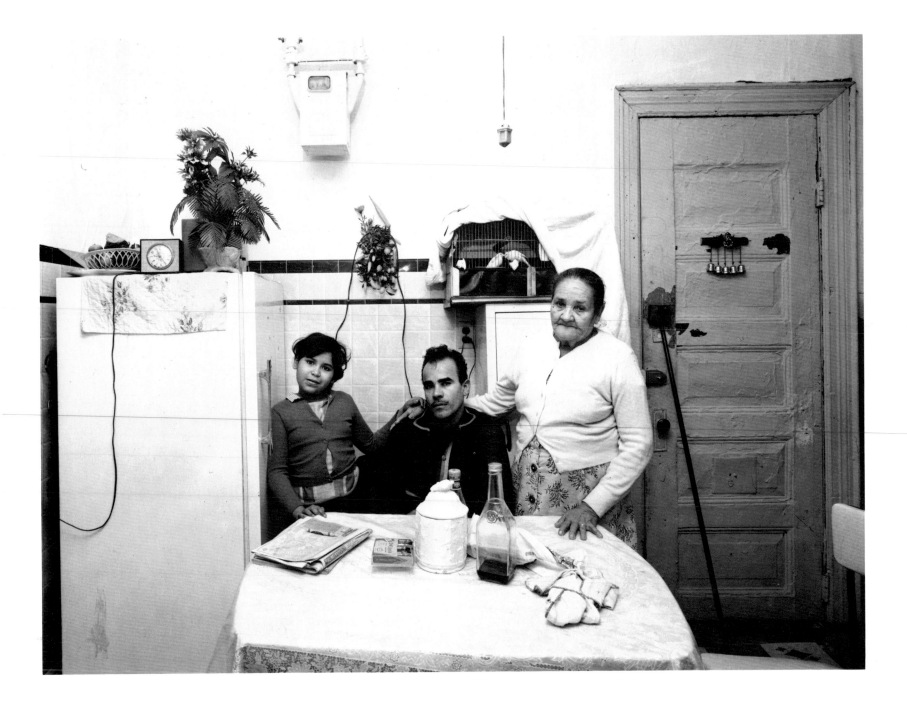

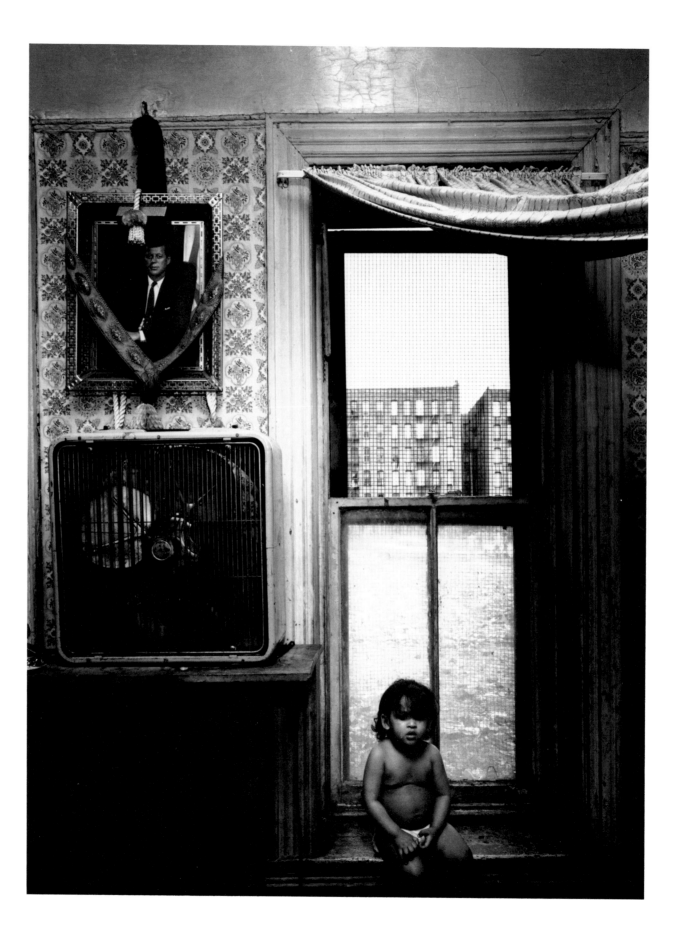

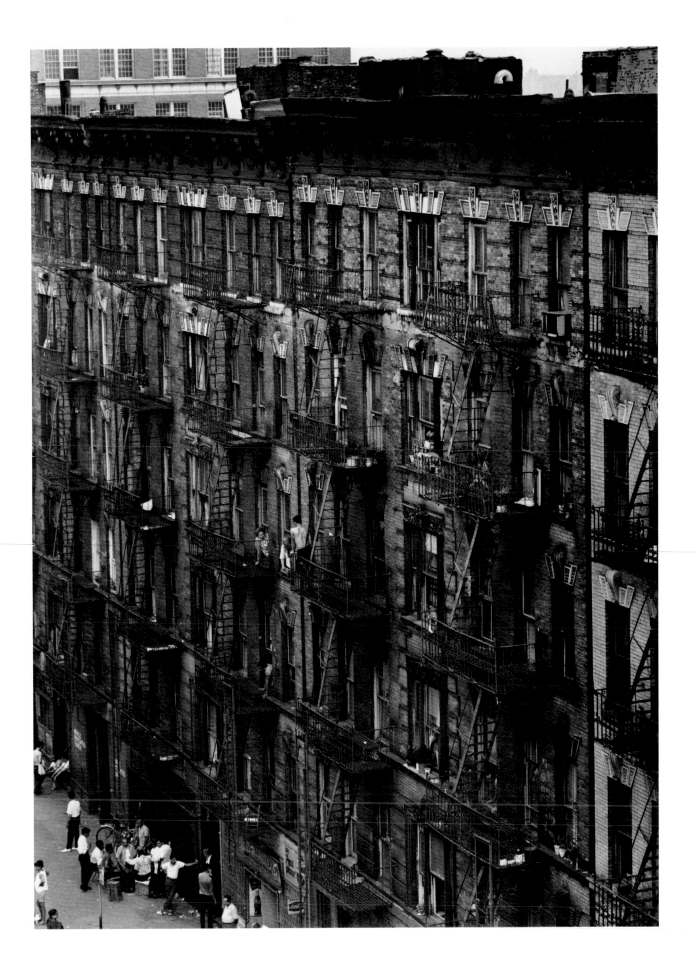

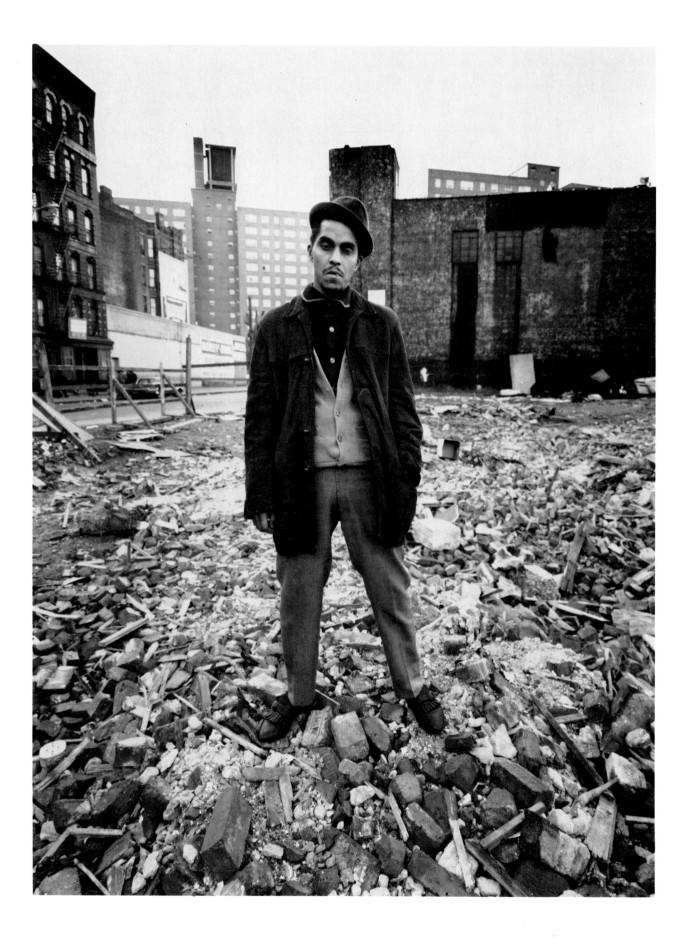

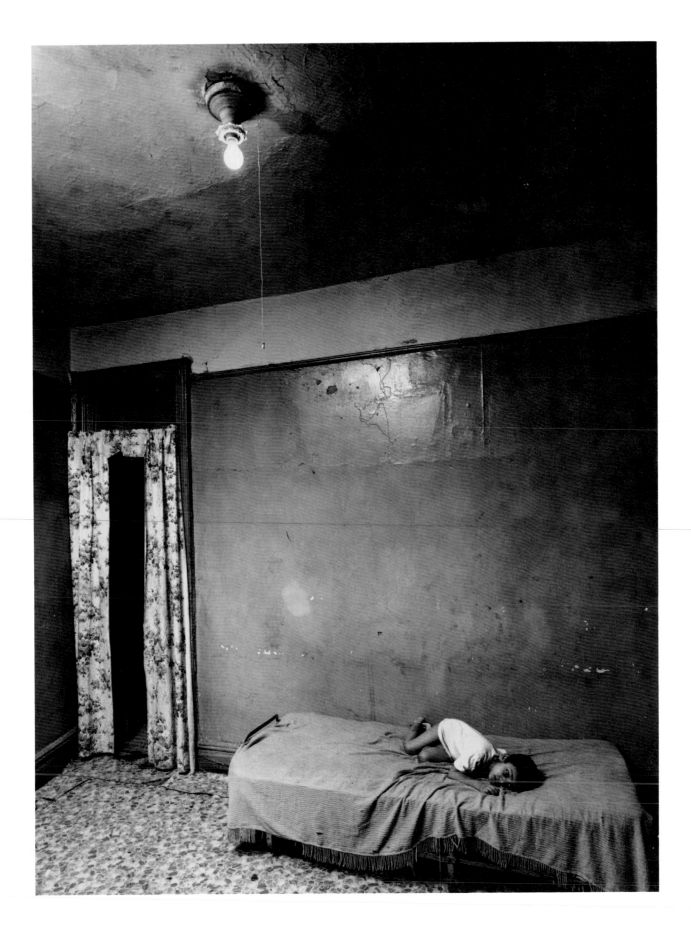

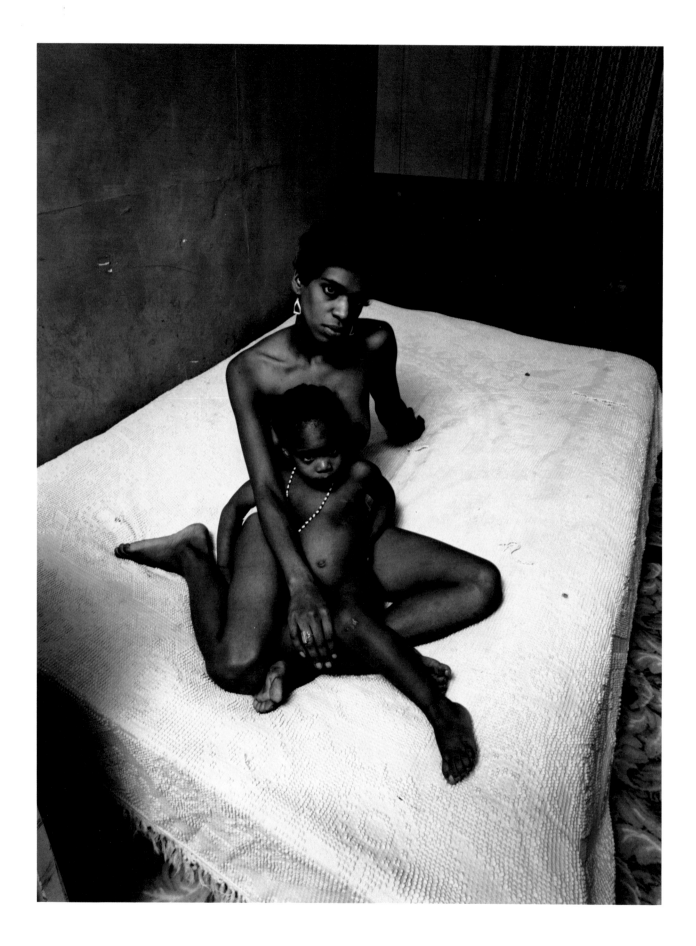

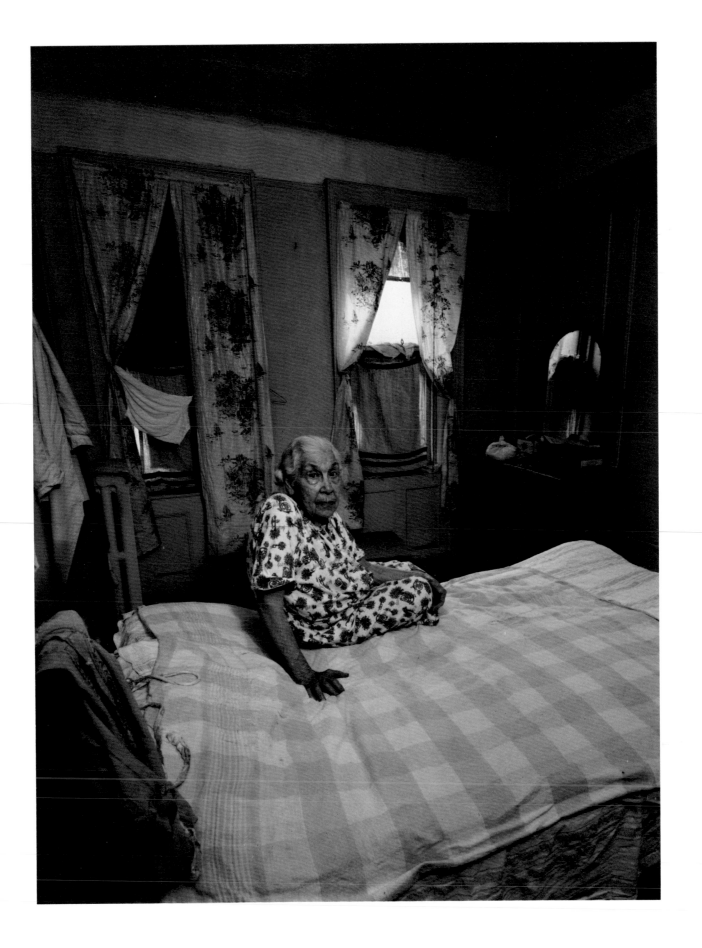

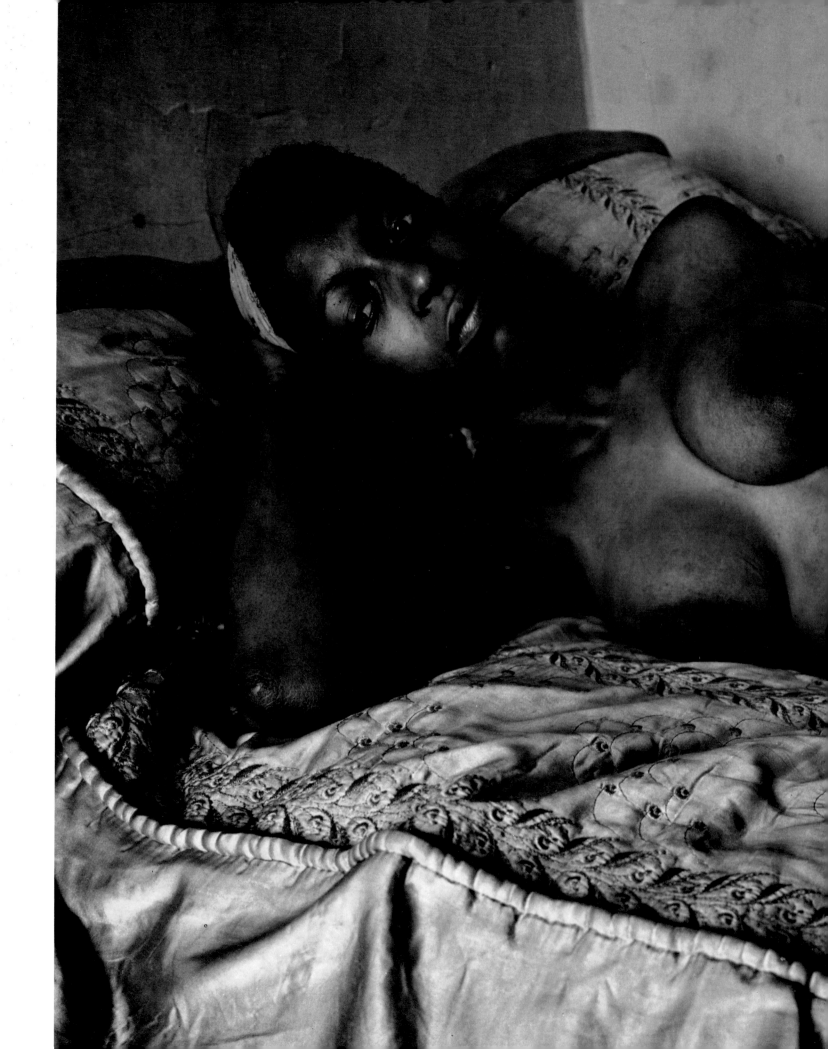

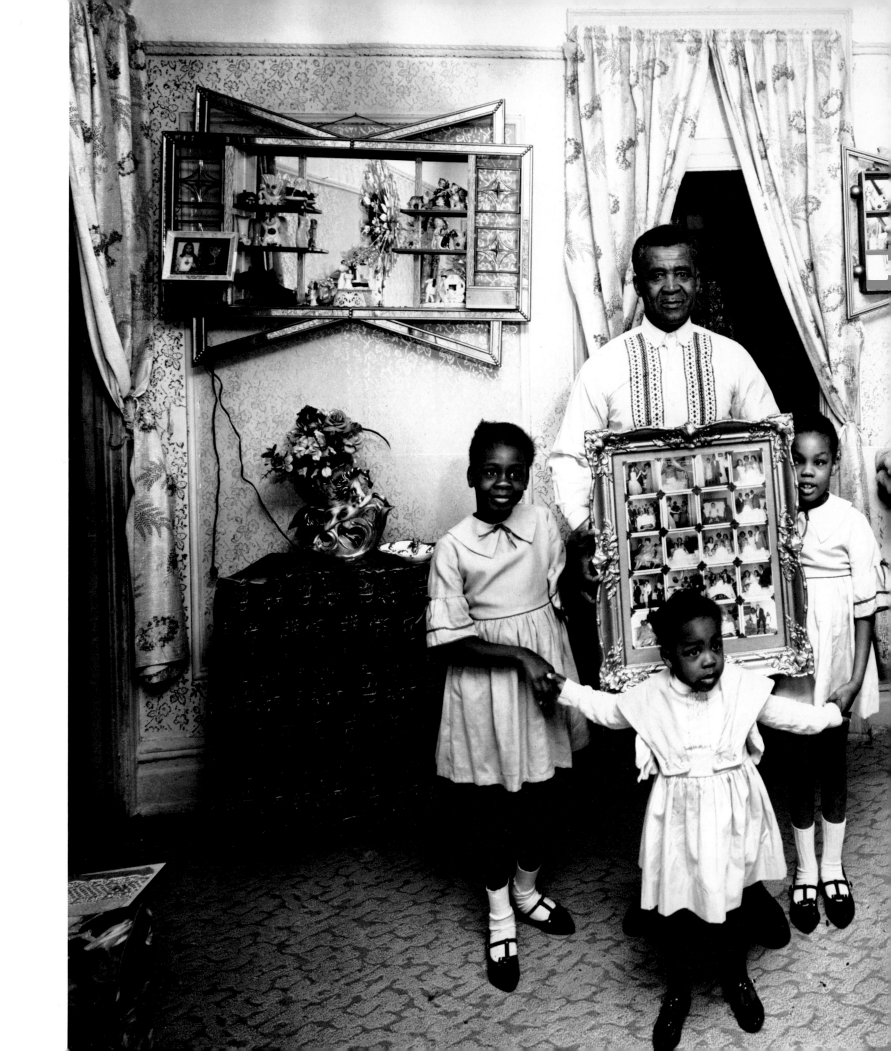

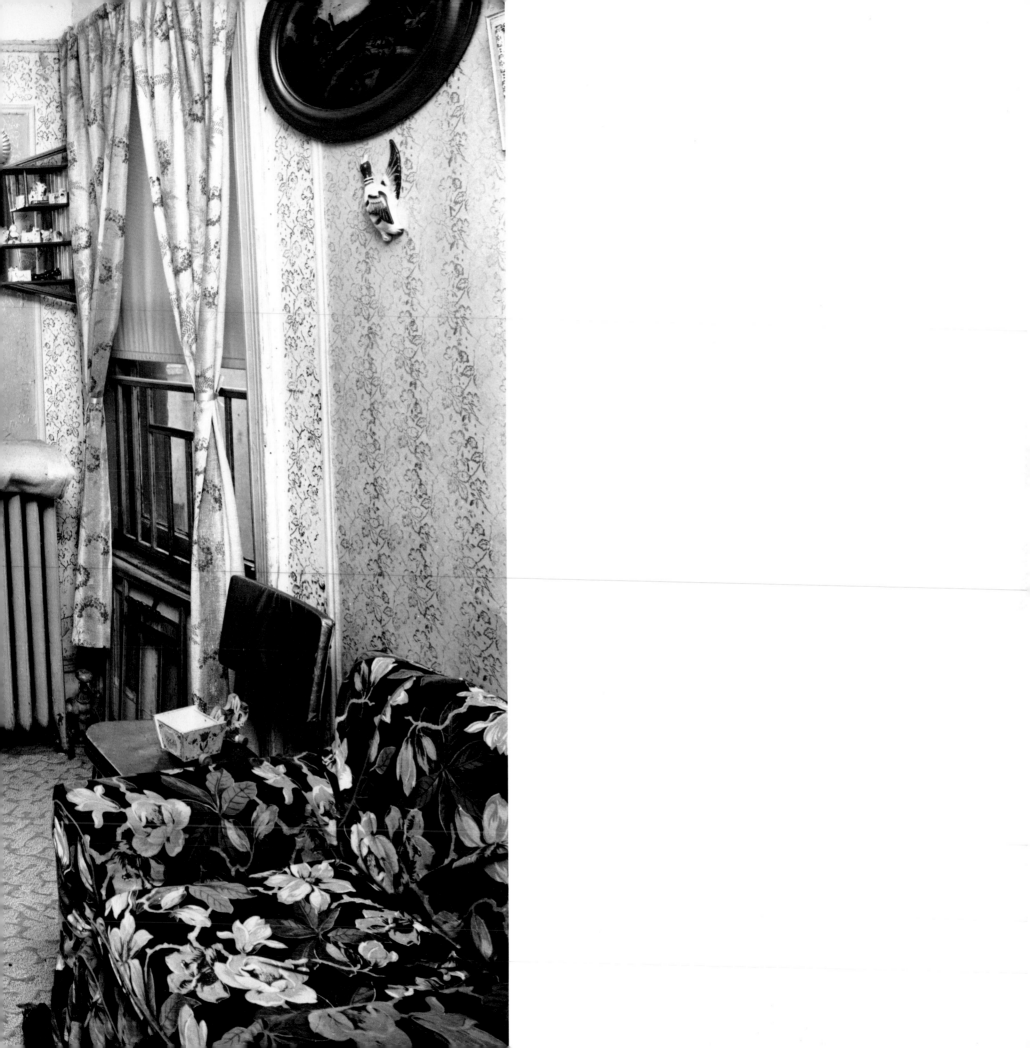

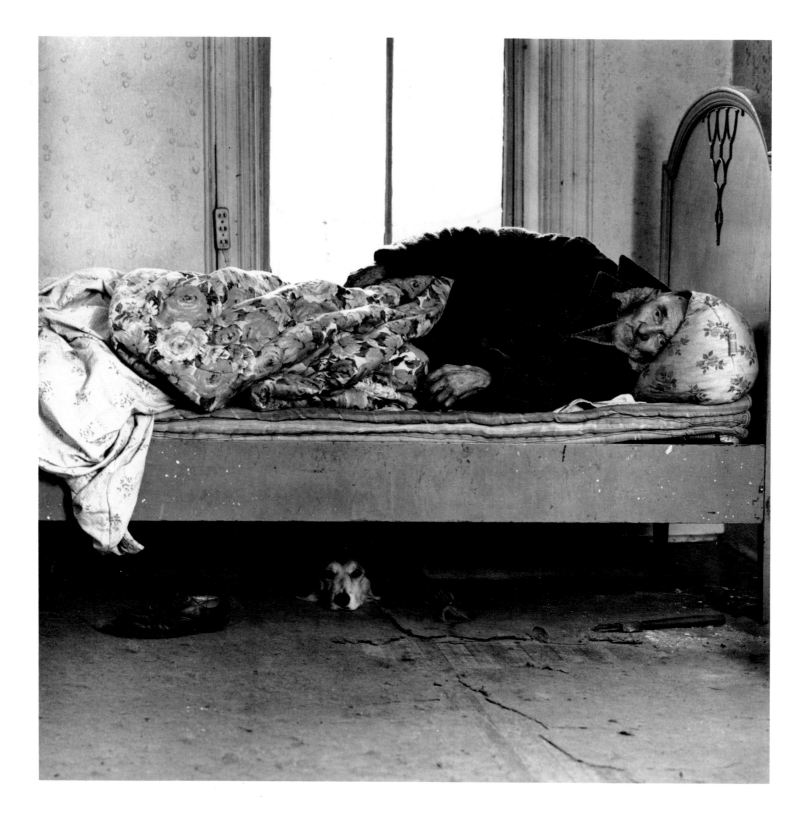

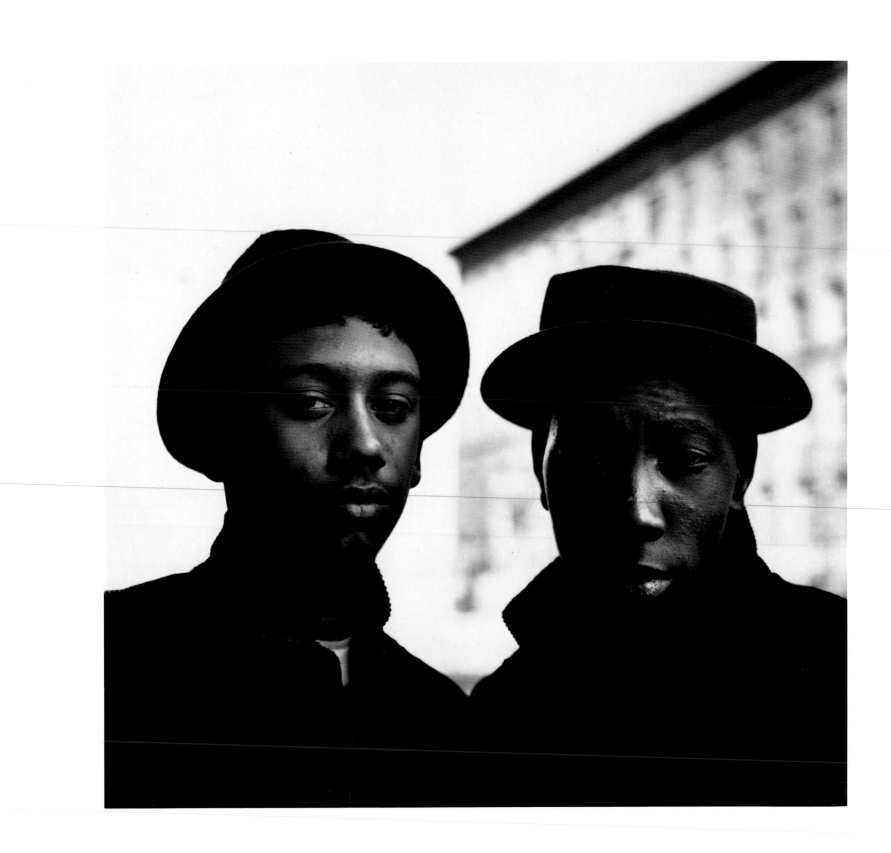

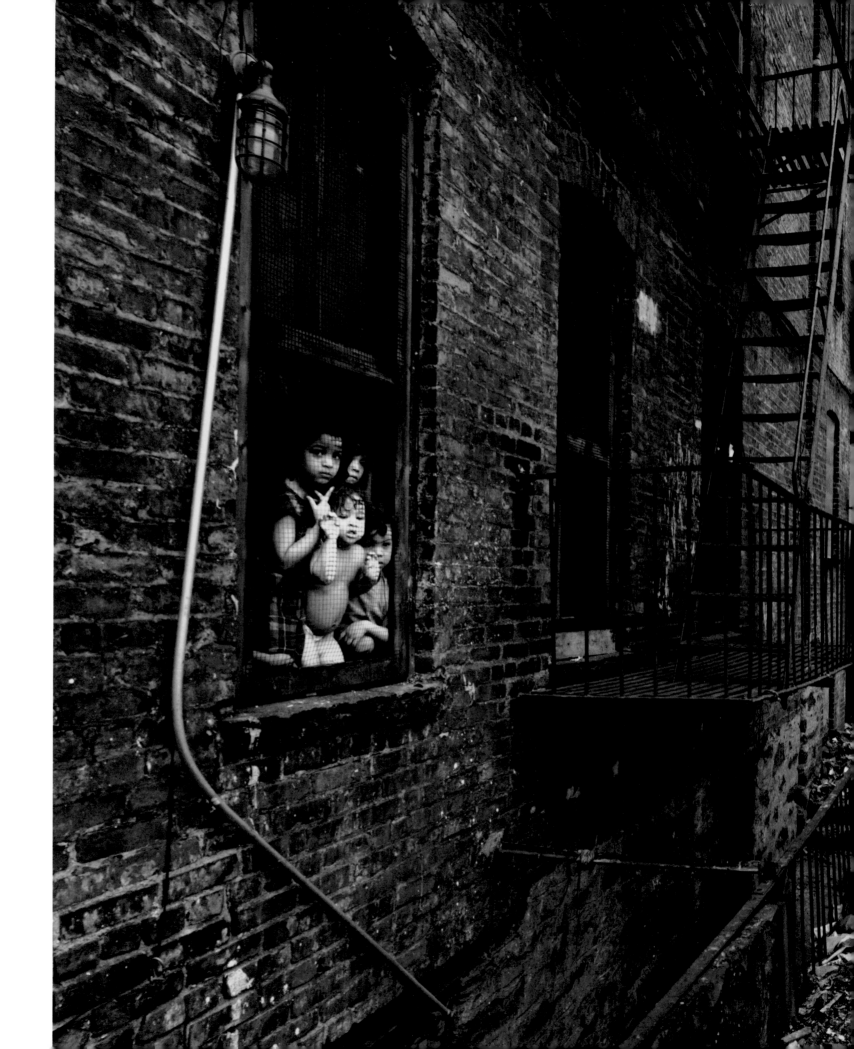

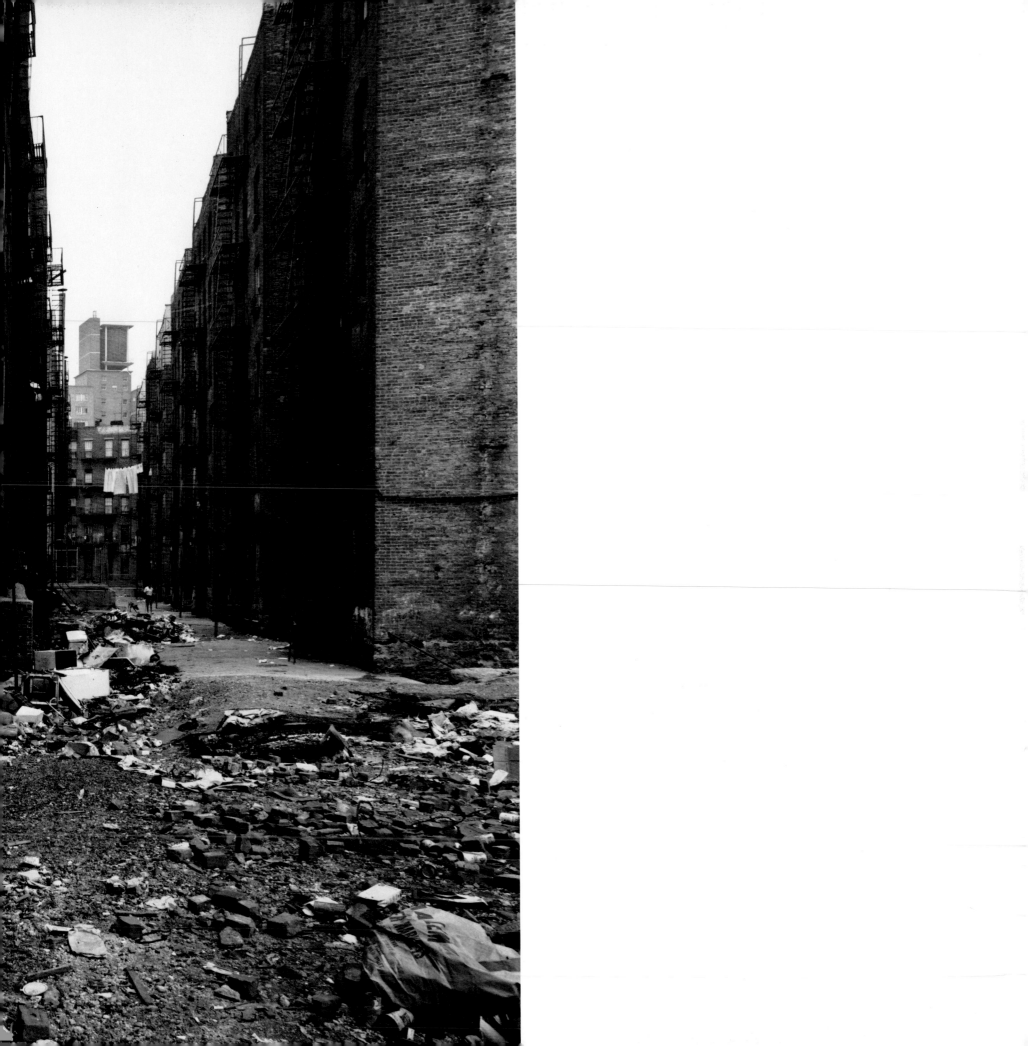

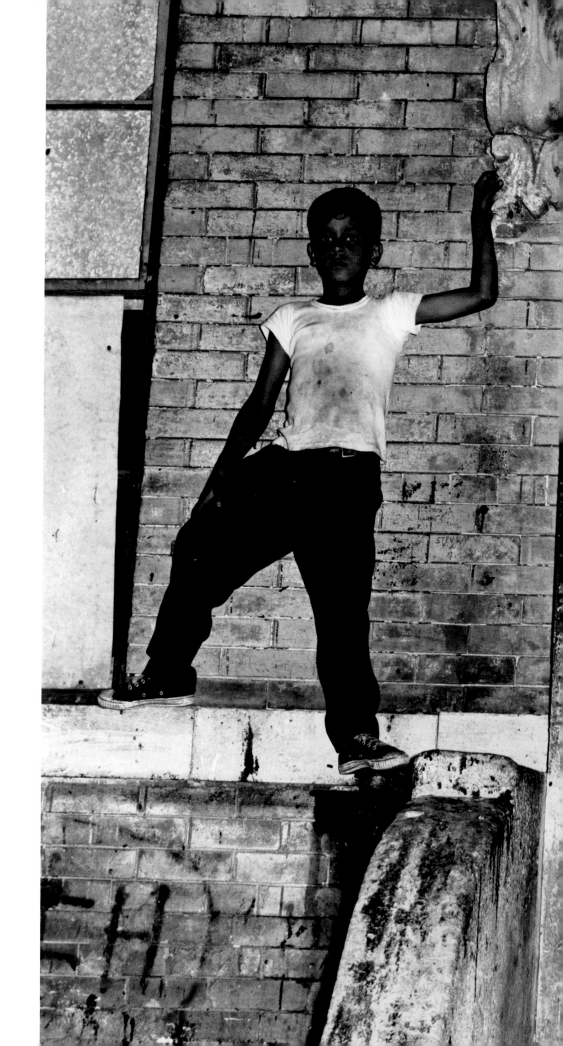

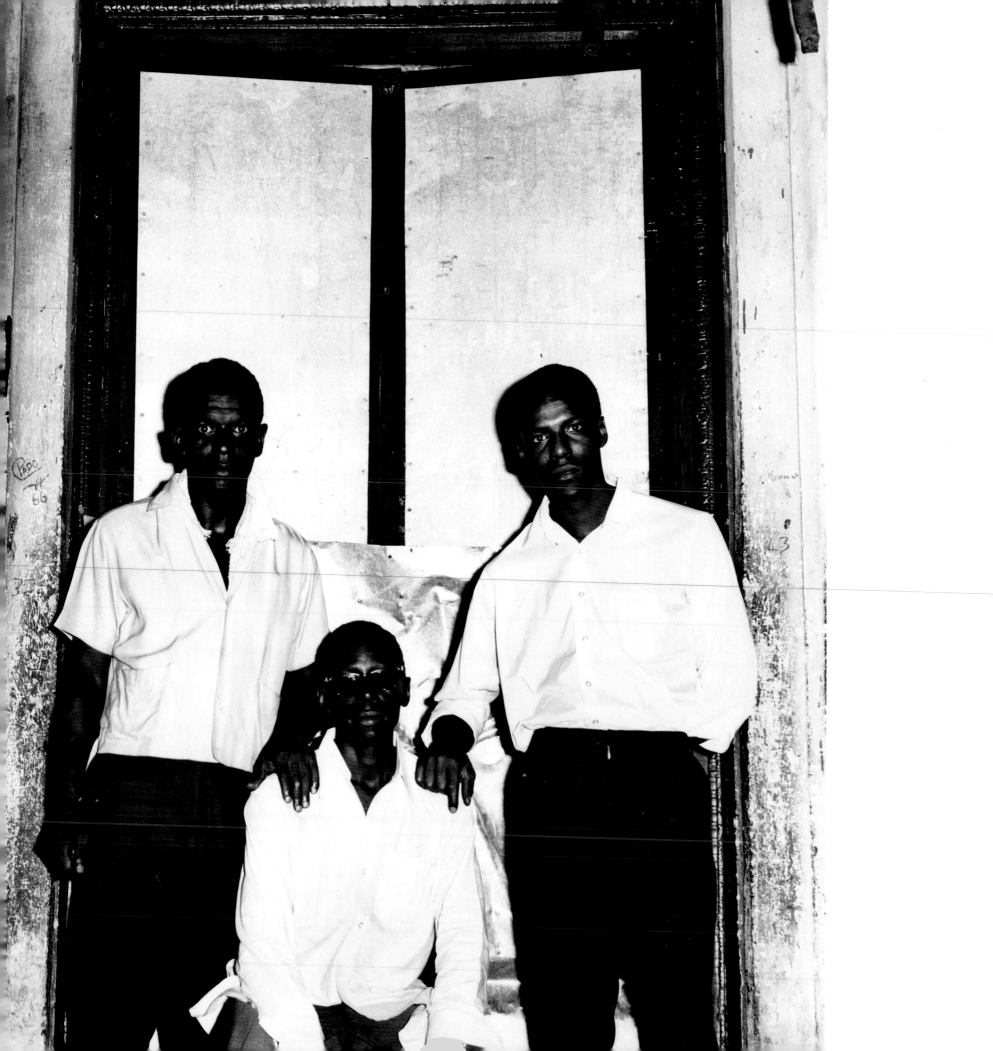

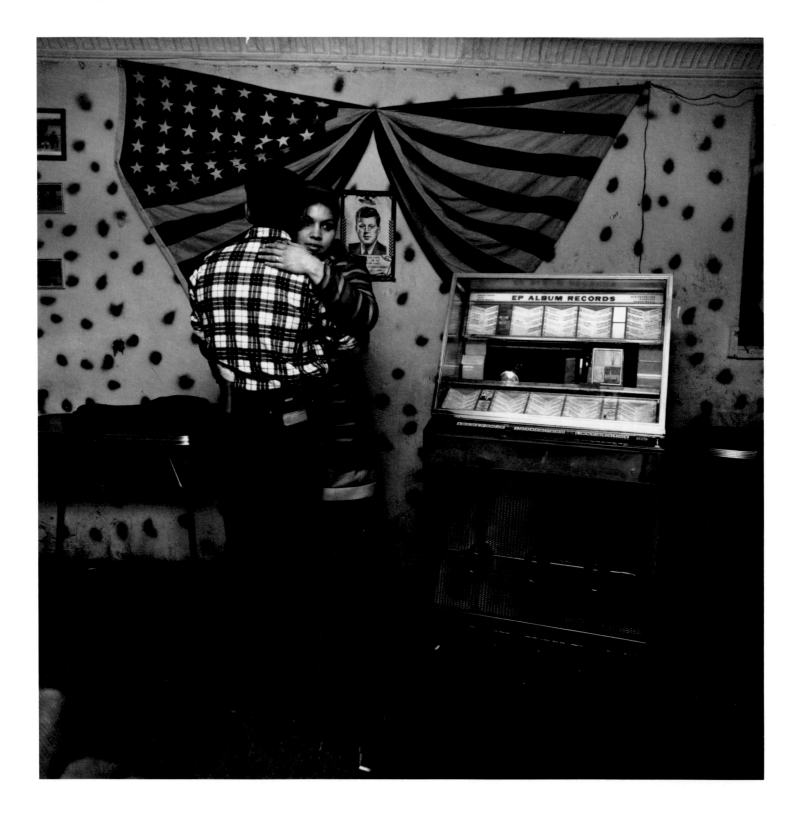

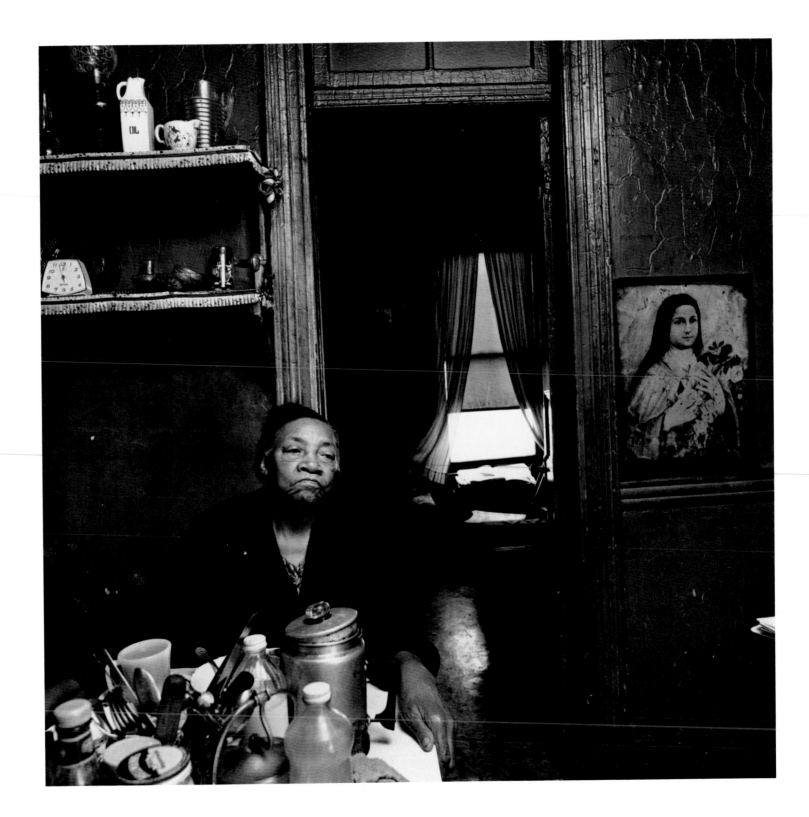

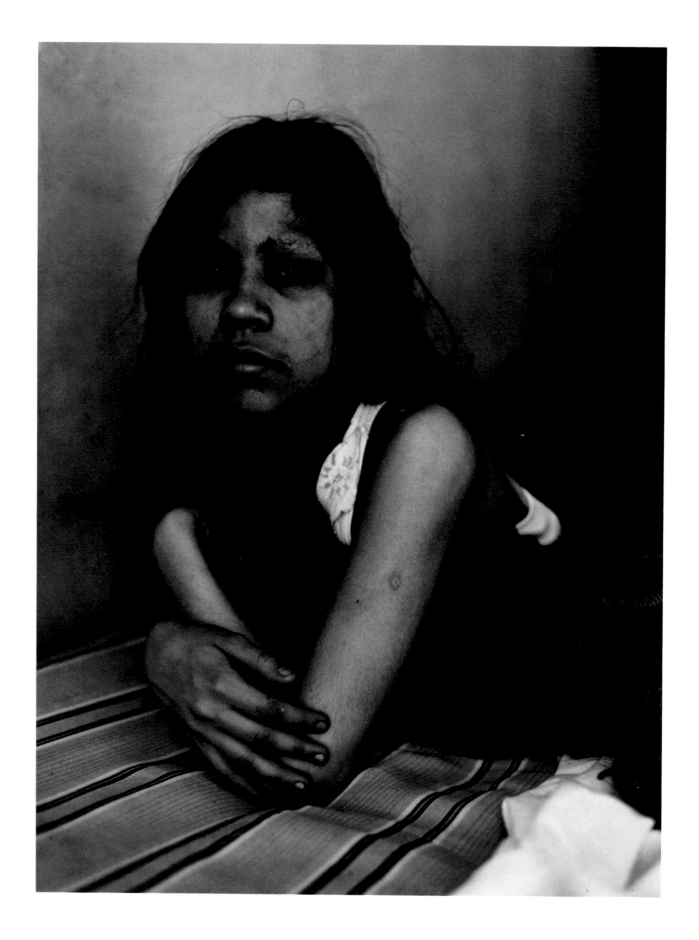

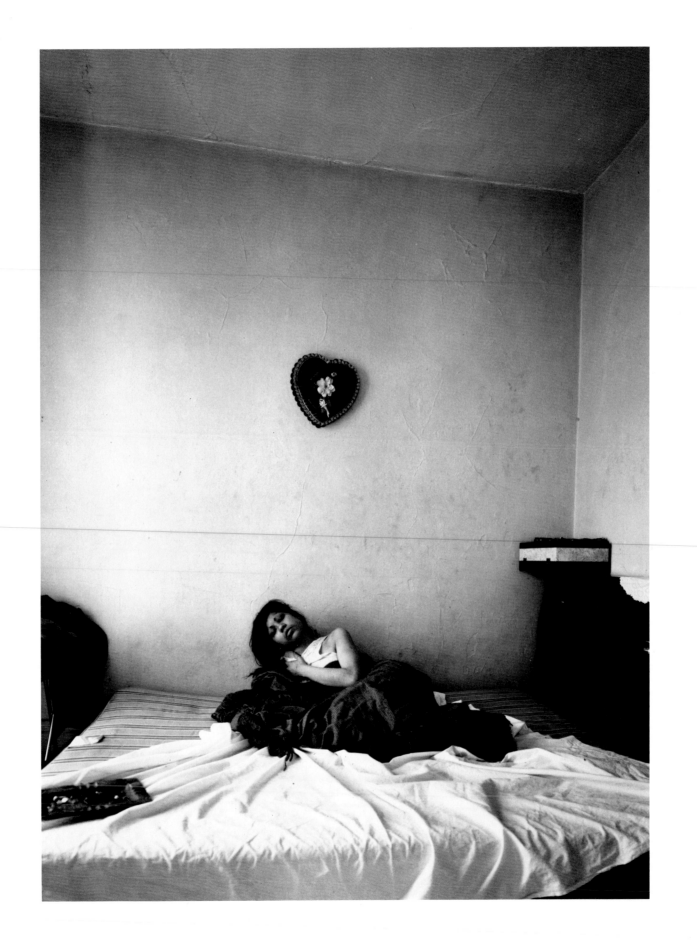

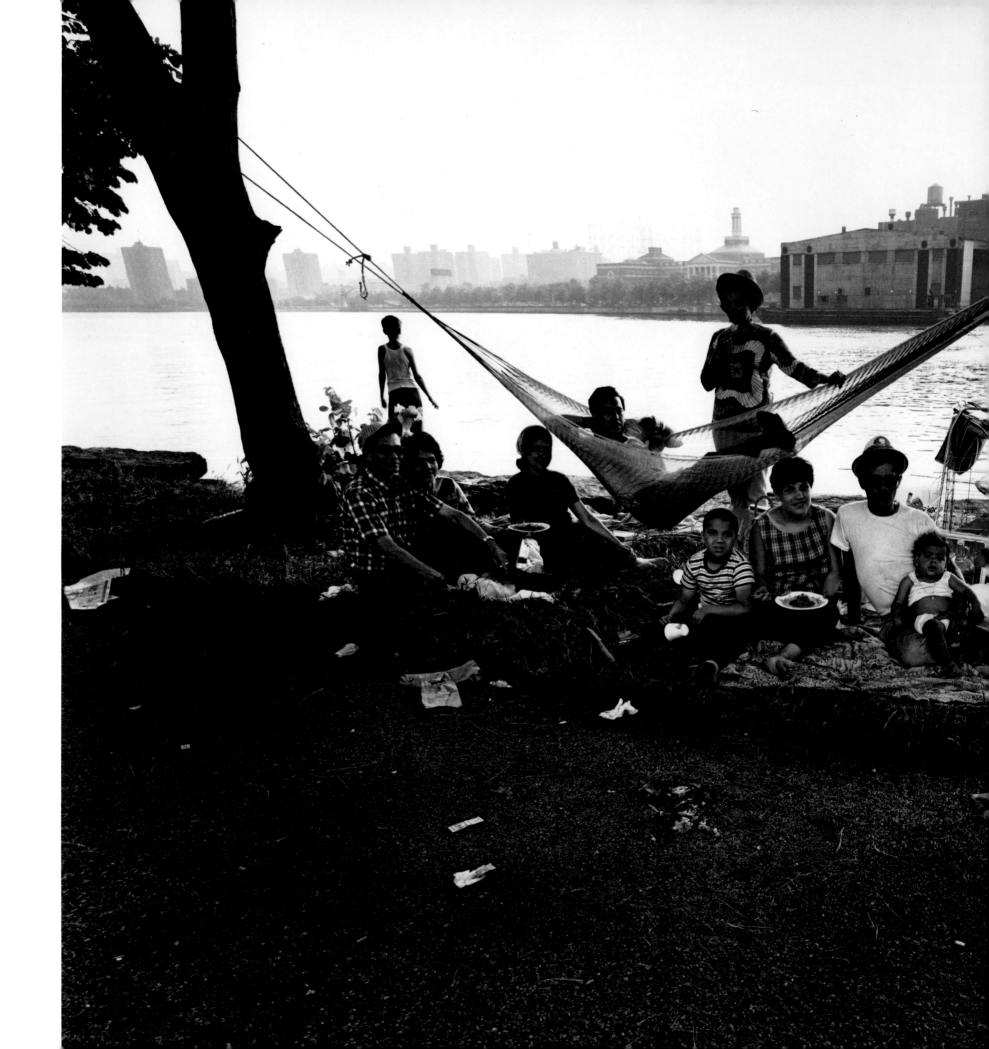

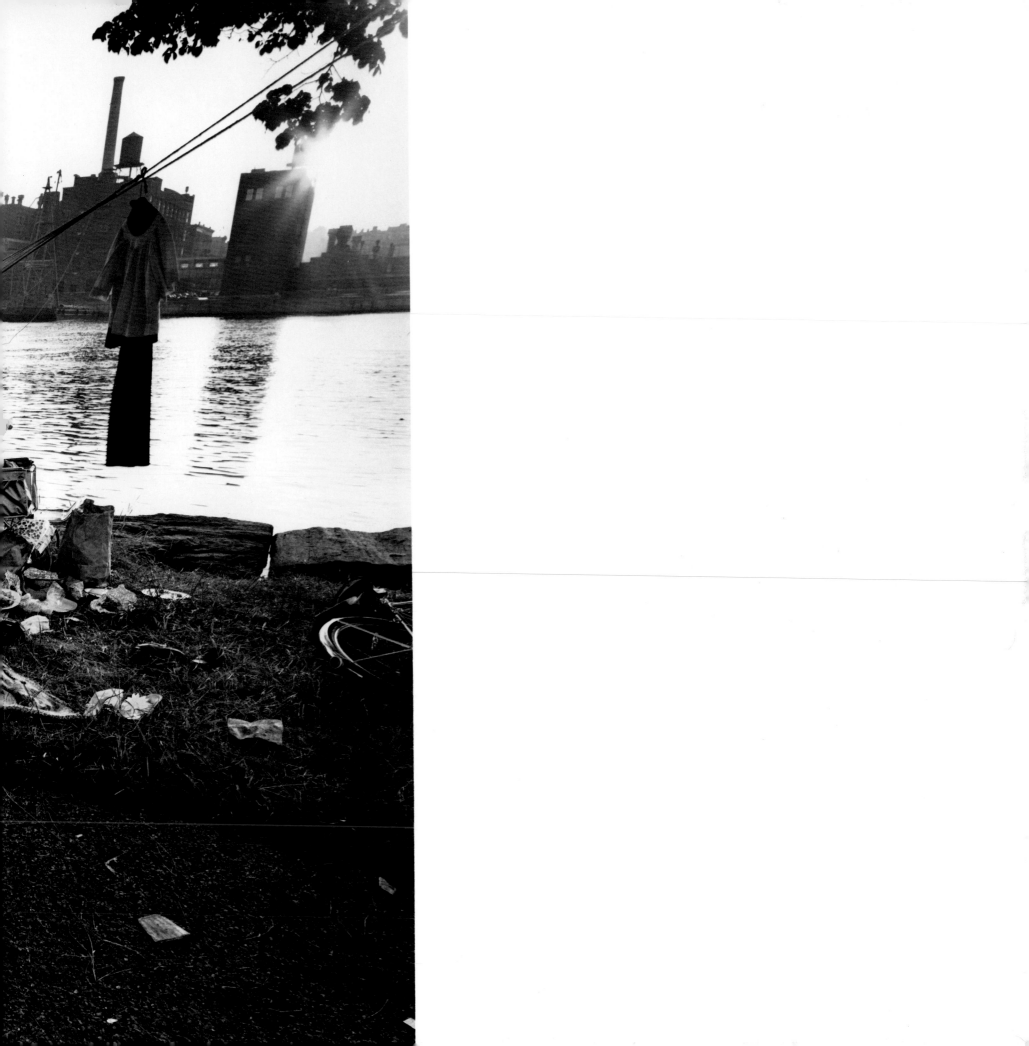

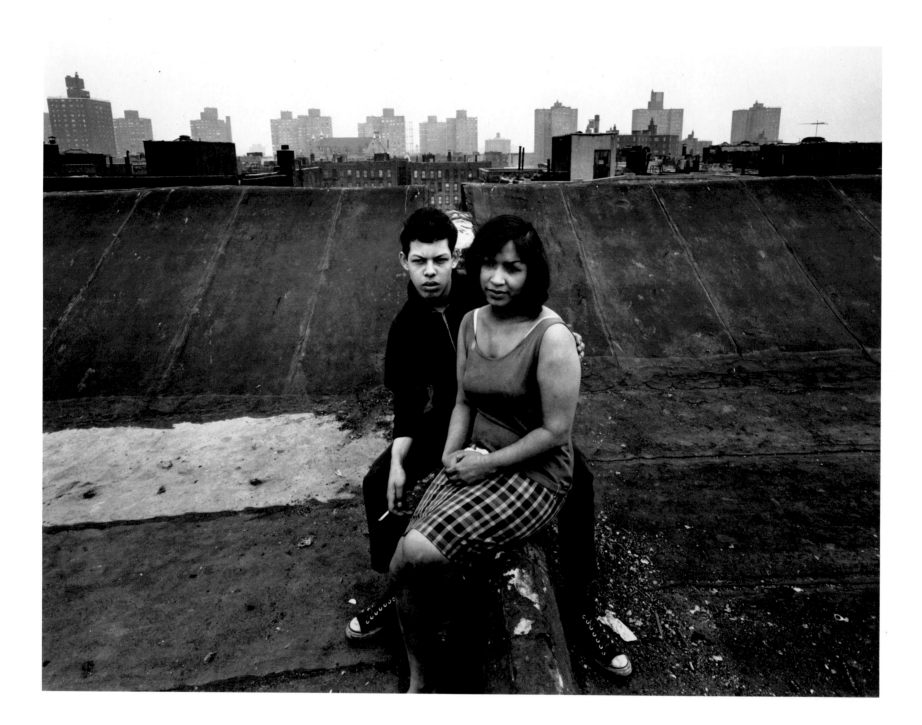

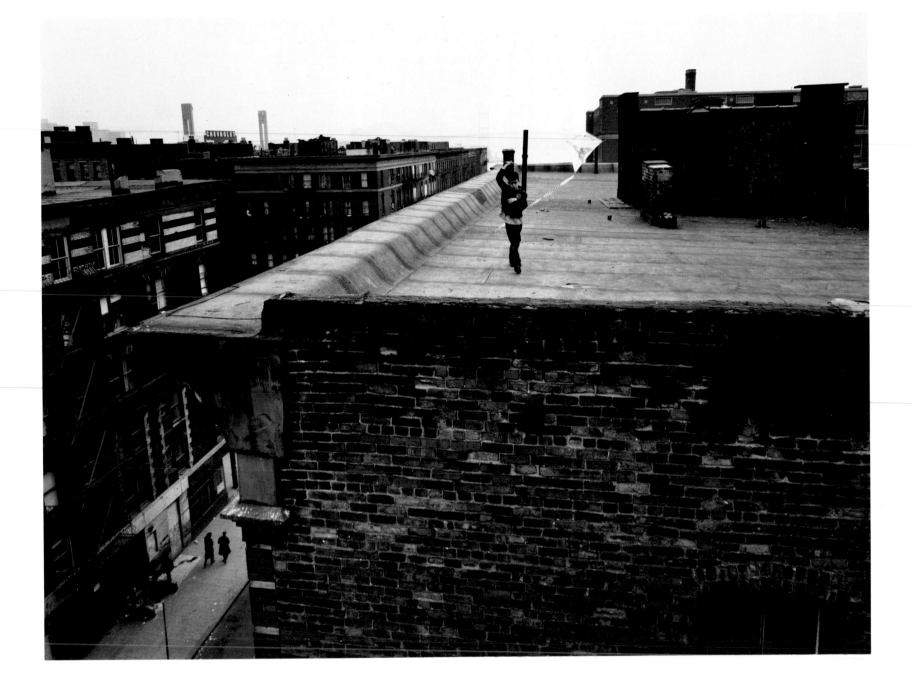

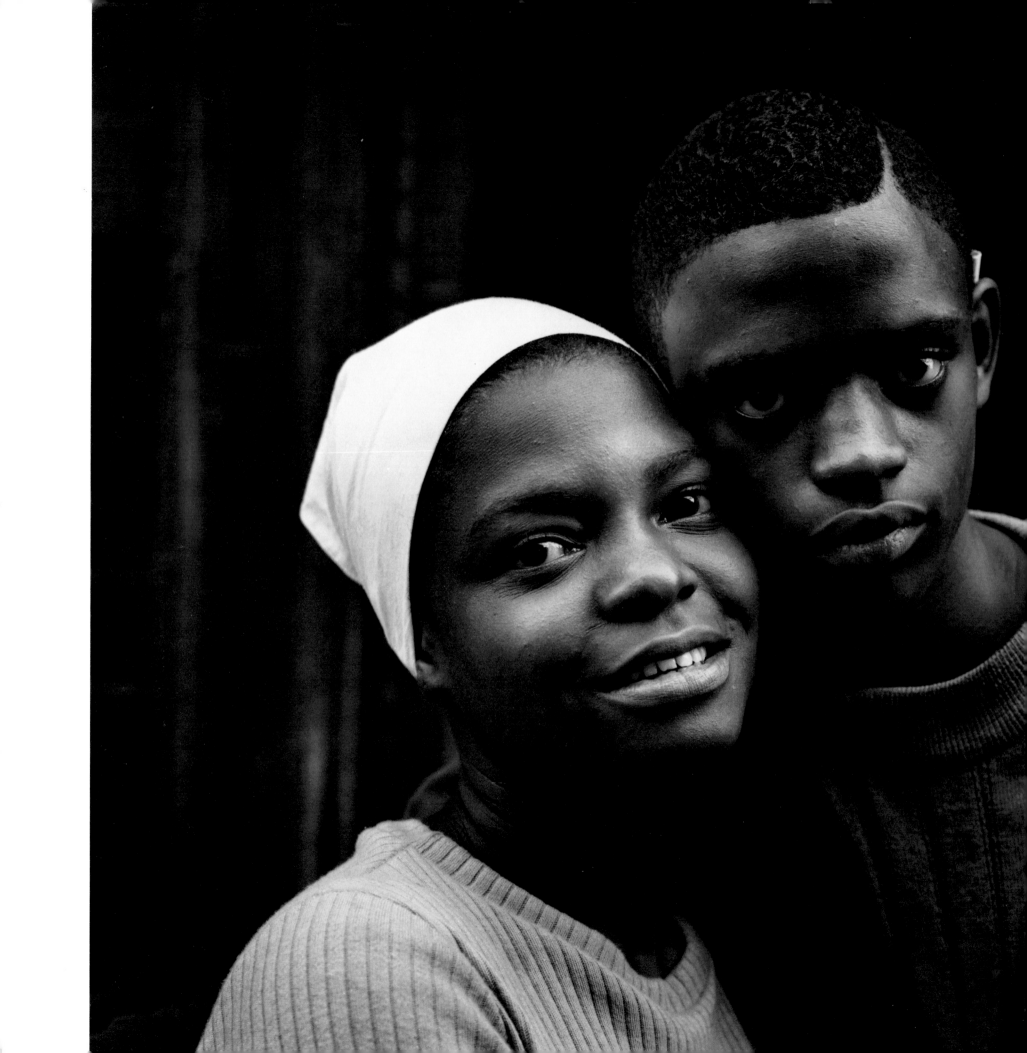

The Cafeteria

1976

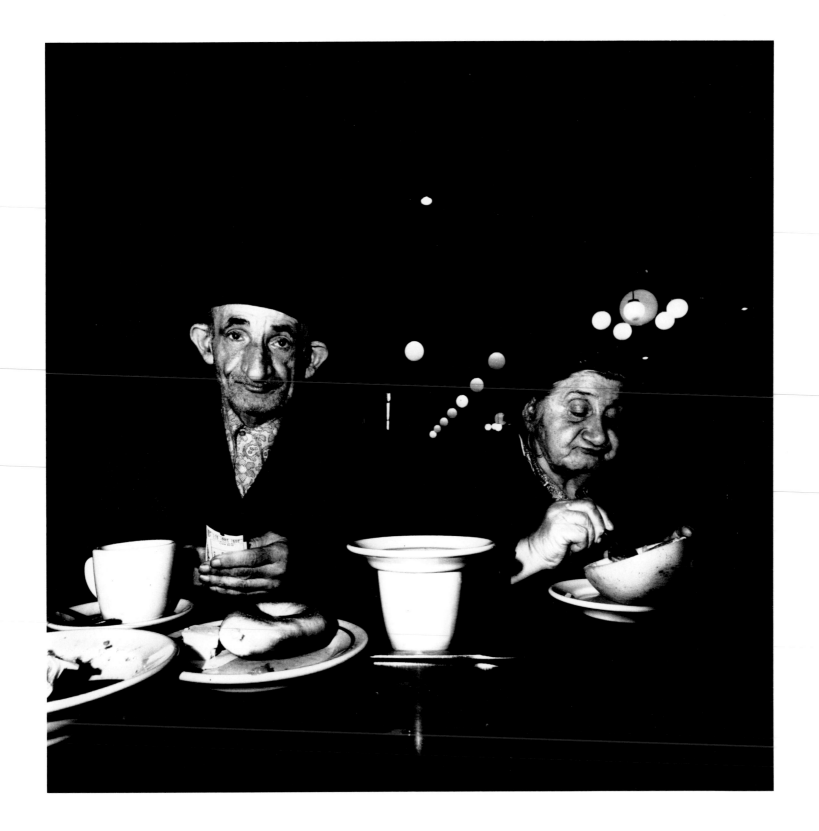

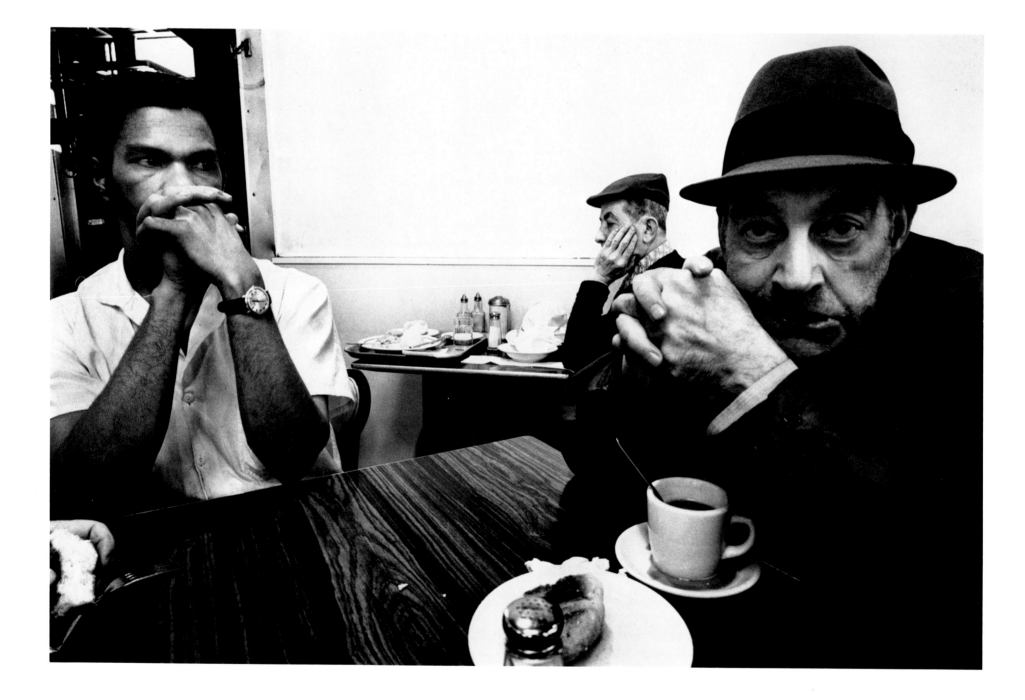

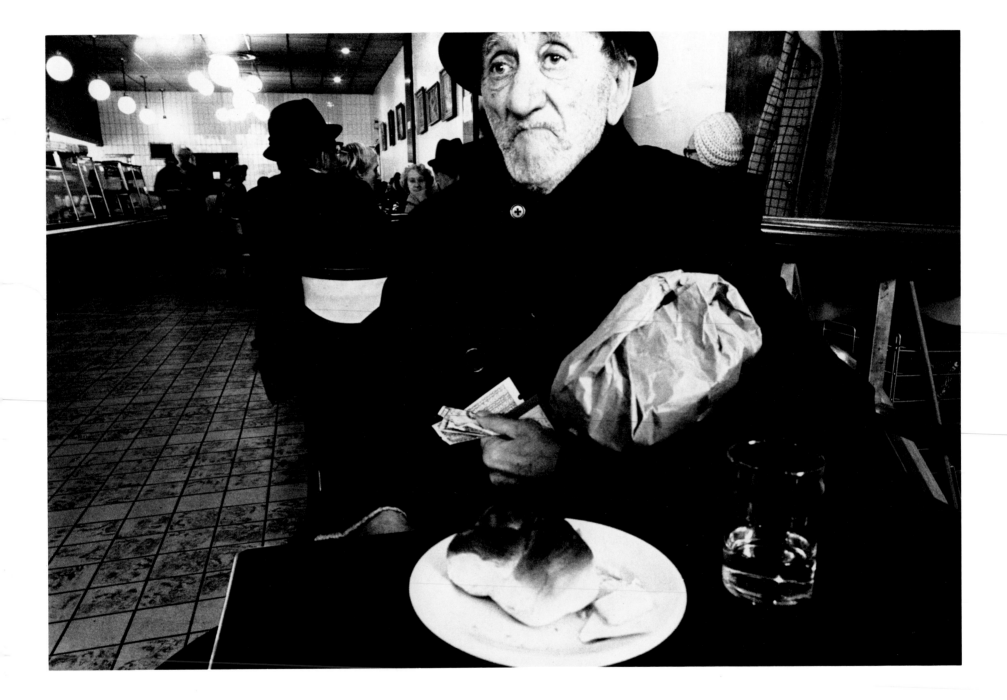

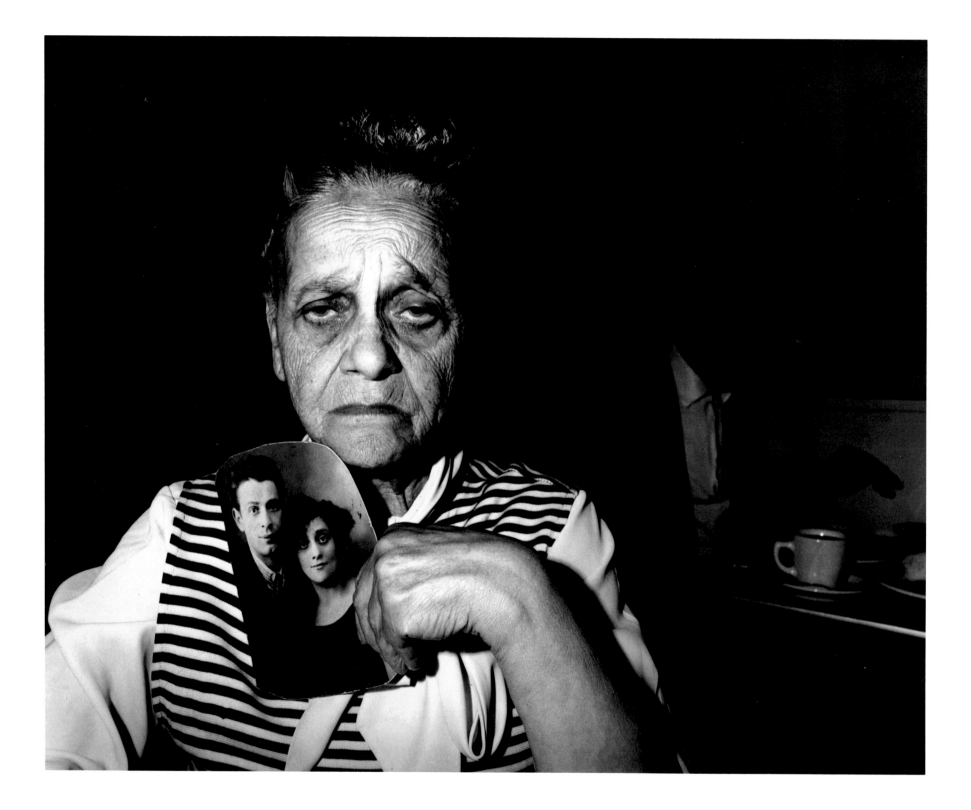

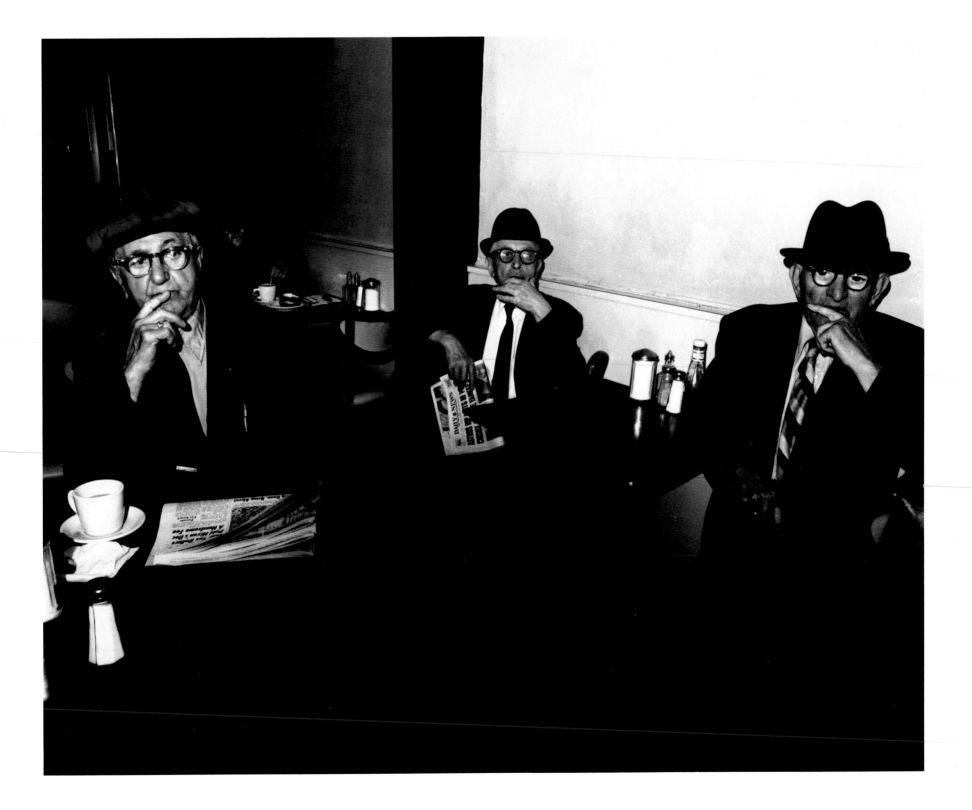

Acknowledgements

I wish to thank Sharon Olds, the poet, who worked long hours with me to focus feelings for this writing. Barney Simon, the writer, who challenged me to ask myself hard questions. Carol Learsy, the editor, who made insightful suggestions. Bob Adelman, the photographer, who encouraged me to write this project and directed its publication. Lorin Driggs, who typed the final manuscript. Elton Robinson, who designed the book, showing an uncanny ability to see the photographs and put them together on pages. Ray Learsy, the publisher, who was open, understanding and enthusiastic from the beginning to the end. Jim Silberman, of Summit Books, who gave us many ideas. The staff and colleagues at Magnum Photos, who have provided a professional base and creative climate over the years. Ronald and Elizabeth Beckman, the industrial designers, my close friends who have inspired me with their humanistic ideals for over twenty years. Grace Oxendine, who has helped me in many ways to continue my work. Ann Haas, for her devoted help. My mother and stepfather, Eleanor and Lester Petchaft, for their love and guidance. Emily, my wife, friend and confidante whose intelligence, energy and passion have helped me find my way. And, finally, the people I photographed, for letting me enter their lives.

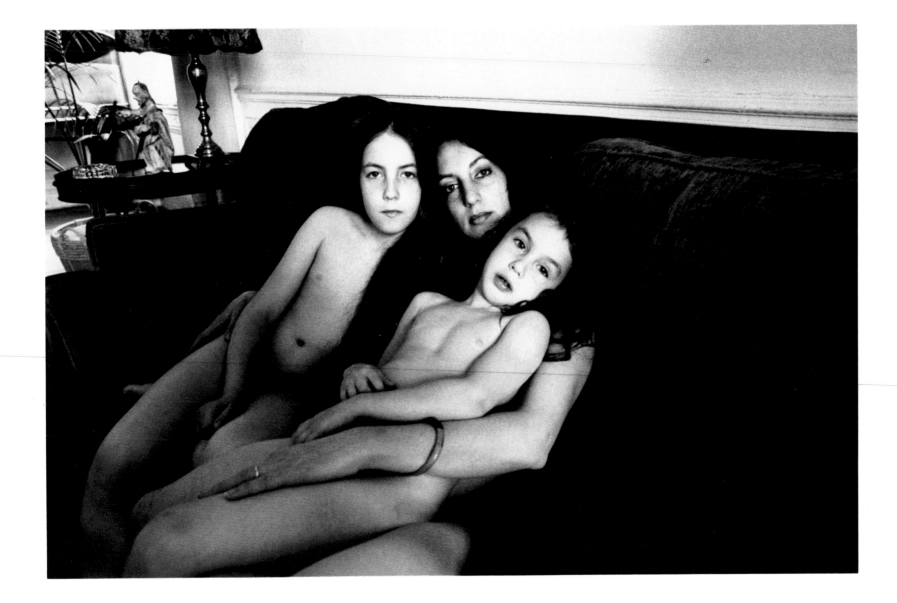

for Emily, Jenny and Anna

1978